BEXHILL-ON-SEA IN 50 BUILDINGS

DAVID HATHERELL & ALAN STARR

AMBERLEY

For Jennie and Sue with thanks for their unending support

First published 2025

Amberley Publishing, The Hill, Stroud
Gloucestershire GL5 4EP

www.amberley-books.com

British Library Cataloguing in Publication Data.
A catalogue record for this book is available from the British Library.

ISBN 978 1 3981 1996 3 (print)
ISBN 978 1 3981 1997 0 (ebook)

Typesetting by SJmagic DESIGN SERVICES, India.
Printed in Great Britain.

Appointed GPSR EU Representative: Easy Access System Europe Oü, 16879218
Address: Mustamäe tee 50, 10621, Tallinn, Estonia
Contact Details: gpsr.requests@easproject.com, +358 40 500 3575

Contents

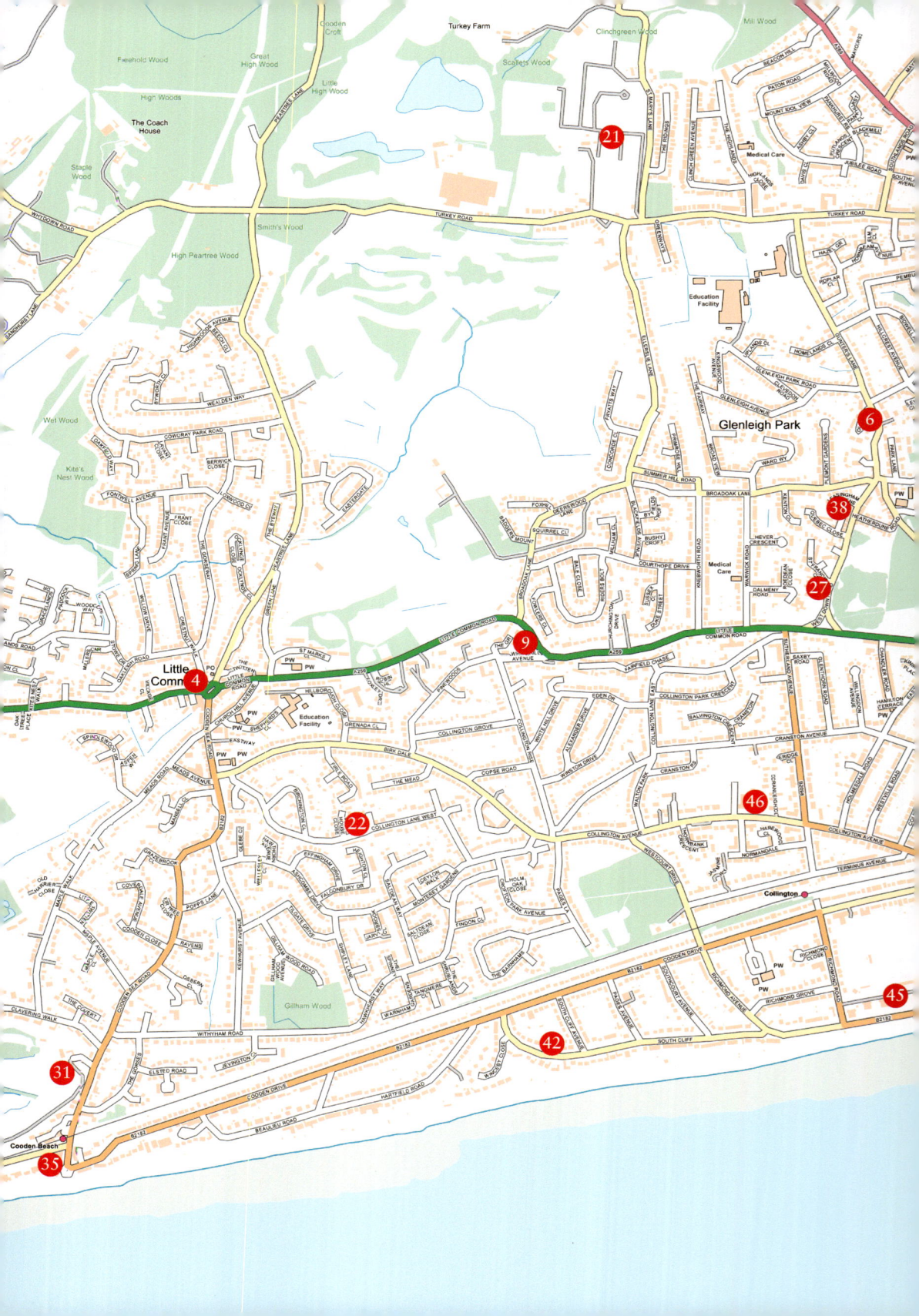

Sidley

Redgrove Wood

Levets Wood

Combe Wood

Little
Worsham Farm

Whitelock's Shaw

Upper
Worsham Farm

Roundacre
Wood

Pebsham

Pabsham

Hospital

Hospital

Old Town

Education Facility

Education Facility

Education Facility

Education Facility

Education Facility

Medical Care

Medical
Care

Education
Facility

Education
Facility

Sports/Leis

Fire Station

Art
Gallery

Police Station

Library

Art Gallery

Bexhill Beach

Medical
Care

King Offa Way

De La Warr Road

De La Warr Parade

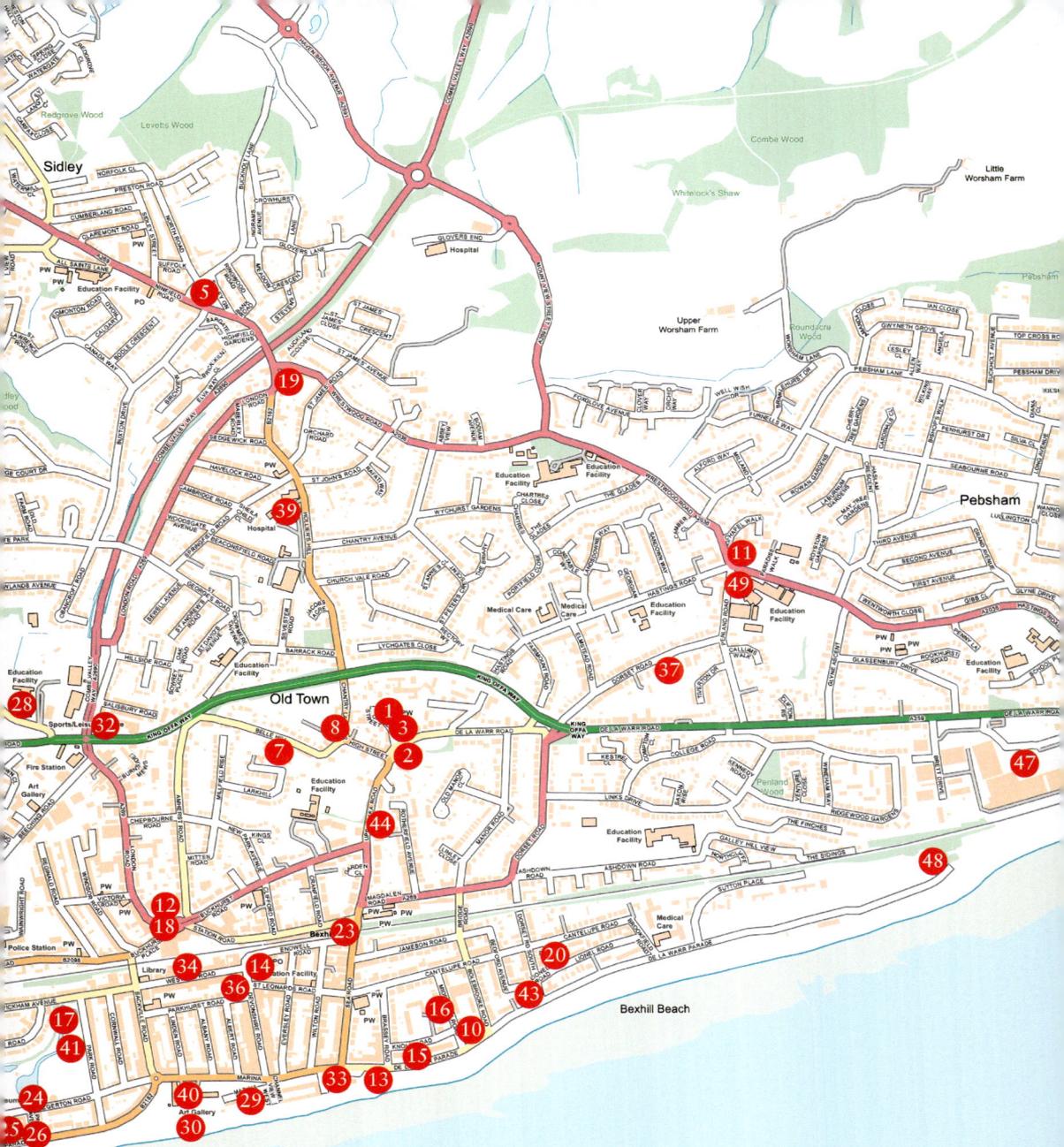

BEXHILL-ON-SEA

Key

1. St Peter's Church
2. Manor House
3. Lychgates
4. Wheatsheaf public house
5. New Inn
6. Down Mill
7. Millfield
8. Barrack Hall
9. Denbigh Arms
10. Sackville Apartments
11. Nazareth House
12. Town Hall
13. Coronation Bandstand
14. The Devonshire
15. Marine Mansions
16. Victoria House
17. Ducks Castle
18. Henry Lane Memorial
19. The Pelham
20. United Reform Church
21. Cemetery Chapel
22. Lake House
23. Bexhill Station
24. Bexhill Museum
25. Oceania
26. Clock Tower
27. The Lodge, St Francis Chase
28. King Offa Primary Academy
29. Marina Court Avenue
30. The Colonnade
31. Cooden Beach Golf Club house
32. Malet Memorial Hall
33. War Memorial
34. The Picture Playhouse
35. Cooden Beach Hotel
36. Boots store
37. Augusta-Victoria College
38. Leasingham Gardens
39. Bexhill Hospital
40. De La Warr Pavilion
41. Bowls Pavilion, Egerton Park
42. Saxons
43. Motcombe Court
44. Upper Sea Road air-raid shelter
45. West Indies apartments
46. Conquest House
47. Ravenside Retail Park
48. Coastguard Station
49. Bexhill College
50. West Parade shelters

Introduction

If we had to sum up Bexhill in two buildings, one would be the white and strikingly modernist De La Warr Pavilion of 1935; the other would be a traditional red-brick retirement bungalow from the same year. These are seemingly poles apart but share a vision of Bexhill.

For centuries it was a small settlement on the top of a low hill, whose main buildings were a church and the odd windmill. The town grew during the Napoleonic Wars, and there were new possibilities when the railway came in 1846. Then in the late nineteenth and early twentieth centuries, Bexhill-on-Sea came into being, with luxury hotels and elegant apartment blocks. The motto of the new town was *Sol et Salubrias* – Sun and Health.

We need to recall how heavily polluted London was in 1900, and how easy it was to come down to the coast by train, or even by car. With the invigorating south-westerlies and protection from the northerlies, Bexhill recommended itself as an ideal place to recuperate. The modest bungalows of the 1930s and 1950s allowed Londoners to retire to a sunny, quiet town by the sea. The great Pavilion, facing outward to the Channel, was designed to provide sunlight and air for the masses. In between these extremes were the expensive seafront apartments, possibly occupied by retired Indian colonels, and a set of high-quality private homes, where wealthy Londoners could spend the summer. The climate and social conservatism of Bexhill made it a safe location for private schools, of which there were many.

A few individuals steered most of this development. Above all there was the De La Warr family, which owned much of the local land. The 7th Earl built the seawall and, in 1890, the Sackville Hotel. The 8th Earl wished the town to become a new Nice, with upper-class visitors, a cycle track and motor races. He later developed the western end, at Cooden Beach. The socialist 9th Earl continued the aspirational dreams, building the Pavilion. Alongside the Earls, with their modernising and grandiose plans, another set of builders moved in. John Webb created Egerton Park and the substantial middle-class houses nearby. R. A. Larkin built huge numbers of small houses and bungalows, attracting a new class of Londoner to the town. Wealthy individuals commissioned buildings for public education, and the churches and the local authority added to the fabric of the town. This was halted in 1940, when Bexhill was surprised to find itself on the front line of a war. Several of our buildings experienced bomb damage.

In the post-war period the town was modified to make way for the motor car, and there were large building developments on the outskirts – apartment blocks, a retail park and a college – which might have been built in any town in Britain. Bexhillians, however, are still concerned with their environment. There has been a successful campaign to preserve much of the old town at the top of the hill. The reworking of the West Parade has sparked real controversy: the argument between the modernists and the traditionalists continues.

How to Use This Book

The buildings in this book appear in chronological order according to the time of original construction. The number on the map corresponds to the number of the building in the text.

The 50 Buildings

1. St Peter's Church

St Peter's, a Grade II* listed church, is mentioned in the Domesday Book and can reasonably claim to be the oldest building in Bexhill. Parts of the building, at the west end of the nave, are quite likely from the early eleventh century. The church has been associated with King Offa's Charter, which is dated AD 772. It also possesses a remarkable stone, probably a reliquary cover, which is carved in an eighth-century fashion but was probably made in the eleventh century.

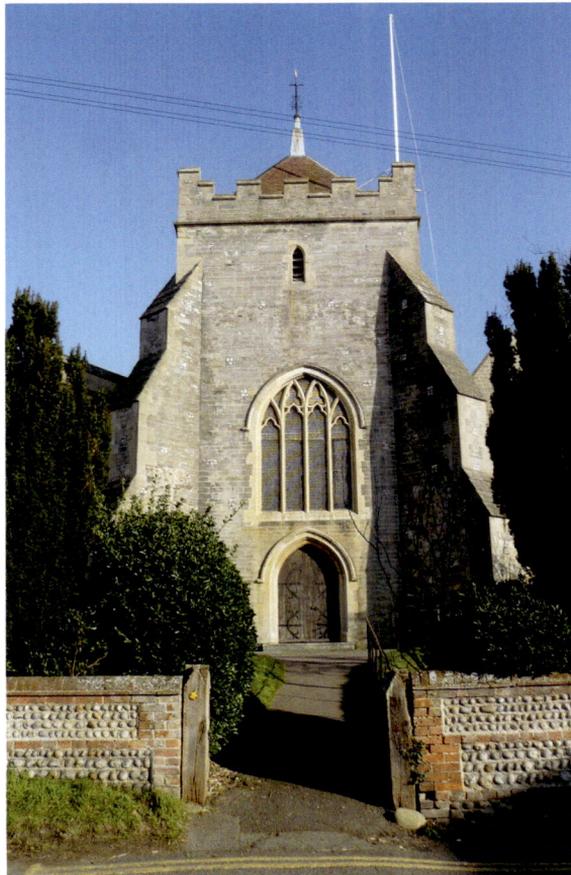

St Peter's Church.

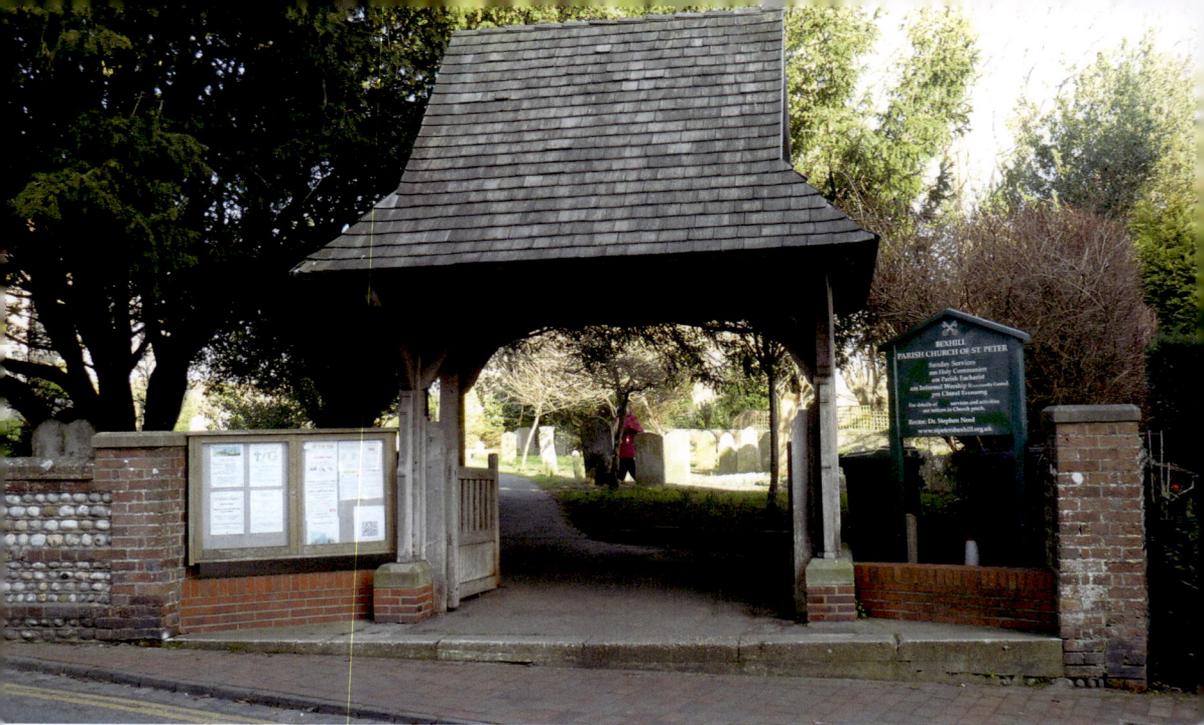

St Peter's Church lychgate.

The church has provided at least a millennium of service, and the fabric has been constantly renewed. The year 1086 saw the first addition to the small Saxon church, with the building of the early Norman tower, slightly lower than at present. The present church retains Norman features. Various alterations were made throughout the thirteenth century. The eastern part of the north aisle was once the chantry, founded in 1453 in accordance with the will of Joan Brenchesle. The chantry provided the town's first educational institution when Dr Thomas Pye, rector from 1589 to 1609, used it as a schoolhouse. The parish vestry provided a large part of the town's early local government and social services.

In the wall of the north aisle are two windows containing panels of some very ancient glass of the fourteenth and fifteenth centuries. In around 1750, Horace Walpole was improperly given the images, which he liked to believe were of King Henry III and Queen Eleanor. He incorporated them into a much larger window. The images finally came back home in the 1920s; at least one historian was thankful that they had been out of harm's way during the wholesale restoration of 1878.

The 1878 restoration followed the plans of William Butterfield. The aisle became twice as long and twice as wide; the galleries were removed; and dormer windows in the roof went at the same time. More alterations were made in 1907 under the auspices of the rector, Theodore Churton. The visible exterior of the church is the work of the last 150 years.

2. Manor House

These ornamental ruins and gardens hint at previous glory. The Manor House was certainly the oldest building in Bexhill after St Peter's Church. In medieval times it was the eastern seat of the Bishops of Chichester. After the Reformation, the Manor of Bexhill was given to the Sackville family, ancestors through marriage to the Earls De La Warr, and the house was at one time used as a shooting lodge by the Dukes of Dorset.

Towards the end of the nineteenth century, the house was renovated by Gilbert Sackville-West (who became the 8th Earl De La Warr in 1896) and his wife Muriel. A generator provided electric light and a telephone was installed; the house had a resident boffin, the eccentric Harry Grindell Matthews. More than £15,000 was spent on renovations and modernisations. On the lower part of the estate, now covered by Manor and Magdalen Roads, a cricket ground was laid out. The Sackville-Wests moved in during 1892 and used the Manor for aristocratic weekend parties. The gardens provided a charming setting for concerts and fetes illuminated at night by hundreds of fairy lights

Following the De La Warrs' very public divorce in 1902, the house was let to August Neven du Mont, a member of the Cologne newspaper family. His early demise at the age of forty-two in 1909 was regretted locally. After the First World War the estate was purchased by Sir Robert Leicester Harmsworth, a younger brother of Lord Northcliffe, founder of the *Daily Mail*. He died in 1937 having amassed a large library. His eldest son, Sir Alfred Harmsworth, was seriously wounded in the First World War and lived a secluded life. Lady Harmsworth lived on at the Manor House until her death in 1963 at the age of ninety-five. The following year the trustees offered the estate for sale.

Manor House remains.

Above: Commemorative ironwork.

Below: Manor House in its heyday. (Courtesy of Bexhill Museum)

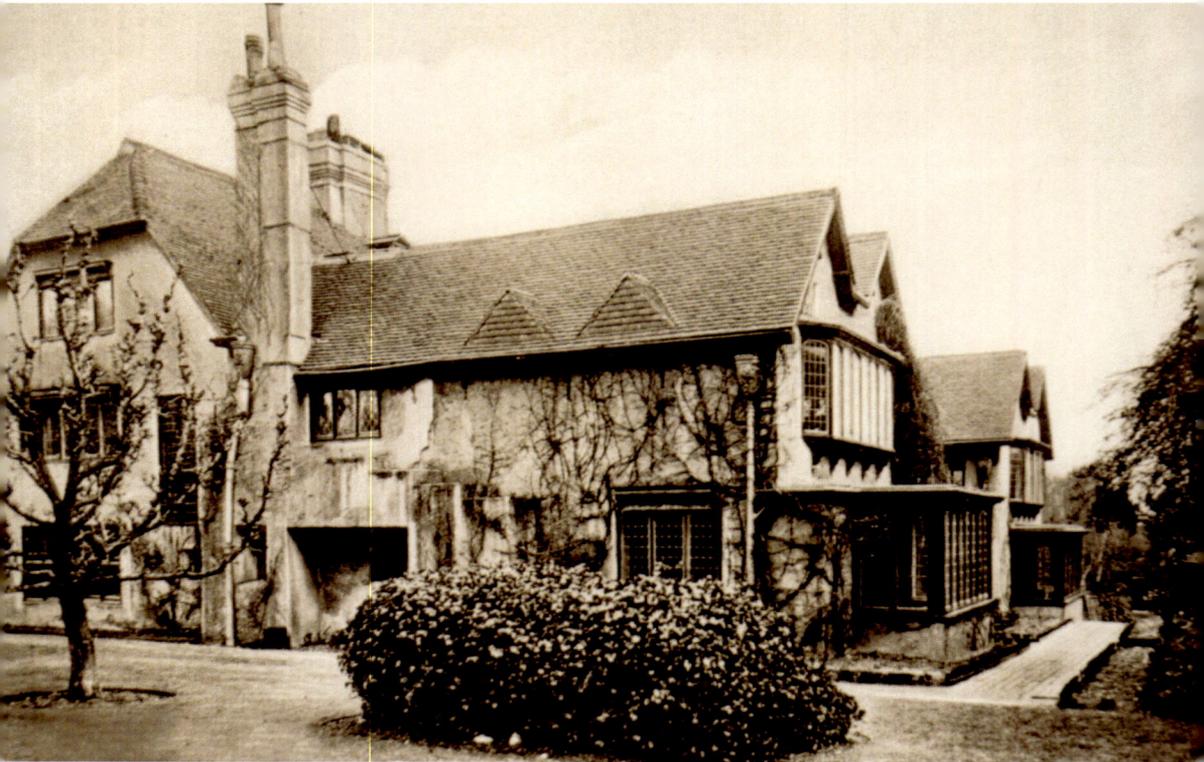

The former Bexhill Borough Council purchased the estate in 1964 for £22,000 and planned to demolish the Manor House, widen what was the main route along the coast and erect a nine-storey block of flats. Public outrage led to the formation of the Old Town Preservation Society.

3. Lychgates

The property at No. 5 Church Street known as Lychgates is – along with the adjoining Lychgates Cottage – the oldest semi-detached in Bexhill. The weatherboarded frontage is recent, but the boards conceal a brick façade built in the late eighteenth century. Behind that façade is a Wealden Hall, probably from the late fifteenth century. There is a continuous aisle at the back, connecting Lychgates to the Lychgate Cottage at No. 4 Church Street.

The antiquity of both premises is evident inside: there are oak-beamed ceilings, raftered walls, large open fireplaces and quaint staircases. At the rear is a former builder's yard and store behind and a rabbit warren of low-beamed rooms. A 1978 investigation found a circular pit during a cellar dig. Today the frontage still has a fire insurance plaque, which refers to 1789 buildings and contents insurance taken out by Edward Crowhurst, bricklayer and glazier, with Royal Exchange Assurance. This is presumably the same Edward Crowhurst who died in 1793 after falling from a scaffold.

The building and its partner have been studied many times: there were archaeological investigations in 1978, 1986, 1992 and 2013. The ownership of the building has been well authenticated as far back as 1553. Education has often been a major part of the town's economy, so it is fitting then that in the early seventeenth century the house was occupied by Dr Thomas Pye, who established Bexhill's first school.

For most of its existence, the building was known as Long Row or New Row. In the twentieth century there was a fashion for giving old houses evocative names.

Lychgates.

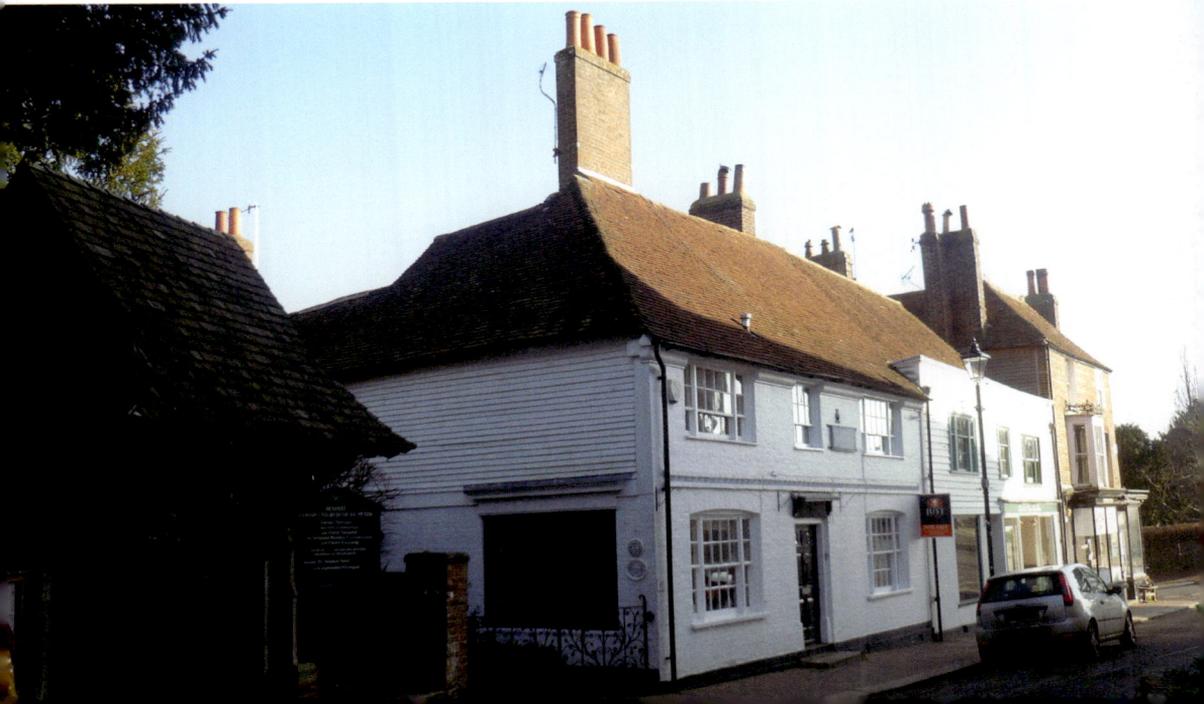

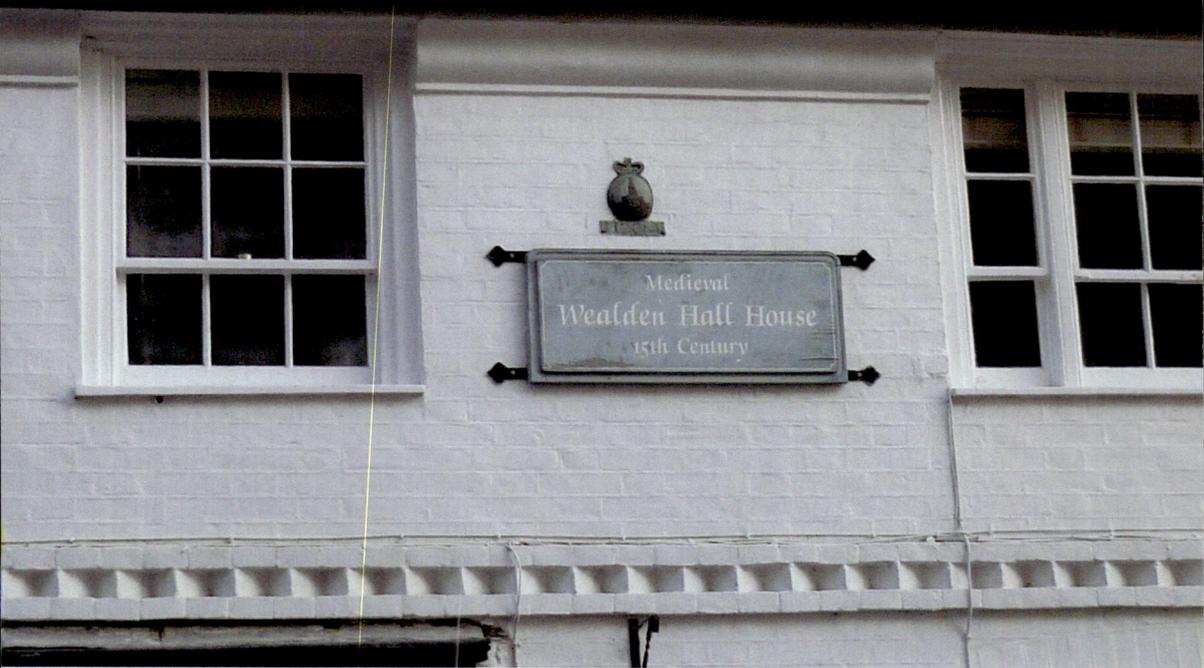

Above: Fire insurance plaque at Lychgates.

Below: Lychgates Restaurant. (Courtesy of John & Sue Tyson)

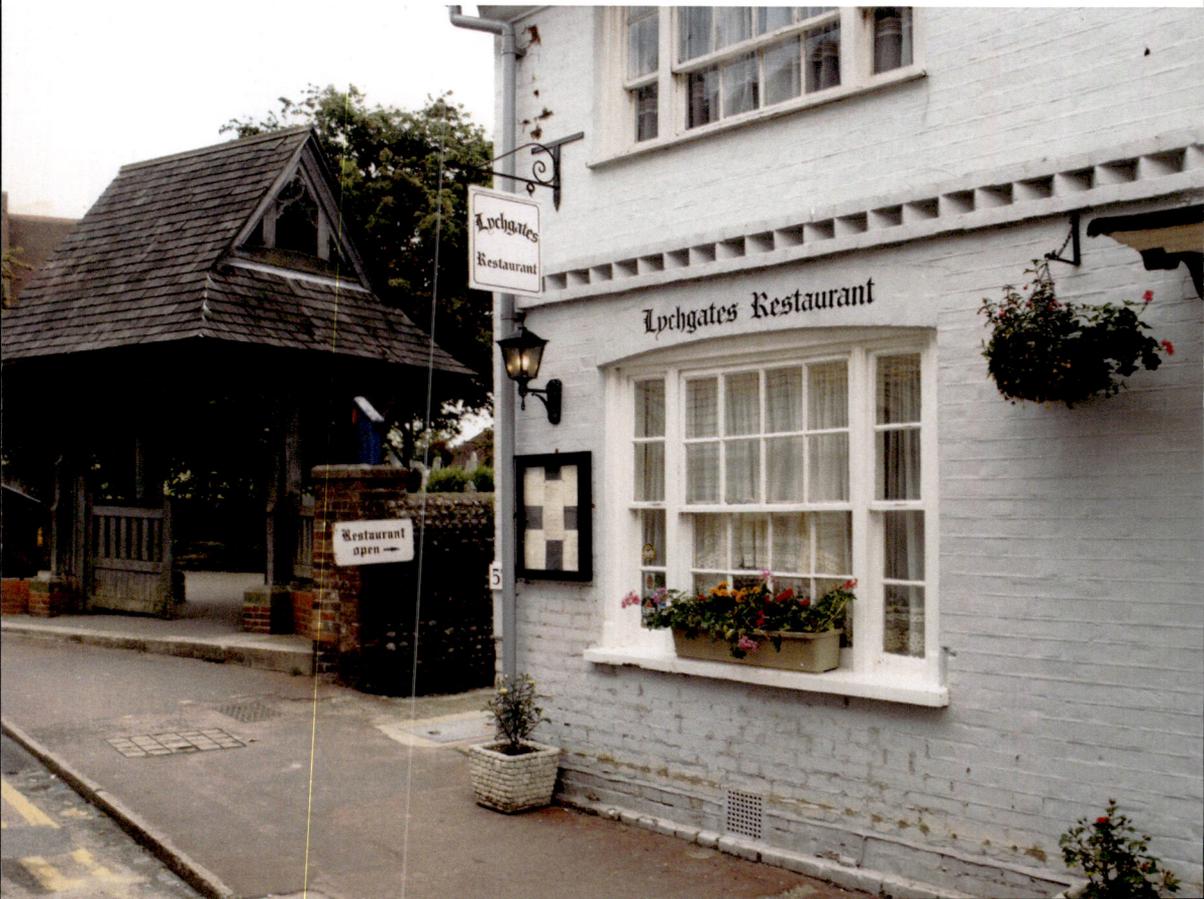

By the 1930s the house was called Lychgates, perhaps in response to the new lych gate built for St Peter's Church in 1907.

Grade II listed status was awarded in 1948. Mrs Audrey Hodgson bought both Nos 4 and 5 Church Street with the intention of opening tearooms. Mrs Hodgson sold No. 5 to John and Sue Tyson in 1986, who opened the Lychgates Restaurant, listed in the Michelin Guide and the Good Food Guide. They sold on the business ten years later and Lychgates is now a private residence.

4. Wheatsheaf Public House

The centre of Little Common is now a large roundabout on the road from Eastbourne to Bexhill, with suburban roads radiating south to Cooden Beach and north towards the Weald.

One hundred and fifty years ago, Little Common was scarcely even a village. There was a blacksmith and a pond, a common and a scattering of cottages. The one feature connecting that lost world with today is the Wheatsheaf Inn. There was certainly a Wheatsheaf here at the end of the eighteenth century, and nineteenth-century visitors enjoyed its old-fashioned charm.

By the late nineteenth century, hunts were gathering huge support, setting off from The Wheatsheaf, especially on Boxing Day. The pack had been formed as Bexhill Harriers by Arthur Sawyer 'Squire' Brook in 1885. The Bexhill Harriers hunt route was Kewhurst to the Pages, Collington, West Cliff, Collington Manor, Sutherland Avenue and Bragg's Farm.

The other rural pursuit was smuggling. The Little Common Gang were headed by George Gillham, a prominent village builder. The Little Common smugglers owned two vessels, *The Queen Charlotte* and *The Long Boat*. The boats were normally kept hidden from view at The Star Inn, Normans Bay. An 1825 auction notice mentions an occupant a Mrs Plumb as a 'respectable and punctual tenant year by year'. The Wheatsheaf public house was rebuilt in 1886.

Licensees came and went. A Mr Godfrey was the landlord of the Wheatsheaf, to be followed by Ma Hemmings – she was very stern, but also kind. Her son-in-law Stan Gibbs looked smart in his Royal Naval Volunteer Reserve uniform. He was chosen to be a member of the guard of honour when the Duke and Duchess of York visited to Canada in 1938. The Gibbs family had long tenure from 1932 to 1970 accompanied by George a forty-year-old African grey parrot. The Gibbs were succeeded by Mr and Mrs Doyle.

A kitchen refurbishment was carried out in 1990. There was a change, of course, in 2006 when the pub became a restaurant, the bar being open to diners only. Now the Wheatsheaf has reverted to a more conventional pub and restaurant closely bound to the local community.

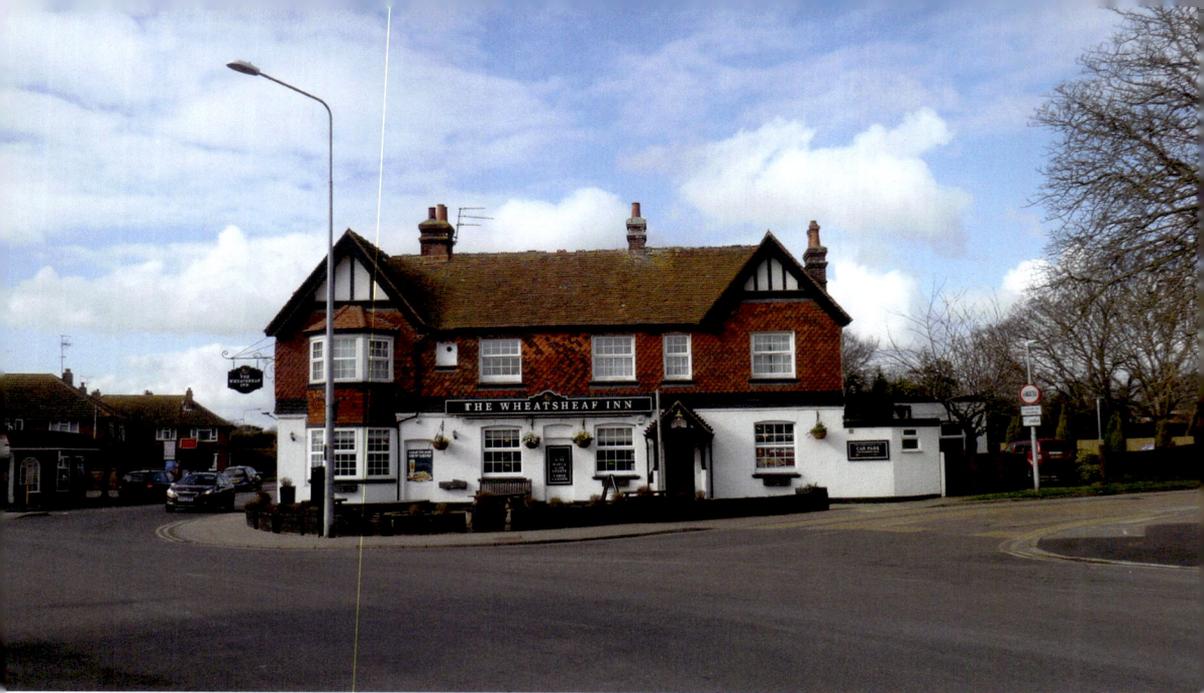

Wheatsheaf public house.

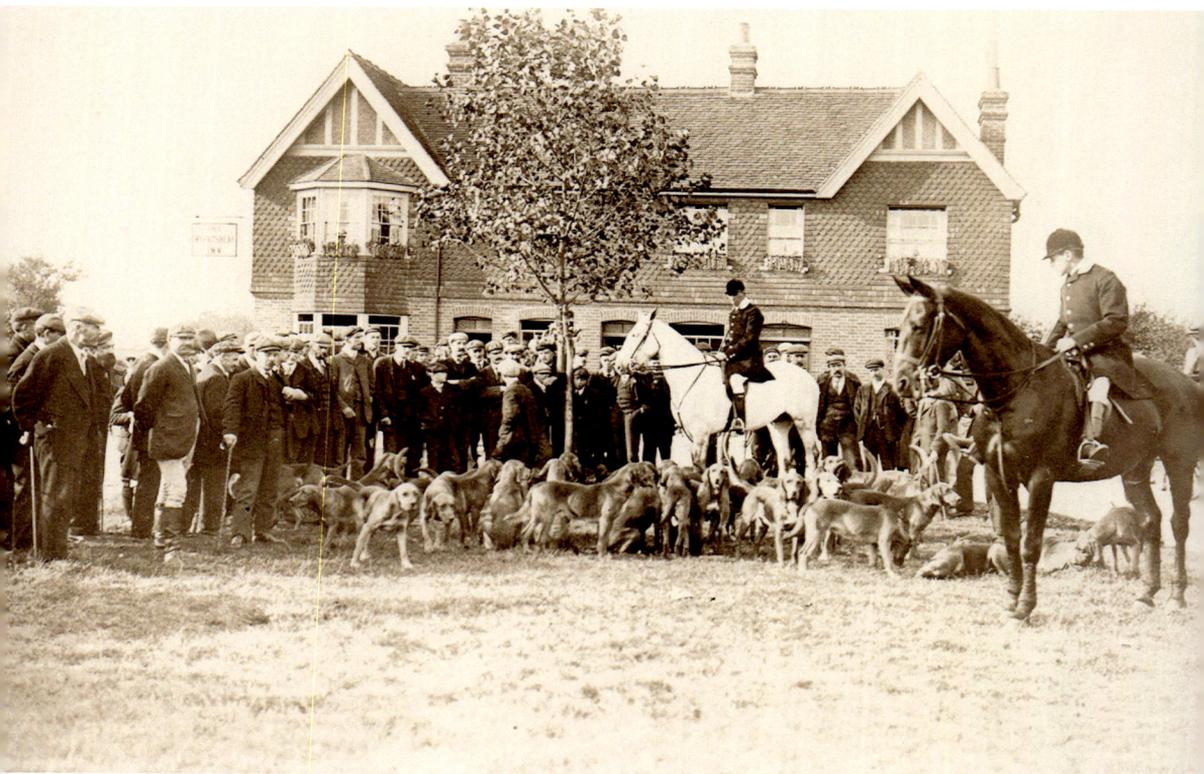

Hunt meet at the Wheatsheaf public house. (Courtesy of Bexhill Museum)

5. New Inn

The New Inn on the Ninfield Road is a Grade II listed building, described as red brick and weather-boarded and dating back to the eighteenth century. As so often with inns, there have been claims for a much older origin.

The New Inn's fame came in 1828, in the episode known as the 'Battle of Sidley Green'. Customs and Excise officers observed smugglers landing a cargo at Bo Peep, near Hastings. The forty-strong Galley Hill patrol tried to stop this but were outnumbered. The smugglers marched inland with their contraband. A group of tubmen were carrying the tubs of alcohol and packets of tobacco, protected by 'batsmen', so-called because of the bat, a 6-foot staff made of ash wood. Things came to a head near the New Inn. While the tubmen pressed on, the batsmen stayed and formed a regular line, hoping to halt the patrol.

In the ensuing fight a blockade quartermaster and two batsmen were killed. Ten smugglers received death sentences at the Old Bailey but were later transported to New South Wales instead. Whilst they were never to return, in recent years their descendants have come to trace their footsteps and visit the inn.

This was not the last fight near, or in, the pub. Over the nineteenth century, it featured in the crime reports of the newspapers far more often than in the society pages. There was 'drunk and riotous' behaviour there in 1869, spilling out onto the Green. In 1890 there was a violent fracas, with twenty-two panes of glass being broken. In 1899 a woman from Brighton stole sheets and a shawl from Ninfield, but was apprehended in the New Inn, slightly the worse for drink but still wearing the shawl. In 1914 a stolen horse and cart were sold; the contract

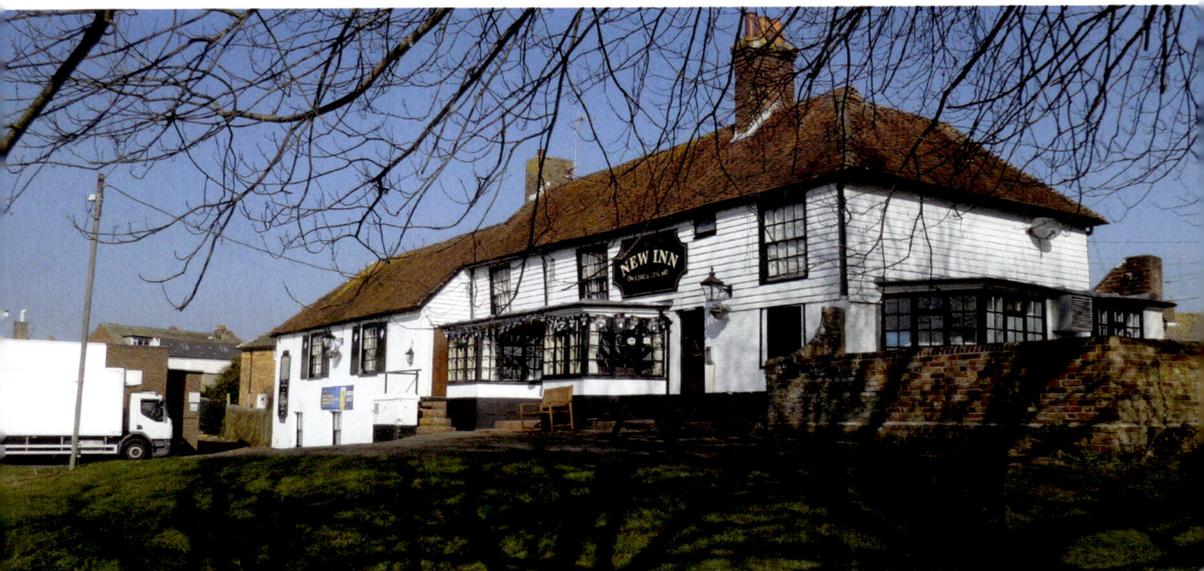

New Inn.

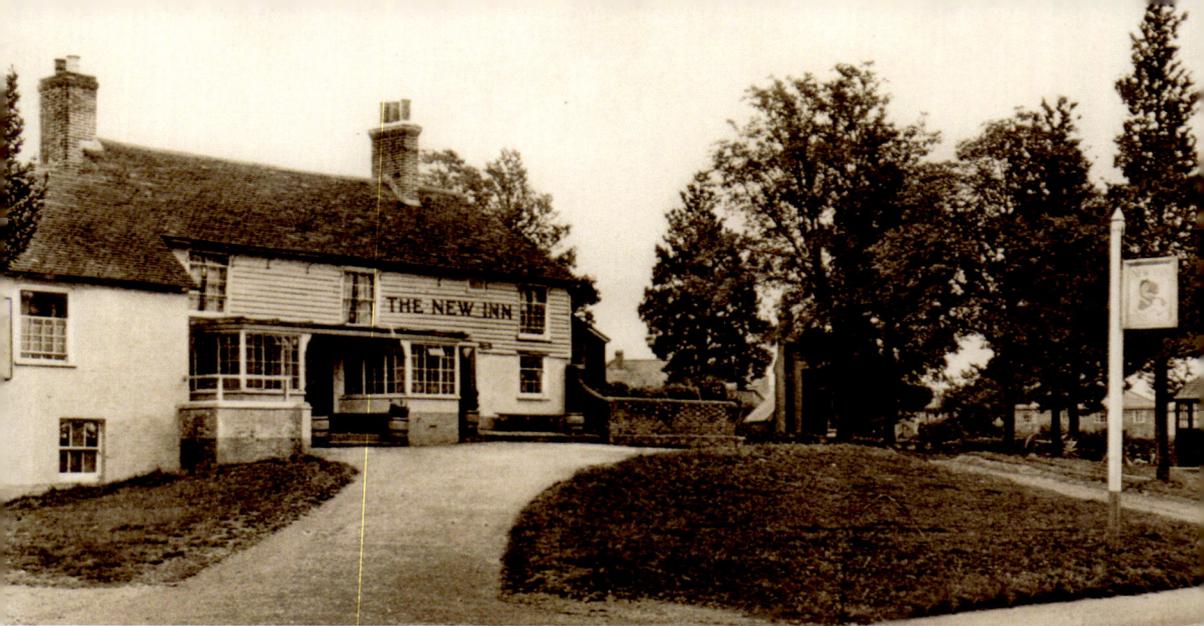

New Inn, early twentieth century. (Courtesy of Bexhill Museum)

was signed on a windowsill of the New Inn. The venue also hosted a number of respectable gatherings over the years.

In 2018 a campaign was launched to save the New Inn. The decision was favourable and today the New Inn continues as a popular community pub. In November 2024 the premises suffered a fire causing damage to the upstairs part of the pub and extensive damage to the kitchen.

6. Down Mill

Before Bexhill became a seaside resort, the main features of the skyline, apart from St Peter's, were two windmills. One was Pankhurst's Mill in Sidley. The other was the Down Mill, better known now as 'Hoad's Mill', which stood on Gunter's Lane, at Bexhill Down. It was erected in the eighteenth century and acquired by the Hoad family in 1857. Before the First World War it was used mainly for wheatmeal and brown flour. The windmill continued working until 1928. By then, an electric motor had been installed to drive the machinery, so the sweeps were no longer used.

The windmill was Grade II listed in 1949. In 1956 one of the sweeps was broken in a gale. The mill eventually collapsed in 1965. The Hoad family meanwhile ran a successful bakery business, with the bakery in operation seven nights a week. They had two shops and five vans.

The artist L. S. Lowry painted the mill in its final years. It is not known what Lowry was doing in Bexhill during 1960 – it is possible that he was holidaying here. The painting is now in Bexhill Museum.

Today only the roundhouse survives, as the main post and trestle disappeared in 2013.

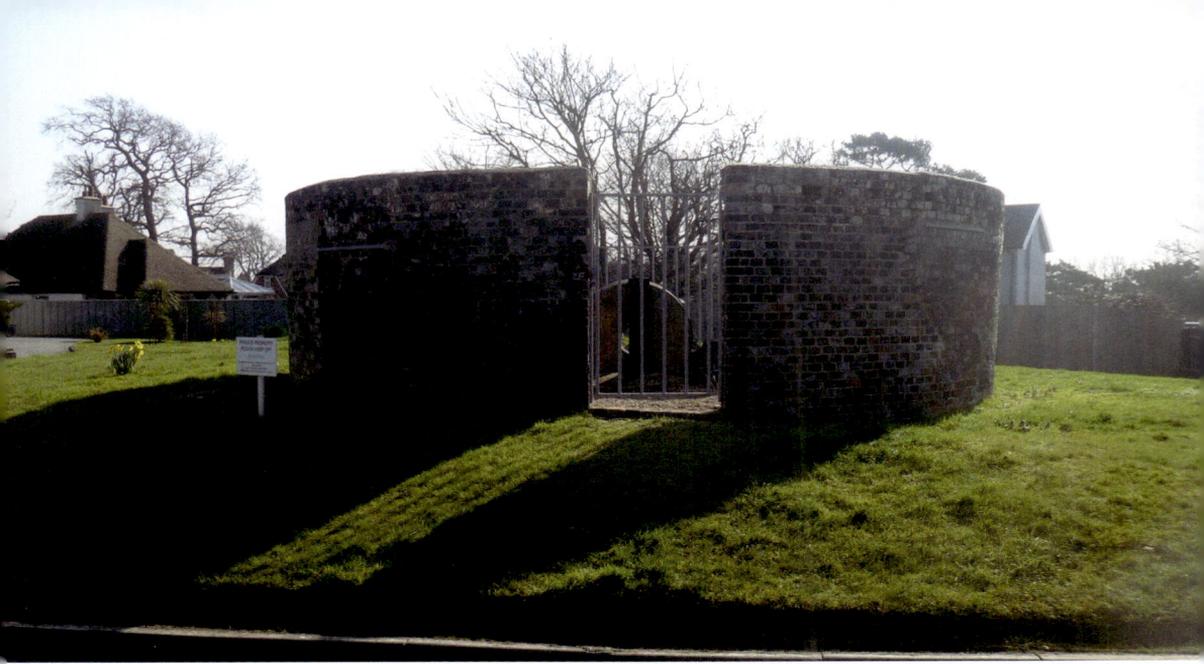

Above: Down Mill remains.

Right: Down Mill in its heyday.
(Courtesy of Bexhill Museum)

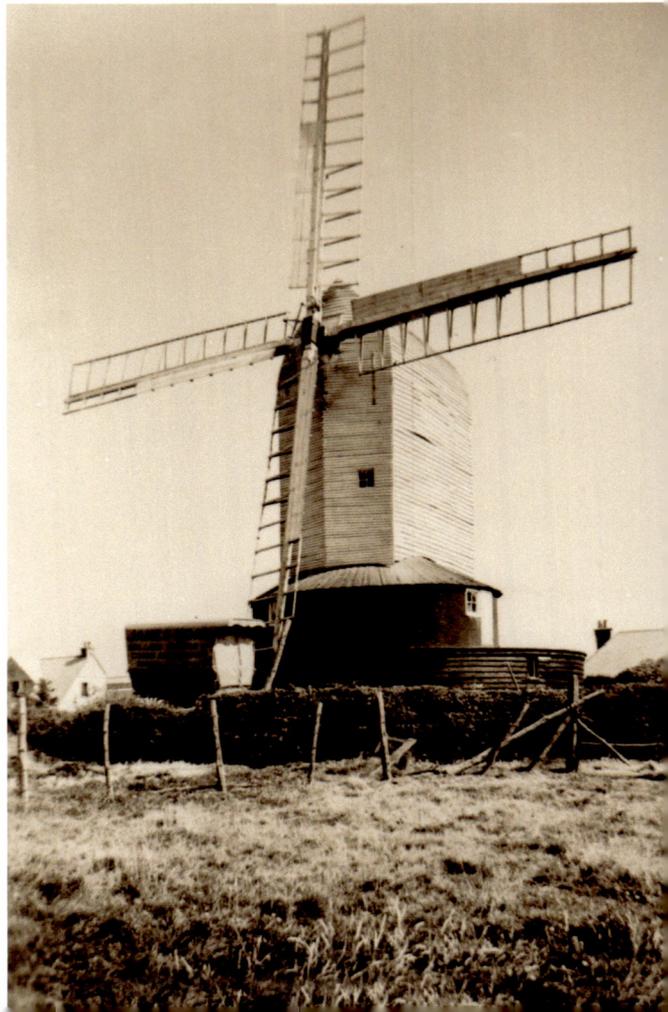

7. Millfield

It appears that there was once a windmill at Old Town. It is certainly a suitable location, and for a long time there has been a plot of land called Millfield next to the current house of that name. Millfield is now usually approached from Belle Hill; this is the back of the building, whose grand frontage once looked out to the south, towards the sea.

Originally it was called The Firs, a three-storey building built between 1793 and 1808 for Josiah Routledge. Josiah invested in a grand project to sink coal mines under Bexhill. Regrettably, there was no coal, and by 1815 the venture was at an end. Unable to pay back his creditors, Josiah fled the country. One of his fellow investors was Nicholas Vansittart, who, disturbingly perhaps, went on to become Chancellor of the Exchequer.

The Firs came into the ownership of the Moorman family, who lived in London but acquired substantial holdings of rural land in Bexhill. It was inherited by Ann Moorman of Clapham, who married her neighbour, Samuel Scrivens. In 1863, Samuel and Anne moved down to live in Bexhill permanently. In the return of Owners of Land, made in 1873, Samuel was designated the second largest landowner with 393 acres and a rental of £736. He was one of the first developers of Bexhill, building between the old town and the railway.

In the next generation, Miss Ann Scrivens became a Fellow of the Royal Meteorological Society, compiling regular detailed meteorological data, and providing regular weather reports for the *Bexhill-on-Sea Observer* in the 1890s. Until April 1897 these reports were compiled at The Firs, then in May the address changed to Millfield.

Millfield.

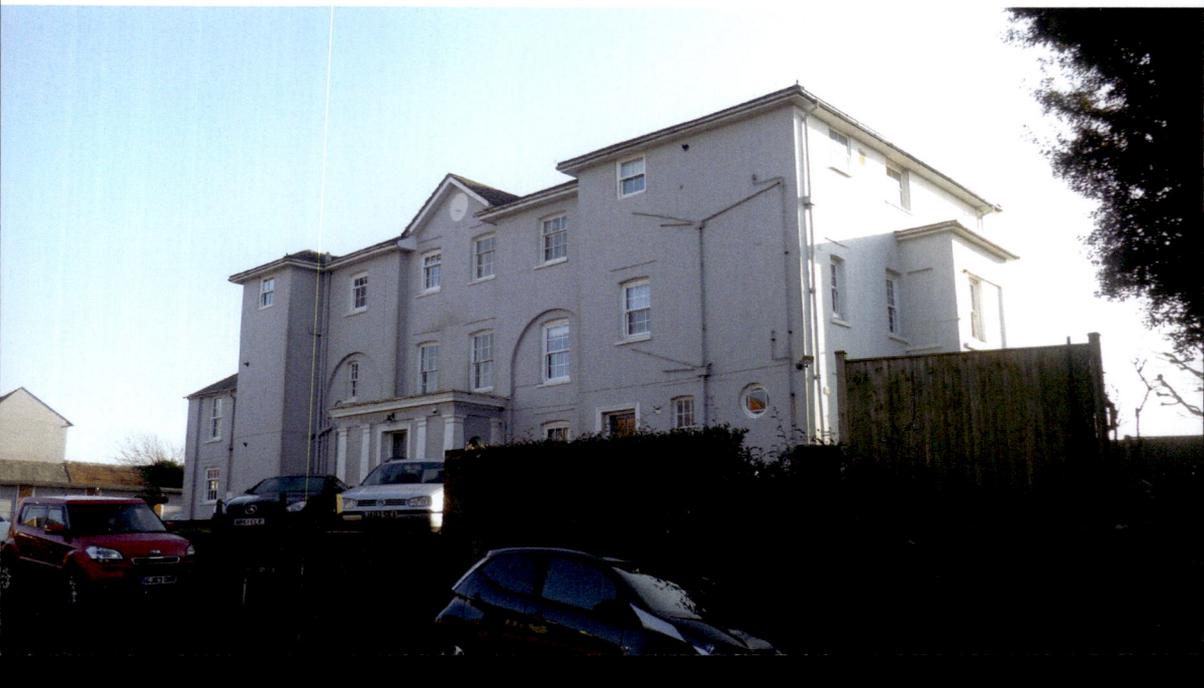

The Scrivens family were in occupation until Millfield became the home of the Mayor William Nicholson Cuthbert just prior to the Second World War. It became a hotel in 1947 before being used by East Sussex County Council as a children's home. It is now a block of eight apartments, having been converted in 1956.

8. Barrack Hall

Barrack Hall was built as a house in the 1790s by a local farmer called William Russell. During the Napoleonic Wars thousands of troops were stationed in Bexhill, notably the King's German Legion, which had been recruited in Hanover from 1803. Russell's farmhouse abutted the giant parade ground and is reputed to be the site of the Legion's headquarters and its officers' mess. Certainly, they would not have wished to live in the mud huts that the men were building. There is a strong tradition that the Duke of Wellington — the Iron Duke himself — stayed at Barrack Hall. After the war, the house reverted to civilian use. The wing fronting Belle Hill was unsympathetically added in the mid-Victorian period and obliterated a Georgian façade.

Barrack Hall went through many phases, being a boarding school under Miss Mary Holland, then the home of Dr Wallis and his family. Dr Frederic Michael Wallis, who went to live at Barrack Hall, succeeded his father in 1880 as district medical officer for the parishes of Bexhill and Crowhurst. For this appointment, he received £60 per annum, plus 12s 6d for each confinement case, but had to supply medicines, except cod liver oil, which could be paid for by the Guardians. He died in January 1892 and was truly mourned.

Barrack Hall.

A successor doctor was Sydney Kent, Australian born, who came to England as a boy. He trained at St Bartholomew's Hospital and his first practice was in Blackheath. He came to Bexhill in 1894 and was for some time in partnership a Dr Barker at Barrack Hall.

At the turn of the twentieth century Barrack Hall was the residence of sisters Agnes and Henrietta Thorneycroft, staunch Conservative Party supporters, who regularly opened their gardens to the public. In 1929 Ernest Sheather, estate agent, advertised 'a fine old residence "Barack Hall", Old Town together with grounds of about four acres'. This attracted Miss Henrietta Howard, who ran a nursing home into the 1970s. Barrack Hall was Grade II listed in 1975.

9. Denbigh Arms

The Denbigh is a public house at White Hill, on the road from Bexhill to Little Common. It was once surrounded by fields and nearby farms, a mile and a half from the centre of Bexhill. In the 1890s there were barely twenty houses between the Denbigh and the next pub. It was a well-built house, according to the auctioneers in 1899, with a garden, good accommodation and stabling. The location had one major advantage: a view over the town from the garden and has been popular with day-trippers.

There has been a pub of some kind on the hill for many years. It is referred to in the 1860s, and in 1874 there was a 'Denbigh Arms beerhouse', owned by Mr Filder, who lived at The Pages. Mr Filder ran into financial difficulties and in 1875 the pub was brought by a London brewer called Wright.

Over the years, the pub has had an association with hunting. Indeed, landlord Josh Smith kept a pack of harrier hounds until they became too much for him to handle. Many clubs and societies have met here such as the Little Common Bonfire Boys.

One noteworthy landlord was the go-ahead Edward Scott, who was the publican from 1898. He provided afternoon teas, a ping-pong club and a darkroom for amateur photographers. He also offered his clients a chance to hear 'the nightingale in full song' in the summer. Sadly, his tenure at the Denbigh ended abruptly when he offered a police constable a bottle of ginger beer. That, at least, was his version. The longer version is that he was providing drinks after hours to the local constable, PC Leverett. When Sergeant Dann appeared at the pub, Leverett ran upstairs. At that point Scott offered the young policeman a ginger beer, a minor offence which could be easily proven. Scott left the Denbigh. Leverett was soon imprisoned for forging cheques. When he was caught, he was in possession of a loaded revolver.

Currently the Denbigh is a popular venue with a beer garden with two pergolas and an extensive menu.

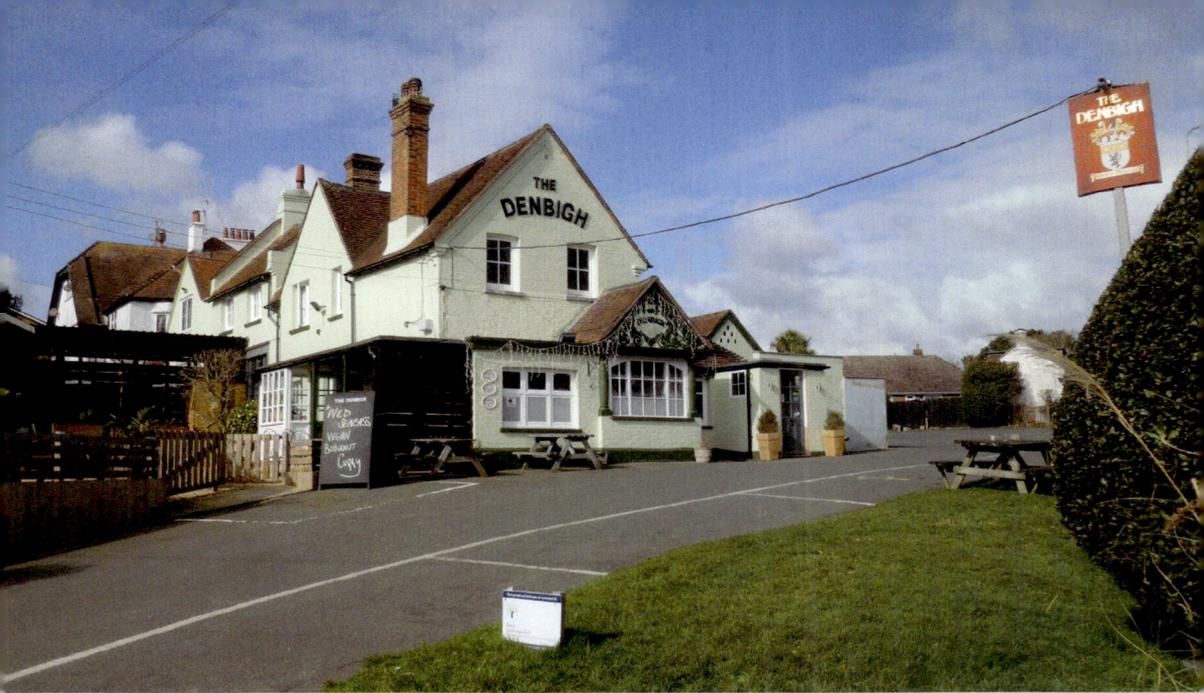

Denbigh Arms.

1C. Sackville Apartments

The 7th Earl De La Warr opened this hotel in 1890. It included a house to be used by the family, occupied by his son, Viscount Cantelupe, when he came to Bexhill in 1891. The venue became Bexhill's premier hotel. Each year saw dukes and duchesses staying here. Lord Curzon, Viceroy of India, was among the many distinguished visitors. In 1897 it provided lunch for the Grand Duke Michael of Russia and the Countess Sophie of Merenberg. It also provided the headquarters for the Bexhill Motor Races of 1902.

In 1897 the hotel was sold to Frederick Hotels Ltd, the owners of the Brighton Metropole. It stayed in their hands for sixty years. Some improvements were made in 1900, including a lounge for 250 people. Furnishings were provided by Maple & Co., the prestigious London furniture store. The hotel was especially popular over the Christmas season, a tradition which continued into the First World War. The grandeur carried through to the Second World War when the hotel was requisitioned by the Royal Air Force and later the Army. During the war the hotel was hit several times by bombs. A serious fire was averted when an incendiary bomb stuck in a difficult spot on the fifth floor.

Post-war Britain was a harsh place for this kind of hotel. It was scheduled for closure in 1957 but was bought by John Higgins. This reprieve was short-lived, and he sold up in 1959. In 1960 it ceased to be a hotel and the contents were auctioned. In 1963 Motel Burstin purchased it with the plan to convert

the building into apartments, similar to schemes in Folkestone, St Leonards and Southend. A further plan was unveiled in 1974 to demolish and replace with a modern four-star hotel and conference centre complete with underground car parking. These plans were not realised, and the building became dilapidated.

In 1989 the Sackville was on the market for £1.7 million, comprising 108 apartments and basement shops known as the Sackville Plaza. It was bought by a residents' buy-out as Sackville Village Ltd with plans for a million-pound refurbishment.

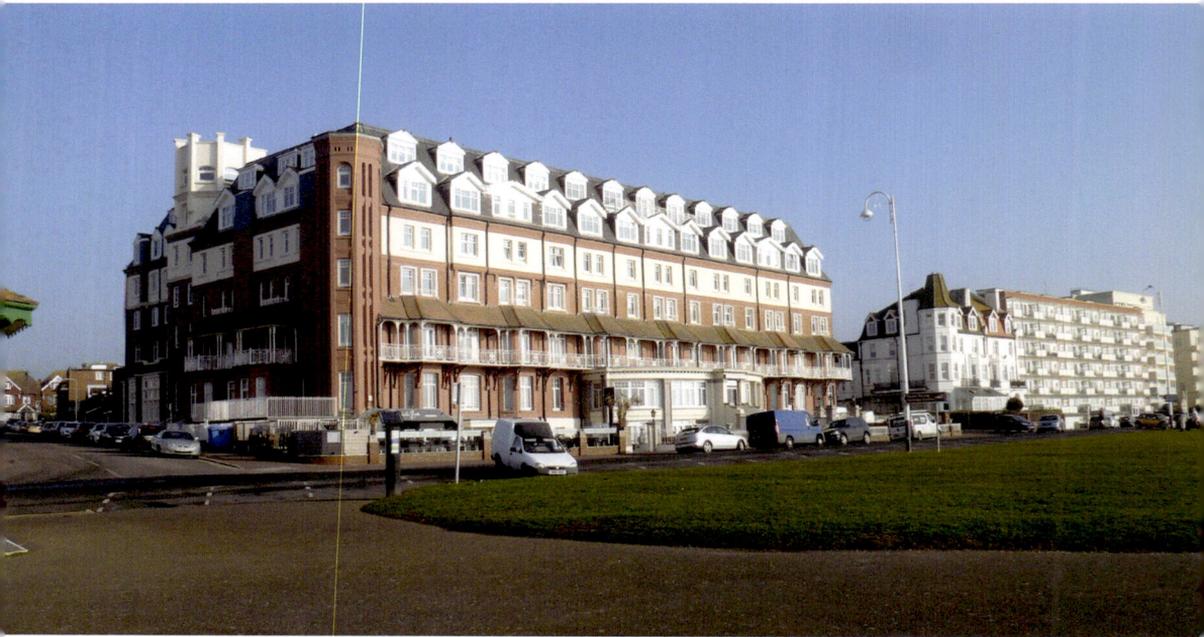

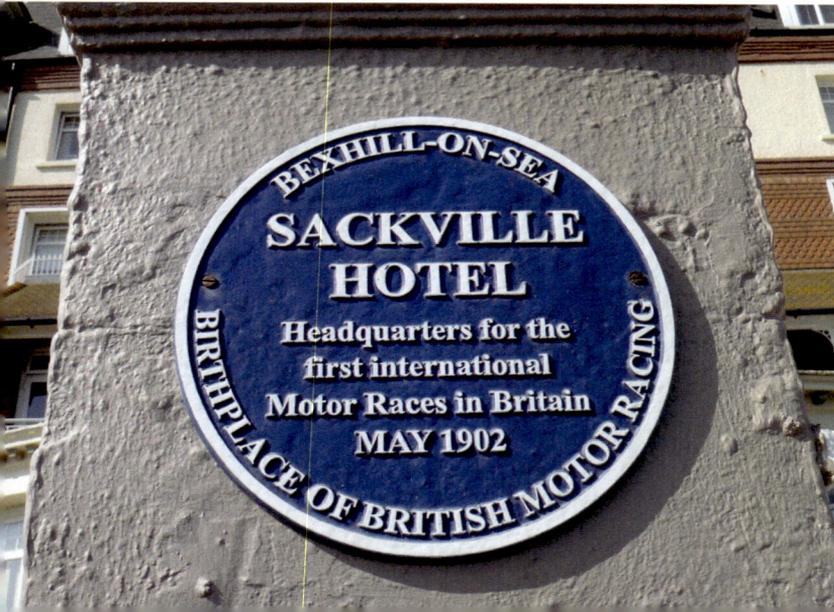

Above: Sackville Apartments.

Left: Sackville Apartments' blue plaque.

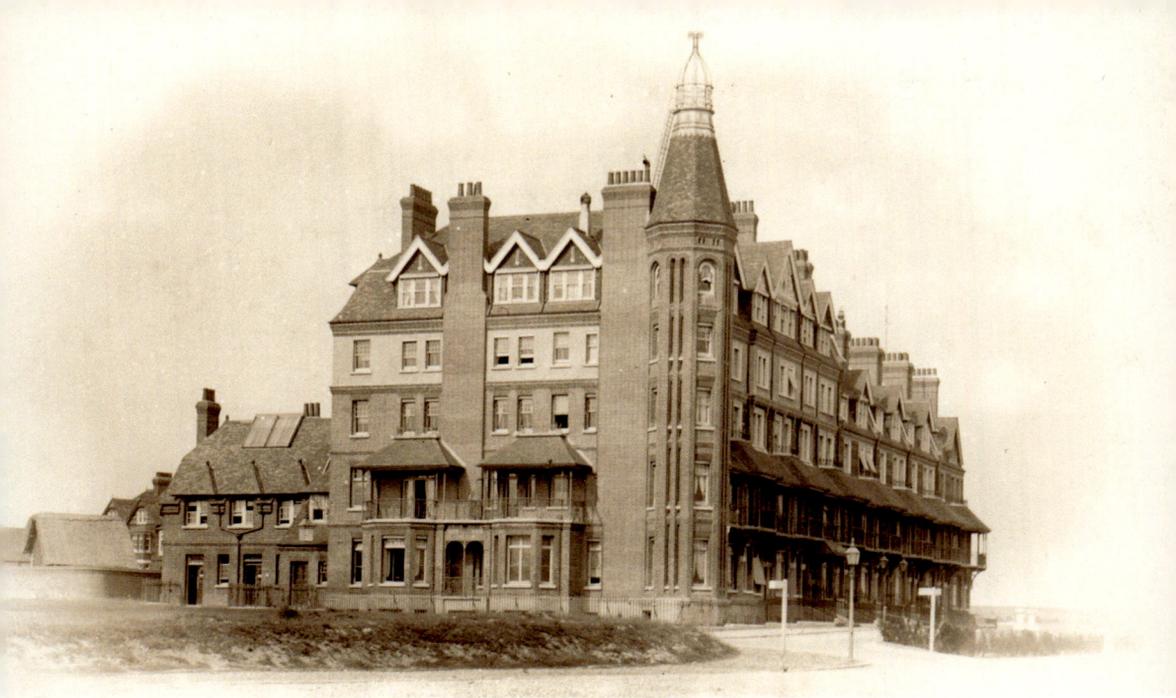

Victorian Sackville Hotel. (Courtesy of Bexhill Museum)

11. Nazareth House

The Sisters of Nazareth originated in France in the 1850s and by 1857 had opened their first Nazareth House in Hammersmith. The Bexhill house was built in 1893–94 by Peter Jenkyns, a London contractor who had moved to Bexhill for his health. The architect, Leonard Stokes, was known for his originality but this building was 'somewhat in the nature of a workhouse'. It was a home for the aged and infirm poor of both sexes and for orphaned girls. It was entirely dependent on fundraising and on contracts with local Boards of Guardians. At that time its reputation in Bexhill was high, although a charge of neglect was levelled in 1922.

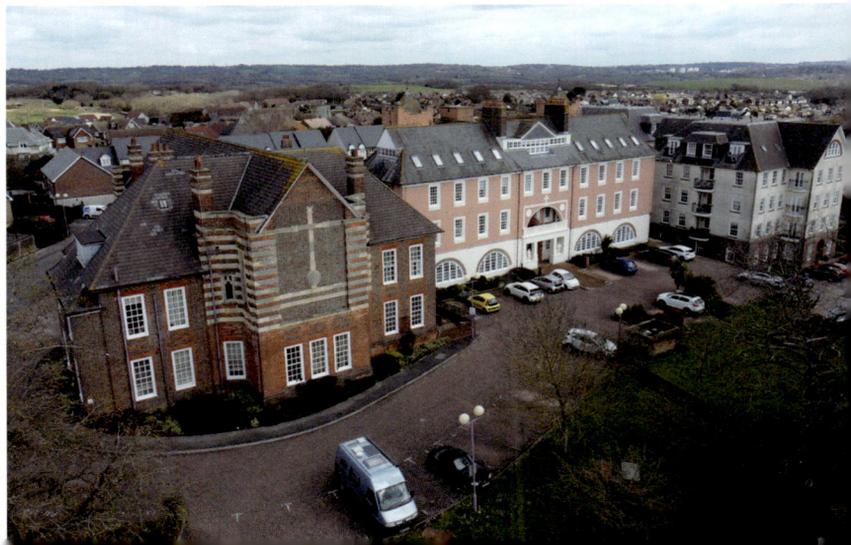

Nazareth House. (Courtesy of Alex Markwick)

In 1911 the west wing was opened, with a chapel upstairs and a dormitory and infirmary for elderly ladies. A men's wing followed in 1926. In 1937 an east wing was added, designed by Pugin and Pugin and providing dormitories and classrooms.

Bexhill Nazareth House hit national headlines in 1953 when two girls were drowned by a heavy wave at nearby Glyne Gap. There were sixty girls with three adults in charge leading to criticism of poor supervision.

12. Town Hall

As Bexhill developed in the late nineteenth century, its local government also grew. There was a clear need for a municipal building and in the 1890s the local board chose a site on land donated by the De La Warr estate.

The council was initially prepared to spend up to £3,000 on the building project. The Town Hall, now Grade II listed, was designed by Henry Ward, and built by a local contractor, Charles Thomas. Ward's plans included the elegant Renaissance frontage and a flexible use of space within the building. It cost £5,250 and was delayed for a time when the workers went on strike. It was officially opened with great ceremony by the Lord Mayor of London, Sir Joseph Renals, in April 1895. The Lord Mayor brought his sheriffs and ceremonial coach to add pomp and colour to the celebrations.

The town went on to become a municipal borough with the Town Hall as its headquarters in 1902. The foundation stone for an extension to the west, which accommodated an enlarged council chamber, was laid in 1908 by the 9th Earl De La Warr at the age of seven, his first public engagement.

Town Hall.

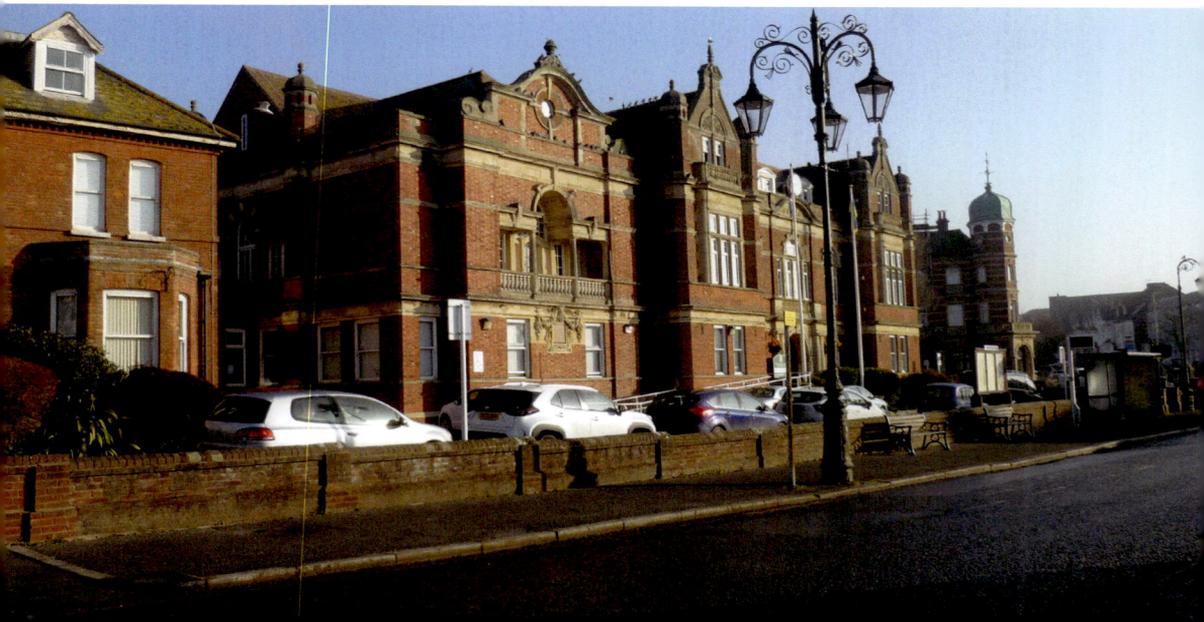

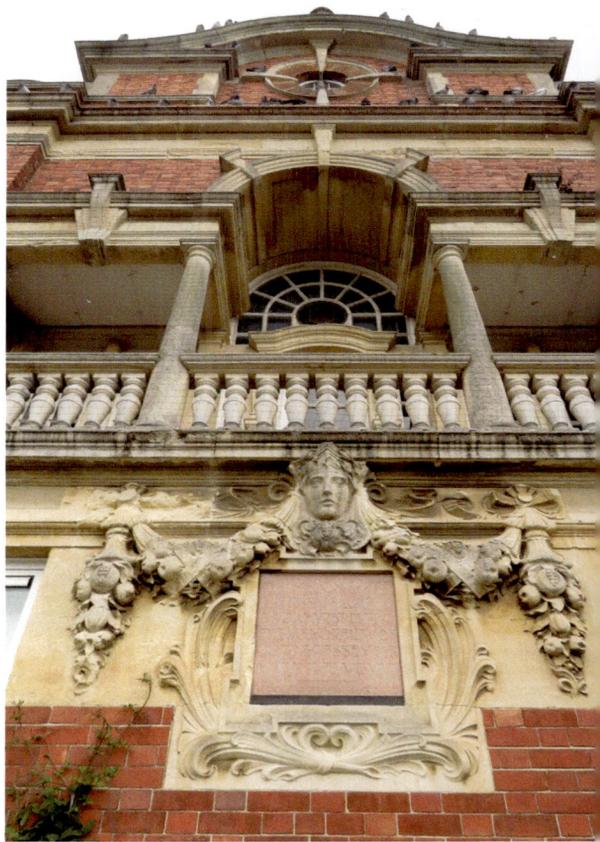

Town Hall plaque.

Almost immediately after, Bexhill became a borough and was responsible for elementary education and highways in the town. In 1925 the borough council acquired the house to the immediate west of the Town Hall for expansion and, in summer 1937, the complex was extended along Amherst Road. The Town Hall was damaged during an air raid in September 1940 during the Second World War. The staff were relocated to Garth Place on the Down, only to be bombed again.

Another westerly expansion occurred in 1960 when the borough council acquired a house to the west of the Town Hall for the use of council officers and their departments. The Town Hall continued to serve as the borough headquarters for much of the twentieth century and remained the local seat of government when the enlarged Rother District Council was formed in 1974.

13. Coronation Bandstand

This building was originally a bandstand erected in 1895. Later purchased by Earl De La Warr, to add exclusivity, the bandstand was surrounded by a seated enclosure. The very popular Stanislaus Wurm's White Viennese Band were regular performers during the summer months: in 1897 the Earl engaged them for a five-month period, and the result was an enormous success. The instrumentalists

wore a white uniform with gold buttons, and were supposedly recruited from the Continent. The conductor became a celebrity, and the bandstand became very profitable. One musician who did not greatly enjoy their music was one of its performers. The young Gustav Holst paid his way through college by playing the trombone for the band.

Being open to the elements proved unpopular with the audience and the structure became a shelter in 1904.

The shelter was awarded Grade II listed status in 2013. By 2020 Rother District Council were faced with significant and immediate repairs and costs were estimated to be around £61,000. The shelter was in a sorry state, vandalised and with dry rot and flaking paintwork. An arrangement was made with Bexhill Heritage to lease the shelter. Bexhill Heritage would utilise the enthusiasm and expertise of its volunteers to embark on a complete restoration of the structure.

This involved the replacement of roof tiles. All old side panels were removed and replaced, as was the floor. All paintwork was stripped back to the wood. Complete rewiring provided lighting and speakers. New maintenance hatches and ventilation panels were installed. In exploring the roof void, a 1974 time capsule of empty beer cans, empty cigarette packets and paint cans was found.

Coronation Bandstand.

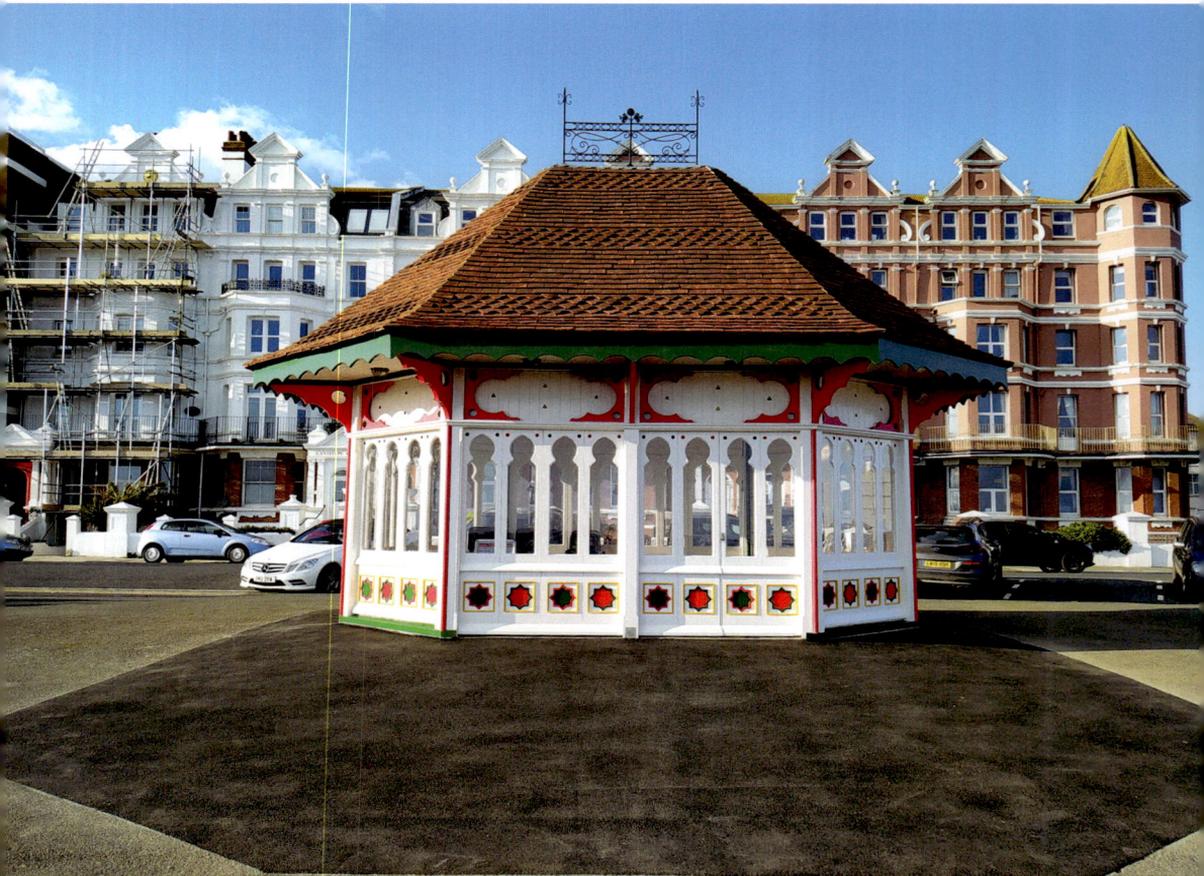

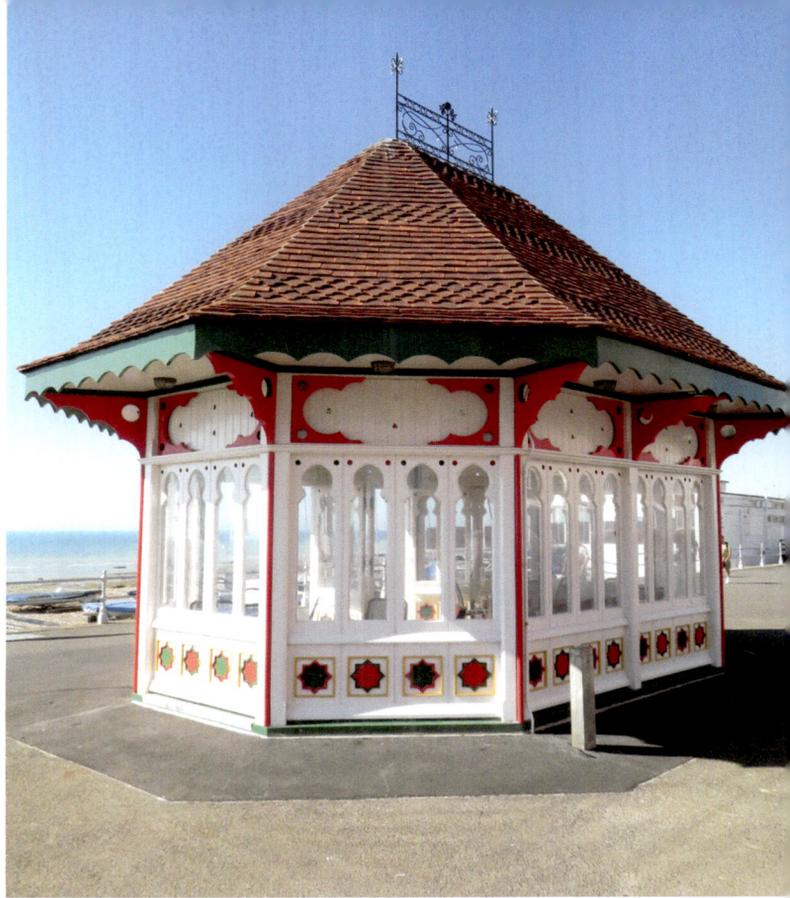

Right: Coronation Bandstand.

Below: Coronation Bandstand. (Courtesy of Bexhill Museum)

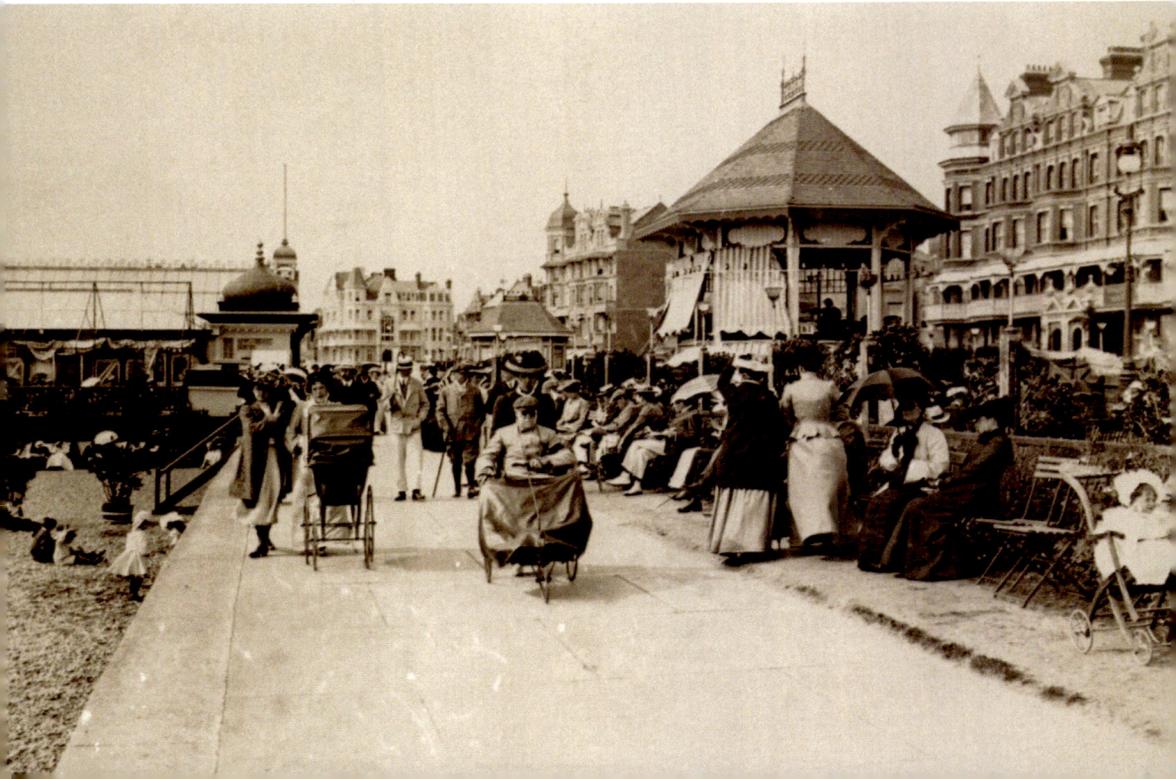

The structure, now complete with doors and what is thought to be its original colour scheme, was launched on 1 April 2023 as the Coronation Bandstand. It is a multi-purpose event space where people can relax, enjoy refreshments, meet friends or simply watch the world go by. It is a fine symbol of the volunteer effort that has created it.

14. The Devonshire

This significant building was the first commercial premises built south of the railway in John Webb's development of Bexhill-on-Sea.

It was completed by Webb in 1886. He became the first licensee but sold it in 1892 to the Sewell family, who carried on the enterprise until they sold it to the brewers in 1934. During the family's ownership they enlarged the upper-floor facilities in 1929. The hotel was a very popular venue for meetings and dances on the upper floors, with a ballroom and forty rooms.

One notorious guest was Obersturmbannführer Heinz Linge, Hitler's valet, who came to the UK on a publicity tour shortly after release from Soviet captivity

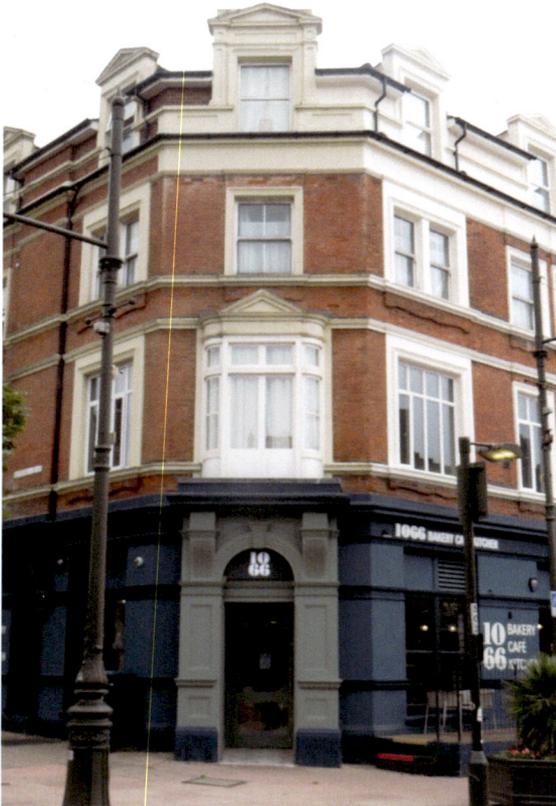

The Devonshire.

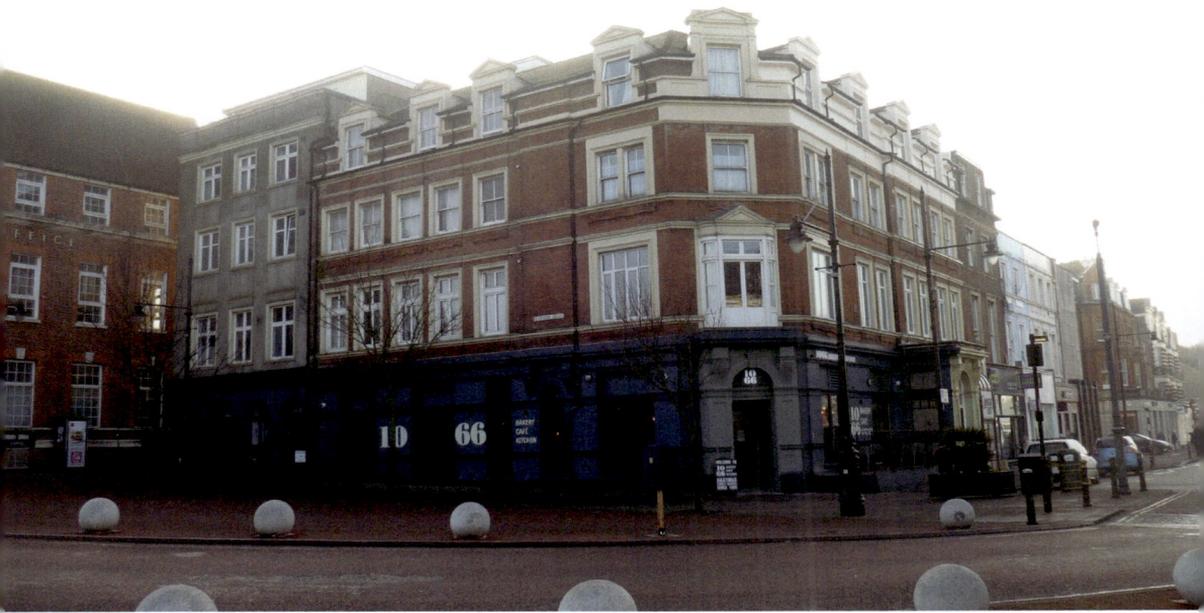

The Devonshire.

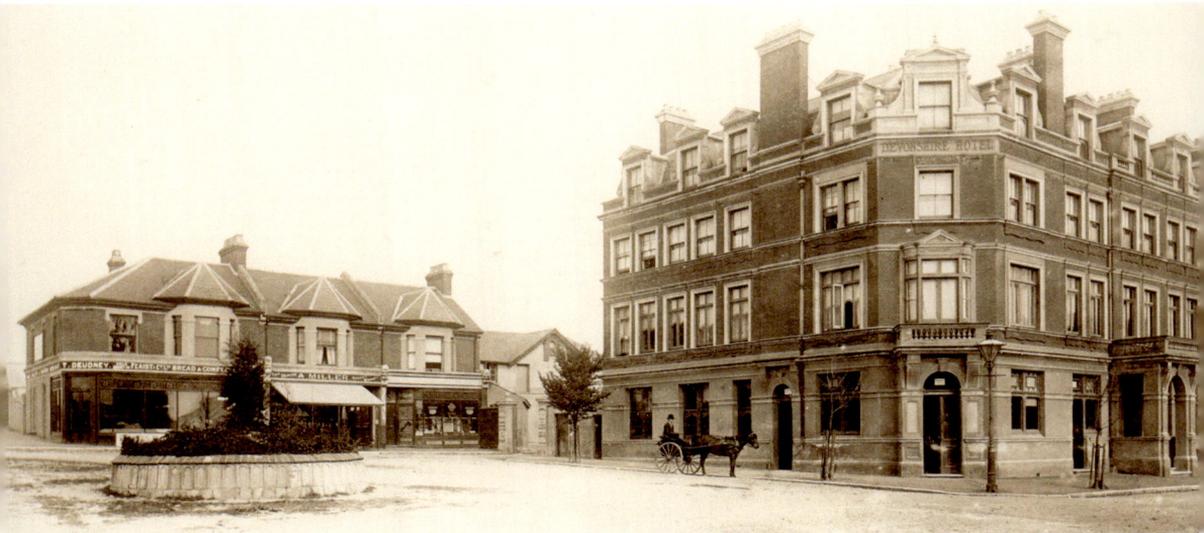

The original Devonshire. (Courtesy of Bexhill Museum)

in 1955. In 1957 it closed as a hotel and for many years the upper floors were unused. By 1974 Bass Charrington were running three ground floor bars with the manager's offices and living accommodation on the top floor.

The year 1979 saw plans to convert the hotel's upper floors into seventeen retirement residential flats, planning permission having been granted the year previous to convert into offices. Nowadays the ground floor is used by the 1066 Bakery: following a complete refurbishment it opened as a café in 2022.

15. Marine Mansions

Marine Mansions is a sweeping terrace of tall houses, built in a loose Queen Anne Revival style, with a strong hint of Amsterdam. It is probably the most beautiful part of the Bexhill seafront. The mansions, Grade II listed since 1990, curve gently along the seafront westward from the Sackville Apartments. When the 8th Earl imagined Bexhill as a watering place for the elite, this was surely the vista he had in mind.

The red-brick mansions would not be out of place in South Kensington, but they were a local product. The architects were Hicks & Alton, and the buildings were erected by C. H. Gold, owner of the well-known yacht *The Skylark*. Gold was a master-mariner who had retired to Bexhill because of ill-health. The air in Bexhill suited him: he recovered fully and began a new career as a building contractor, employing 400 men. Construction of the 'palatial pile' began in 1893 and was completed by 1896. The mansions were renamed as different buildings acquired their own character; the Carlton Hotel (which had a ballroom in which 100 people could sit down for a dinner and dance), for example, became Carlton Court. Other blocks include Berkeley Mansions Flats and Knole Court Flats.

In the early twentieth century there was a noticeable female presence here. Clara Mordan (1844–1915), the suffragist, came to Bexhill suffering from tuberculosis and died at No. 18 Marine Mansions. For many years Dorothy Purrott ran a dancing school at Berkeley Mansions. Newdigate House was a nursing and convalescent home, where patients could rent cheery and airy rooms, and be attended by their own physician. They also had access to private beach huts to help with their rest cures. There was serious medicine carried out here. The home

Marine Mansions.

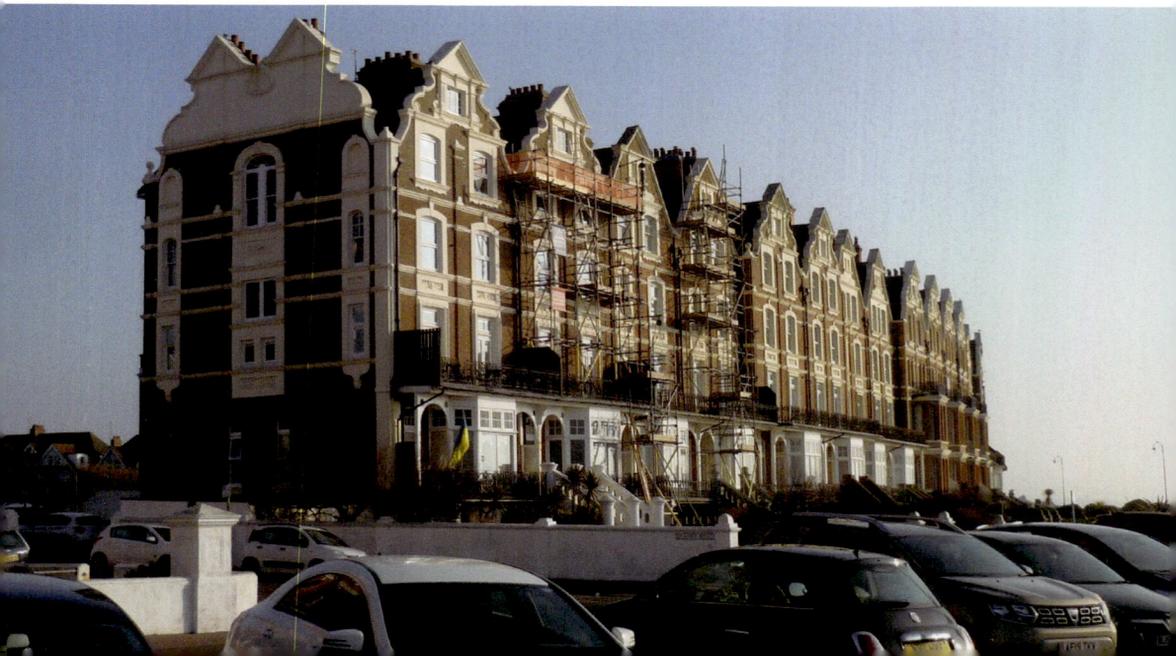

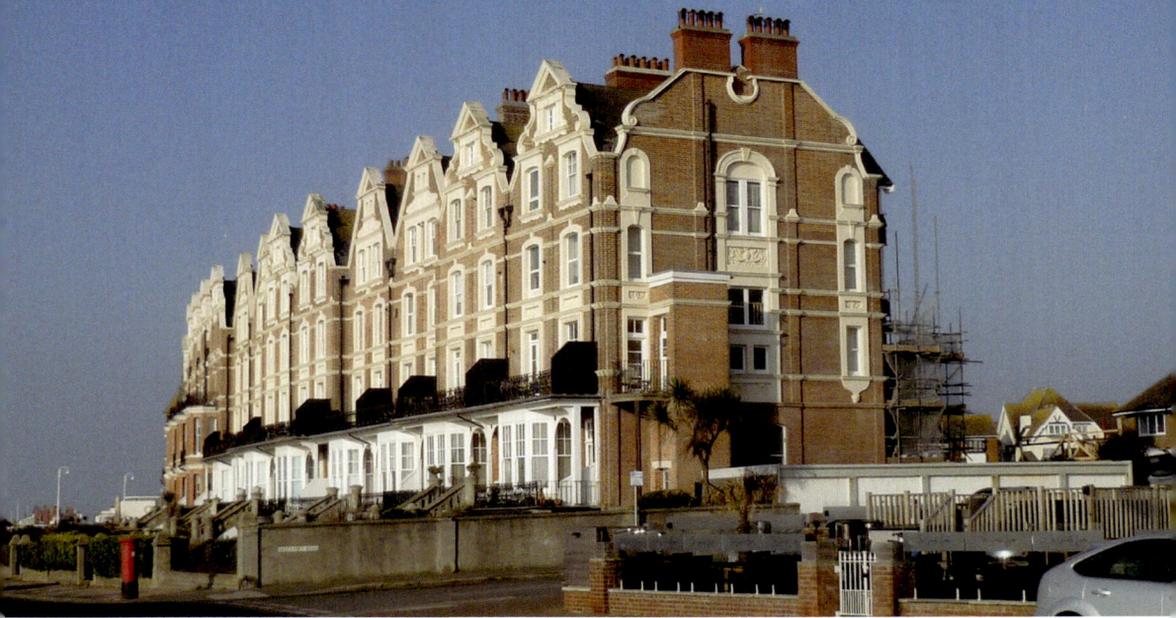

Marine Mansions.

was run by Ann Symons Eccles. Her husband promoted the benefits of massage, and their son became an admiral in the Royal Navy.

One of the buildings was demolished by a bomb in September 1940 and was not restored until twenty years later. Viewed from the promenade, it is the sixth gable from the right. Two entrances were replaced in a 1950s style that broke the symmetry of the northern elevation. These were restored to the original style in 2016.

16. Victoria House

Alfred Marshall Jay, a prominent London churchman, stockbroker and philanthropist, enjoyed his golf by the sea at Bexhill Golf Course. He stayed at the prestigious Sackville Hotel and purchased a plot of land to the side of the hotel, where he had a detached house built in 1897. This was the year of Queen Victoria's jubilee, so the house was known as Queen's Cottage until being renamed as Victoria House in 1939. The Jay family came down to Bexhill in the summer and were happy to use their house for charitable purposes. His philanthropy led Marshall Jay to donate the land for the Christchurch Methodist Church.

He sold the house in 1907, planning to build a new one further inland. The next occupant was Dr Lanyon Owen, who would in 1916 become a major in the Royal Army Medical Corps. By 1923 Queen's Cottage was taken by Flight Lieutenant Raphael Chevallier Preston, who had begun his flying career in the Royal Flying Corps in 1917. Later he was the flying chauffeur to the Duchess of Bedford, who

was herself a pilot. The duchess and Preston flew together from Woburn to the Gambia, being shot at on the way.

A guest in 1924 was eighteen-year-old Prince Arkartdamkeung Rapheephat, whose semi-autobiographical novel *Lakhon Haeng Chiwit* (*The Circus of Life*) is regarded as the first important Thai novel. The prince described Queen's Cottage as 'a nice two-storey house with beautiful green plants creeping along its walls'. In the novel, the house is owned by a Captain Andrew and was once the summer residence of Queen Victoria herself.

There was a rapid turnover of occupants through the 1920s, including William Waterhouse-Reynolds, a corset manufacturer who was the MP for Leicester South in 1922. In 1932 Gladys Wiseman SRN opened a nursing home styled as the Victoria Nursing Home, later the Victoria Hotel, and in this guise the premises carried on until purchased as a private dwelling in 1991.

Victoria House plaque.

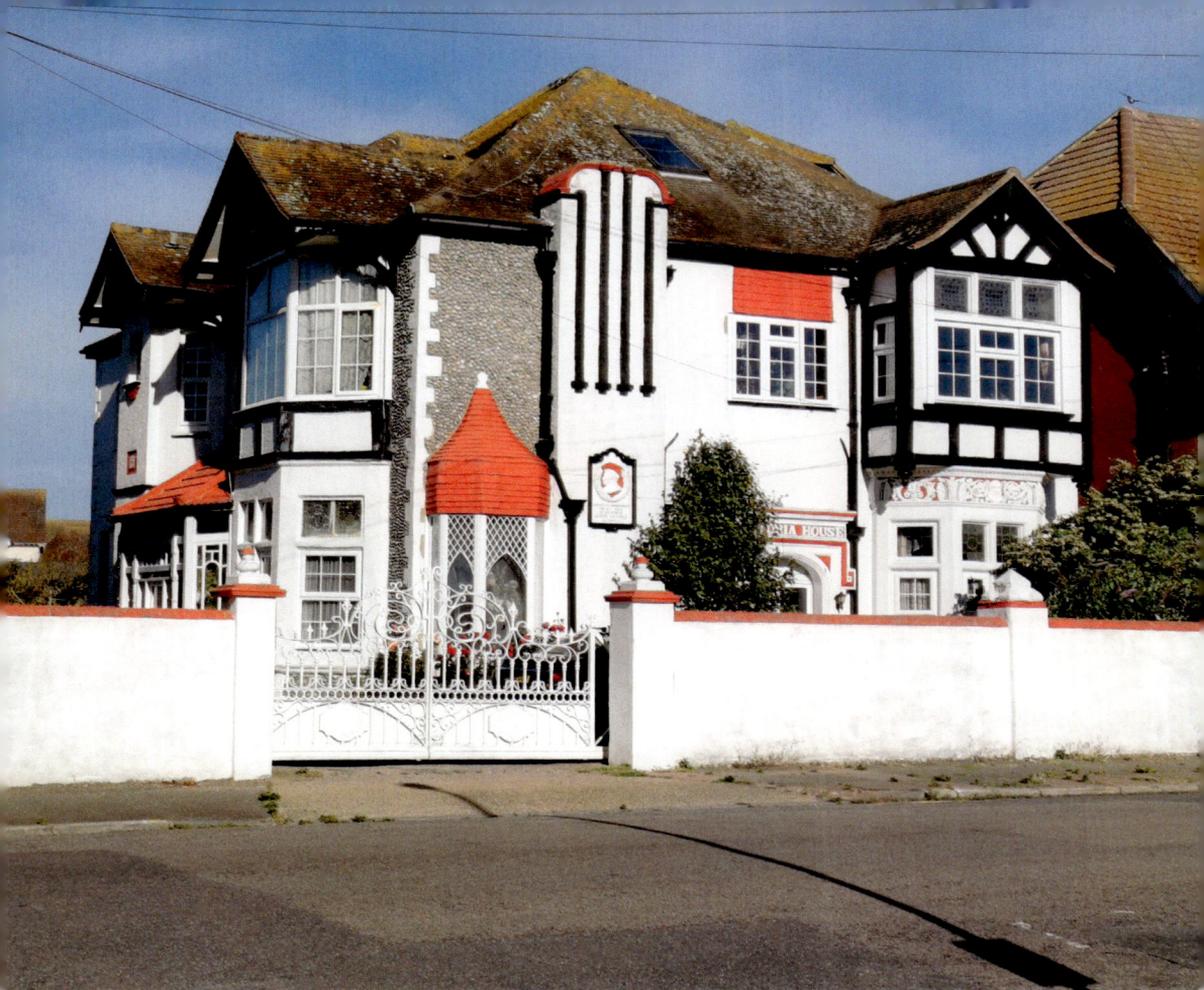

Victoria House.

17. Ducks Castle

Ducks Castle in Egerton Park did not enhance Bexhill's claim to be an aristocratic watering place. It belongs, however, to the municipal seaside of the twentieth century, along with shell houses, model villages and crazy golf.

Egerton Park is a legacy of the work of John William Webb (1840–1922). Webb was a builder rather than an architect; there is no signature building among the many he constructed in the town, but on his death in 1922, the local newspaper called him 'The Maker of Bexhill'. He collaborated with the 8th Earl in the early days of the resort, constructing the seawall, and, in part-payment, was given land to develop in the centre of town. Faced with low-lying marshland which was liable to flooding, to the west of his housing development he created Egerton Park. Even today the park has areas underwater after heavy rain.

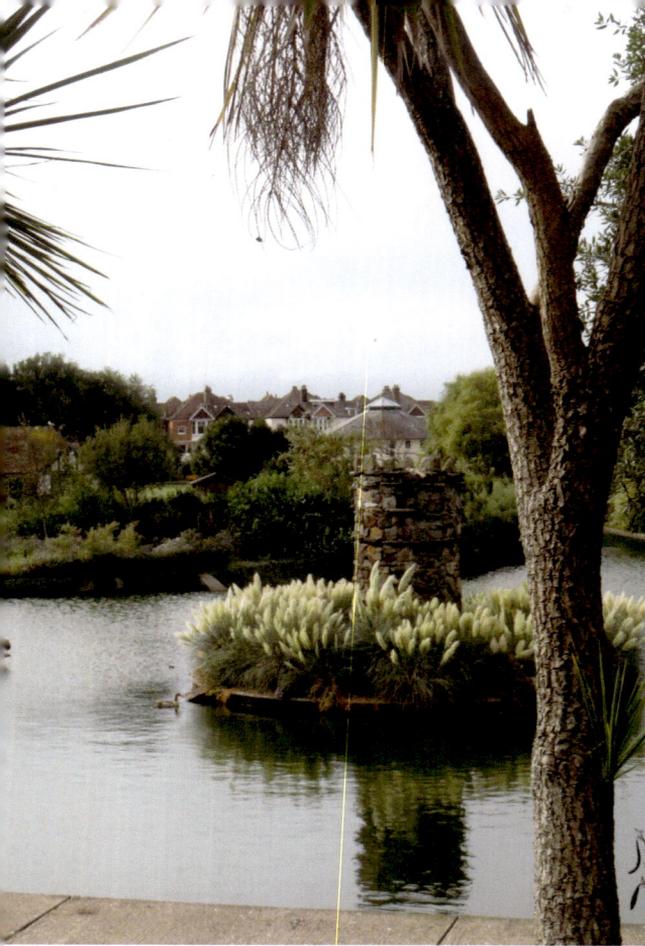

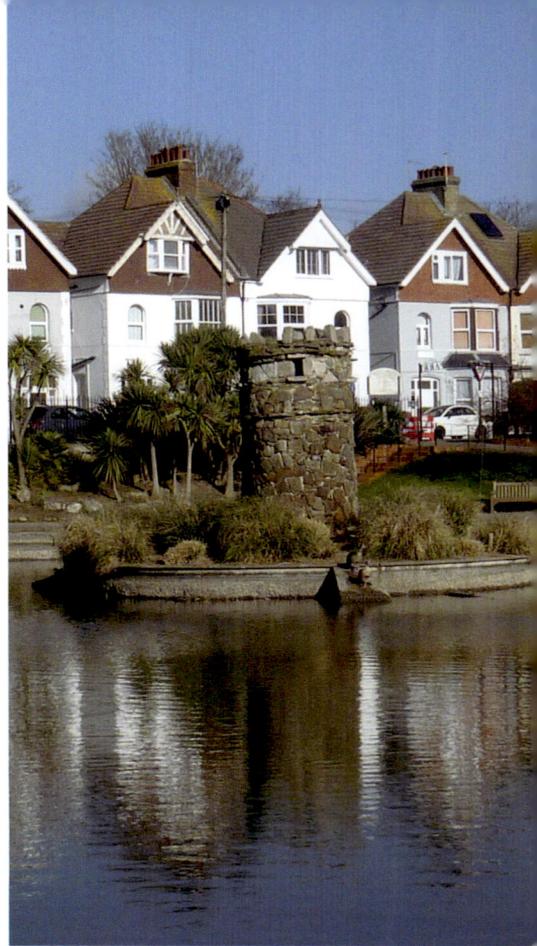

Above left and above right: Ducks Castle.

The work was carried out in the 1888–92 period. A publicity image from 1887 shows the plan to have a waterway with a circular island surmounted by trees. However, the council was responsible for adding 'an ornamental lake and rustic bridges' when it took over the park in the early 1900s. In 1907 a *Bexhill Observer* correspondent suggested that the council had built it to house pigeons.

As for the park itself it has been repeatedly repurposed over the decades to meet community needs. There were bowling greens and tennis courts and a swimming bath. The site of the bowling green adjacent to Ducks Castle was problematical as it is said that woods were liable to end up in the lake.

A shelter hall was built, which is now Bexhill Museum. Outdoor entertainment was provided by The Pergola, an entertainment venue which was supplanted in later years by an indoor theatre and bowling greens. In 1951 an area with raised beds was created as a garden for the blind. Today bowling and tennis remain along with an outside gym and an extensive children's playground. The annual Green Flag award is earned on a regular basis. Through all of this, Ducks Castle has remained.

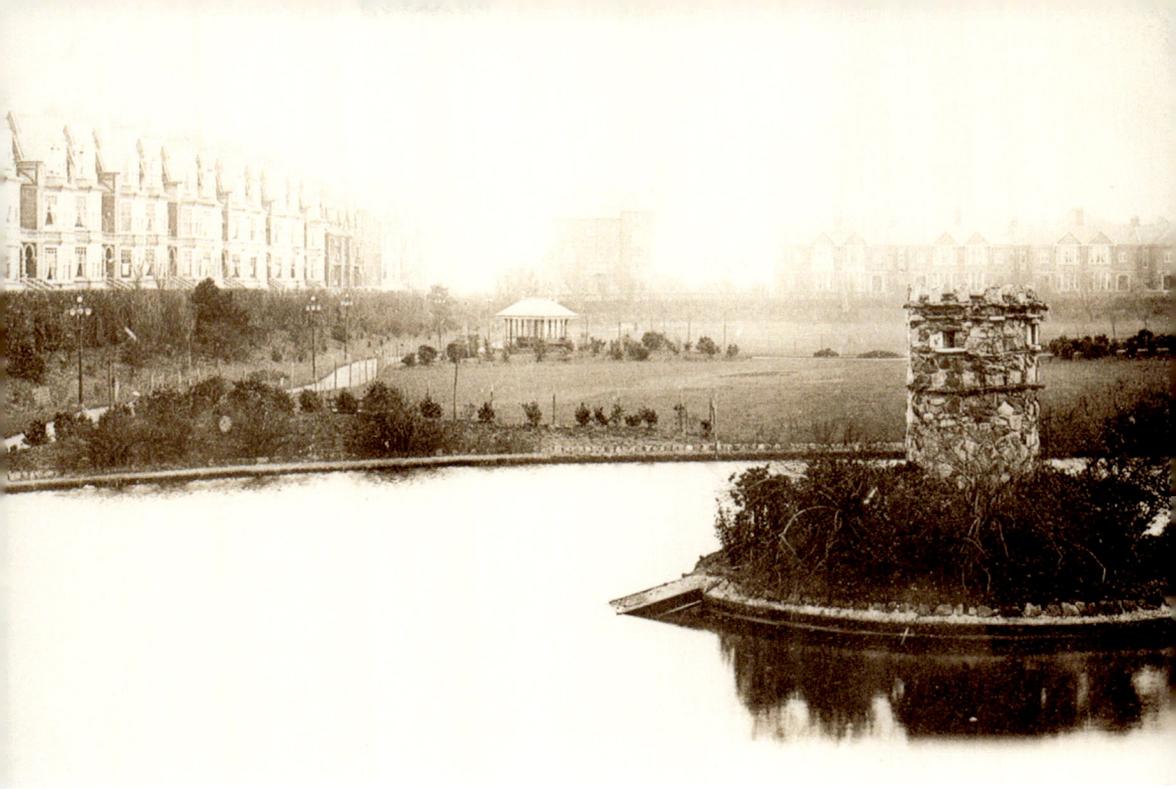

Ducks Castle. (Courtesy of Bexhill Museum)

18. Henry Lane Memorial

This Grade II listed memorial, designed as a drinking fountain, is not, as is often thought, a war memorial but a tribute to Lieutenant-Colonel Henry Lane (1827–95), who is known as the 'Father of Local Government in Bexhill'. The memorial was funded by public subscription and was unveiled by his widow in June 1898. Lord Brassey and the 8th Earl De La Warr were present and made speeches. Designed by George Ball, the Borough Surveyor, and built by J. M. Whitehead and Sons Ltd, Westminster, the ornamental monument is made from York stone, granite and brick. It features an alabaster medallion of the Lieutenant-Colonel, with laurel wreaths below.

Lane was born in India and served in the 5th Bengal Light Cavalry. His military career, including the relief of Lucknow, is summarised on the north face of the memorial. In 1865 he inherited the family residence at Broadoak and became a key figure in the development of Bexhill. He was a churchwarden and Justice of the Peace, and a keen supporter of the Liberal Party.

The pressing needs for improvement in drainage and other amenities made the time ripe for a new era to commence. The Medical Officer stated that conditions were 'slow poisoning', and various other complaints during the following months resulted in the formation of the Local Board, who were responsible for drainage,

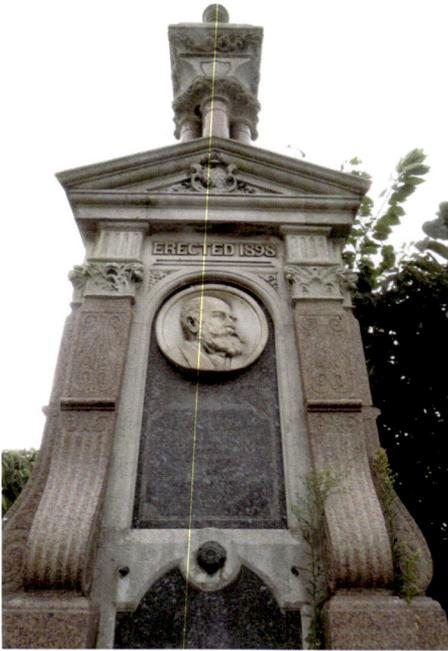

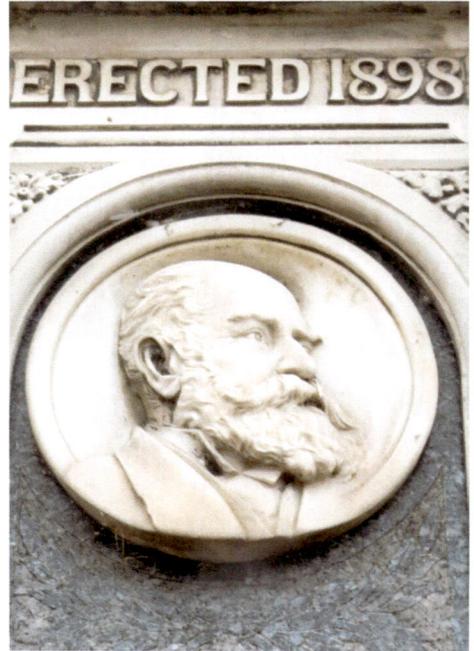

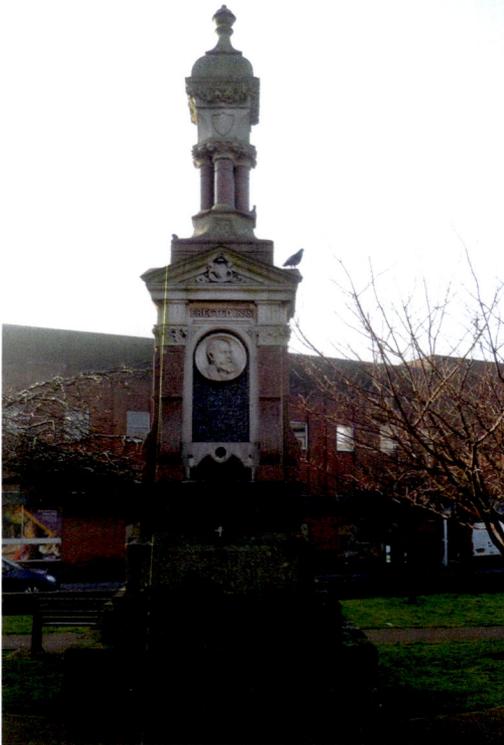

Above left: Henry Lane Memorial.

Above right: Henry Lane Memorial plaque.

Left: Henry Lane Memorial.

water and lighting. The Public Health Act of 1875, under which Local Boards were formed, gave further impetus to the Bexhill Local Board's formation. The need for the Local Board was confirmed by the prospect of Earl De La Warr's expansion east of Sea Road, and the continued growth of Bexhill village itself into urban development. A diphtheria outbreak in 1885, caused by water contamination, gave further impetus.

In May 1884, the Local Board of Bexhill was formed, and Lane became chairman, a post he held for ten years. He then became chairman of the Urban District Council, which superseded it. In 1902, on the coronation of Edward VII, Bexhill received its Charter of Incorporation as a municipal borough.

19. The Pelham

The Pelham family were a major force in Sussex from the time of Henry IV. Their extensive landholdings included at one time some land in Pebsham, to the east of Bexhill. This was presumably why the proposed Railway Hotel in Sidley, completed in 1900, was given the family's name.

The hotel was designed by Joseph Barker Wall and built by John Pelling Goodwin; it was opened in 1901. The building comprises 8,000 square feet over three floors and a basement. It stands opposite the site of Sidley station, opened in 1902 as part of the Bexhill West branch line, which operated until 1964.

In the latter part of the twentieth century, the pub acquired a bad reputation, but the building was reborn when Sidley Baptist Church stepped in. In 2012, more

The Pelham.

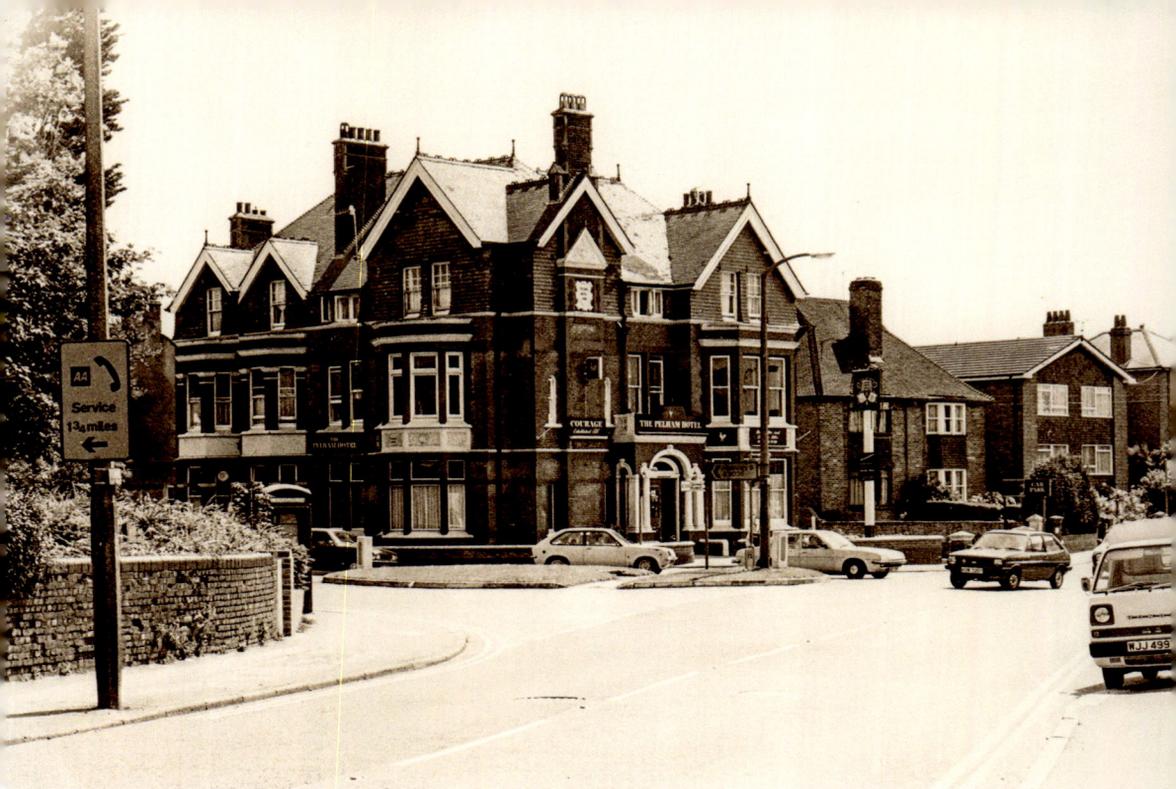

The Pelham. (Courtesy of Bexhill Museum)

than £400,000 was raised in donations to buy the freehold for the building in its entirety for under £250,000.

The Pelham opened in 2015 as a community hub, the coffee lounge augmented by free debt-counselling, a stop-smoking clinic, a table tennis club and multisensory groups for disabled adults. The Pelham has been completely refurbished, with phase 4 being completed in 2019.

20. United Reform Church

Earl De La Warr gave this plot of land for a place of permanent Presbyterian worship on a ninety-nine-year lease, with an option to purchase the freehold for £200. Two foundation stones were laid in 1901.

The architect was George Herbert Gray, who was also the agent for De La Warr's estate. The builder was Levy Murrell of Windsor Road, who submitted the lowest of six estimates at £2,100. Known as St George's Church, the present building was meant to be part of a much larger church.

What the pioneers had built was never intended to be a permanent church but a lecture hall, stage one of a far grander two-stage project. No sooner was phase one finished than a special appeal was launched for phase two. But the total cost of the completed complex – lecture hall, classrooms and big church – was £6,100.

Above and right: United Reform Church.

The realisation was dawning, as it had to the police in the building next door, that this was not going to be the centre of modern Bexhill. They were out on a limb and by 1909 there was a proposal to buy a new site and build on it. The Presbyterians considered buying a piece of land between Eversley Road and Wilton Road.

The Bexhill Lecture Society started off here in 1907. Winter lectures could draw an audience of over a thousand people. One speaker was Ramsay Macdonald, later a prime minister. There was a talk on folk song from Cecil Sharp and Barry Parker spoke about garden cities – these were the leaders in their fields in 1910. The talks were organised by Reverend James Fraser, later the Moderator of the Presbyterian Church of England. Reverend Frederick Ernest England, who came in 1928 and retired in 1971, was a frequent visitor to the Augusta-Victoria School for German girls, whose worship took place at St George's.

The church became St George's United Reformed Church in 1972 with the union to the Presbyterian and Congregational Church, St John's in London Road. The year 1982 saw a revival of croquet on Thursday afternoons on the church's lawn. The great storm of 1987 damaged the church spire.

21. Cemetery Chapel

As the town of Bexhill grew, burial facilities needed to keep pace. By the mid-1800s the churchyard of St Peter's Church was closed, and burials commenced in the nearby Barrack Road cemetery. Towards the end of the nineteenth century this too was filling up. The council and the local papers concerned themselves with 'the Cemetery Question'. At one point it appeared that J. Lambert Walker was prepared to give the town a substantial area of land, the Highland's Estate. But then there was an unexplained rupture between Mr Walker and the council.

Land at Clinch Green, to the north of the town, was purchased by Bexhill Corporation in 1899. It was a large purchase – 32 acres – allowing room for future growth. There was, however, the matter of the chapel to be sorted out. If it were consecrated to the Church of England, the Nonconformists could be unwilling to use it. At one point the possibility of two chapels was raised.

The cemetery opened in 1901, with the chapel opening in 1902. It was designed by William Herbert Alton and built by Frederick William Parker. Above the porch and entrance to the chapel is a stone relief showing the coat of arms of Bexhill Urban District Council between the words Bexhill Cemetery. The chapel has a capacity for services of fifty people.

Frederick William Parker was born at Belle Hill and became a builder in the firm which his grandfather founded in 1800. From the early 1920s he became known as an undertaker. He carried out the last burials at St Peter's churchyard and the Barrack Road cemetery; he also conducted the very first funeral in the new cemetery in 1901. The next year he was the undertaker at the first funeral

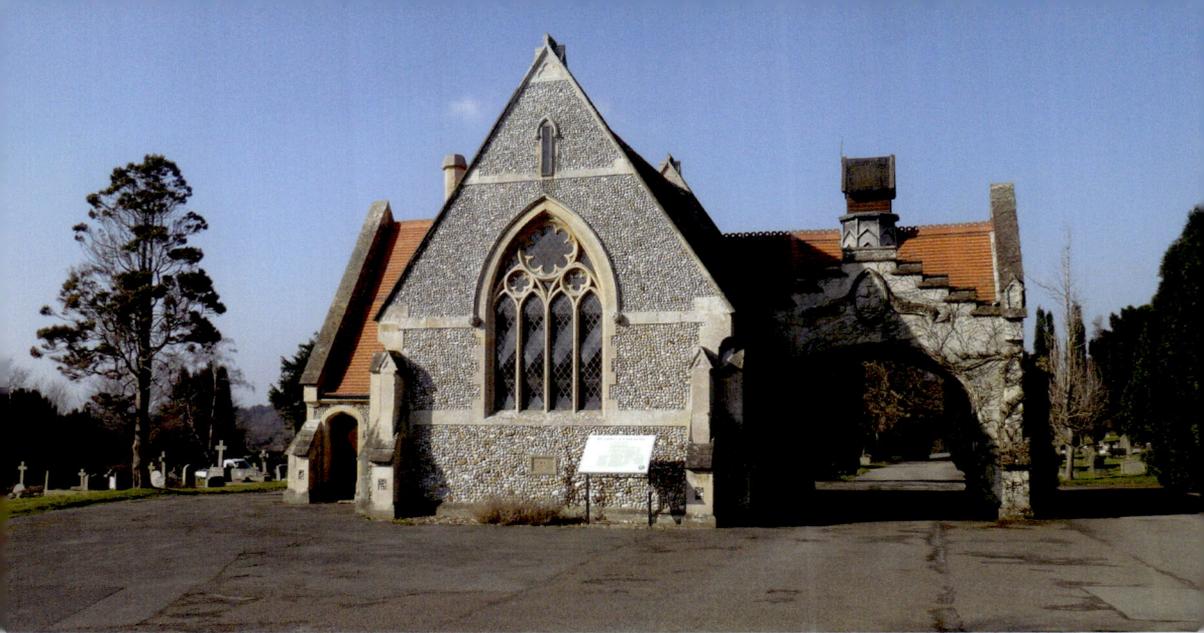

Above and below: Cemetery Chapel.

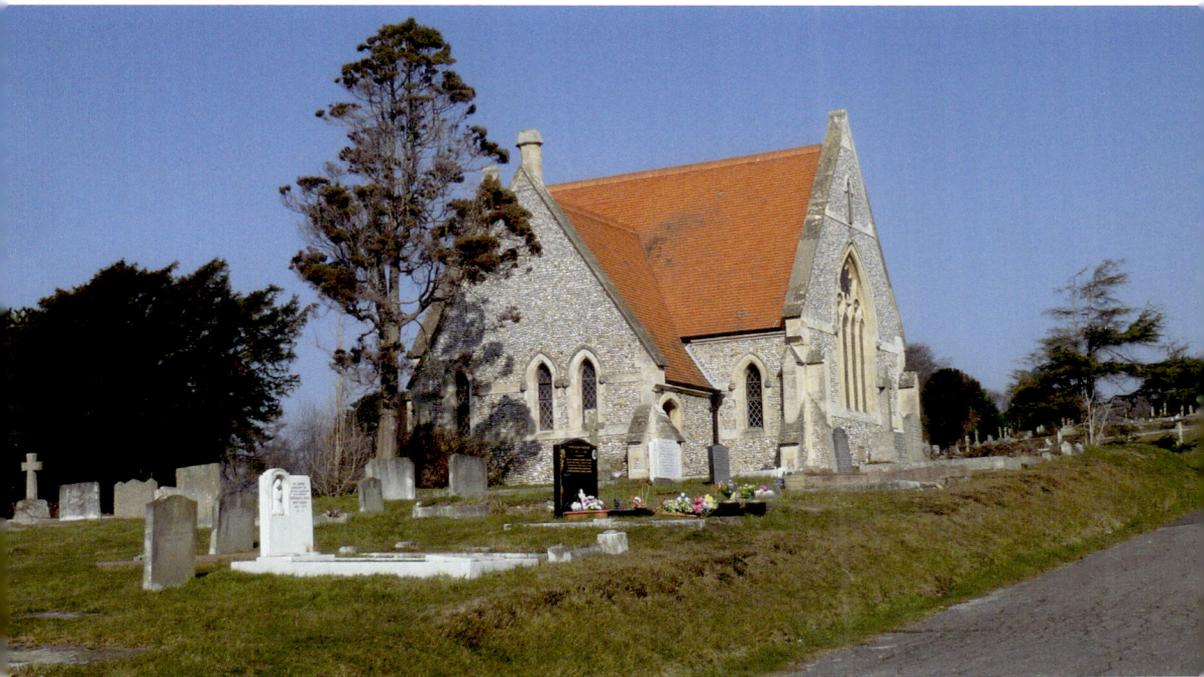

service held in the Cemetery Chapel. A new development of six houses near the old cemetery entrance is to be named after him.

There is a headstone here for Henry and Eleanor Wodehouse. Their son, P. G. Wodehouse, dutifully visited his parents' home in Bexhill, and invented a fictional seaside resort 'Bingley-on-Sea'.

22. Lake House

This building began life in 1895, when it was called The Beeches, an imposing private house in extensive grounds. It typifies the private schools which proliferated in prewar Bexhill. Lake House School was first set up in 1894 by Frank Bond, an MA from Brasenose College. The school was a 'Preparatory School for Sons of Gentlemen' located in Woodsgate Park. Bond moved the school in 1901 to this house in Collington Lane.

In November 1914 Bond, already an alderman, was elected Mayor of Bexhill. It is perhaps not surprising, as the private schools were such a large part of the local economy. In 1914 they were especially busy because sons and daughters of gentlemen were no longer being sent to the Continent. Bond was active as a local politician, and the local press was always there to cover the successes of Lake House – sports days and theatrical events were covered, and the academic achievements of the boys were celebrated.

After the death of his wife, who helped run the school, and during a period of ill health, Mr Bond sold up in 1929. The purchaser was Frederick Hammett Knott and the school was renamed Beechmont School. It was renamed back to Lake House in 1934 by new proprietor Alan Herbert Williams. There are few memoirs of the school, but the photographer Michael Ward bitterly remembered the day when his father and the actor John le Mesurier drove him down to Bexhill and 'dumped' him at Lake House.

At the start of the Second World War, there were hopes that the school could continue, albeit with fewer pupils. Soon, however, the school was evacuated to

Lake House.

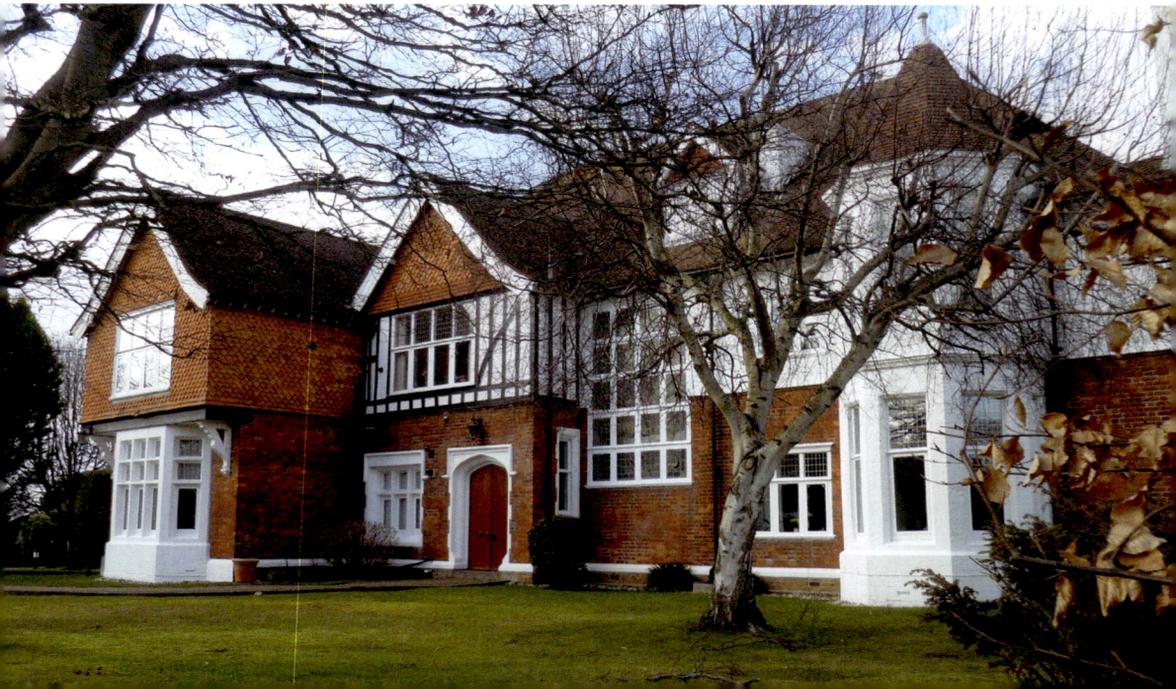

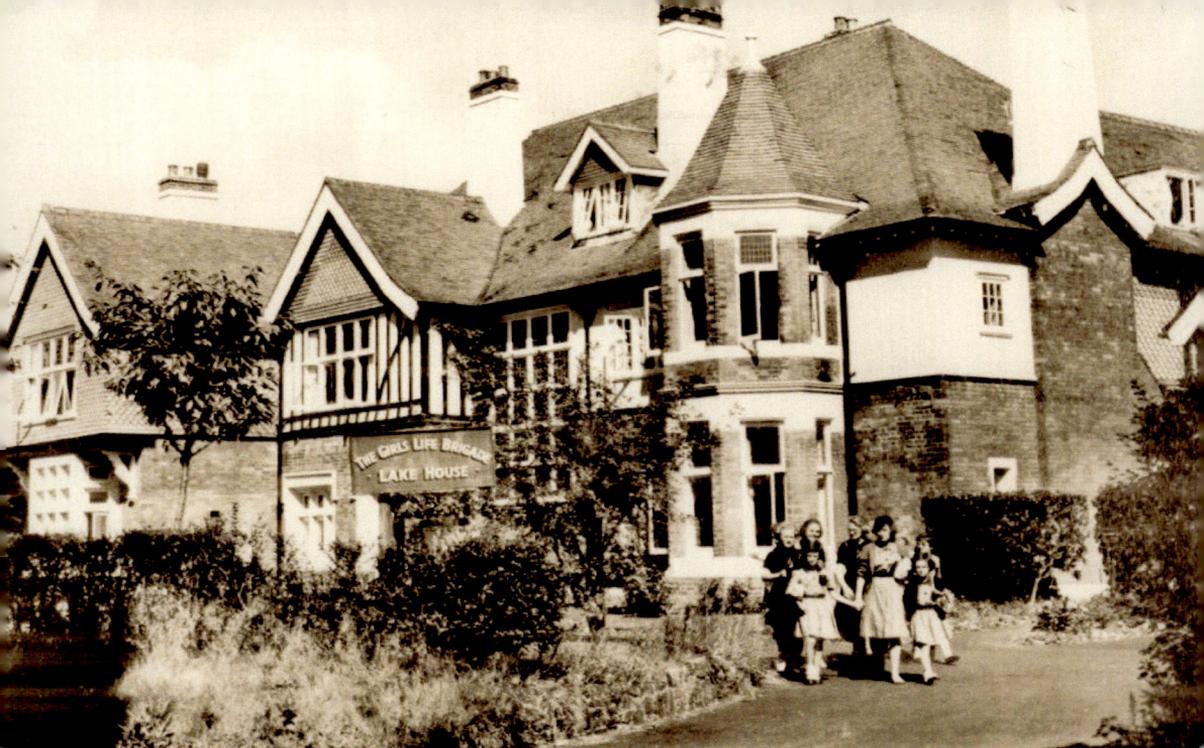

Lake House. (Courtesy of Bexhill Museum)

the Pen-Y-Gwyrd Hotel in Snowdonia, never to return. The Bexhill premises were requestioned by Canadian forces. Post-war the building was purchased by the Girls' Life Brigade and used as a training centre and holiday home until 1990. The coach house was converted to a chapel in 1951.

Following the departure of the Girl's Life Brigade the extensive grounds were developed with housing. The conversion of Lake House itself has been done sympathetically with great care.

23. Bexhill Station

Bexhill station has very long platforms and a very wide ramp leading from the platforms up to the exit. It is often said, wrongly, that the platforms were extended swiftly to accommodate the funeral train of the Maharajah of Cooch Behar, or that they were designed specifically to welcome great hordes of public schoolchildren each autumn.

The railway came to Bexhill as part of the London & Brighton Railway line. The first Bexhill station opened in 1846 and was sited where Sainsbury's car park is now and was convenient to service the commercial growth of the town.

As Bexhill-on-Sea developed in the 1880s – south of the railway line – a new station was opened on the other side of the line fronting onto Devonshire Square in 1891, now convenient for the expanding town. In the 1880s a post office was

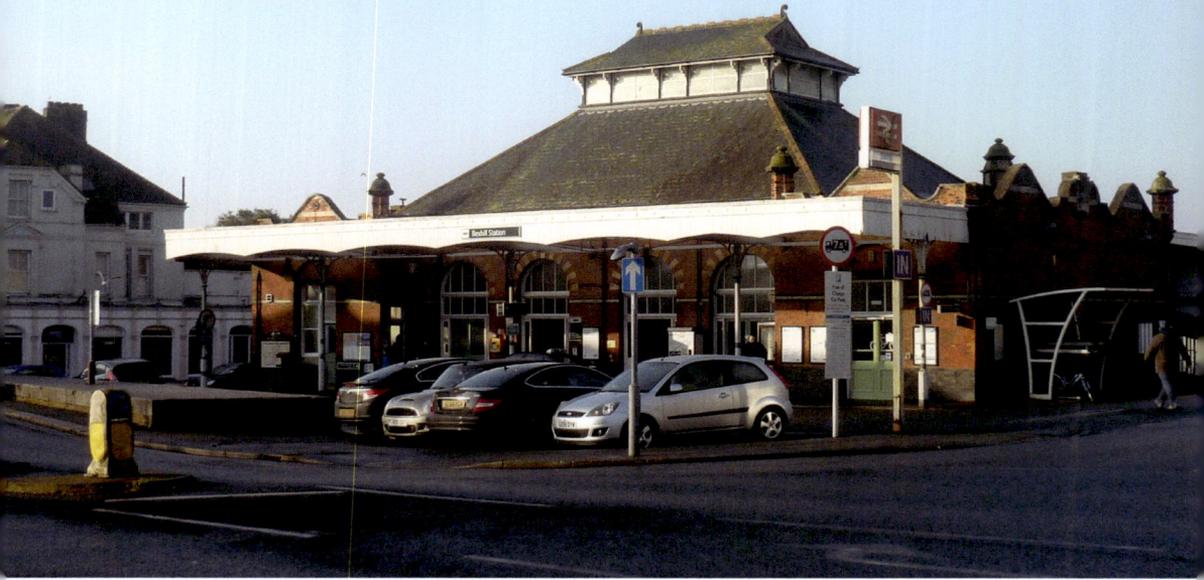

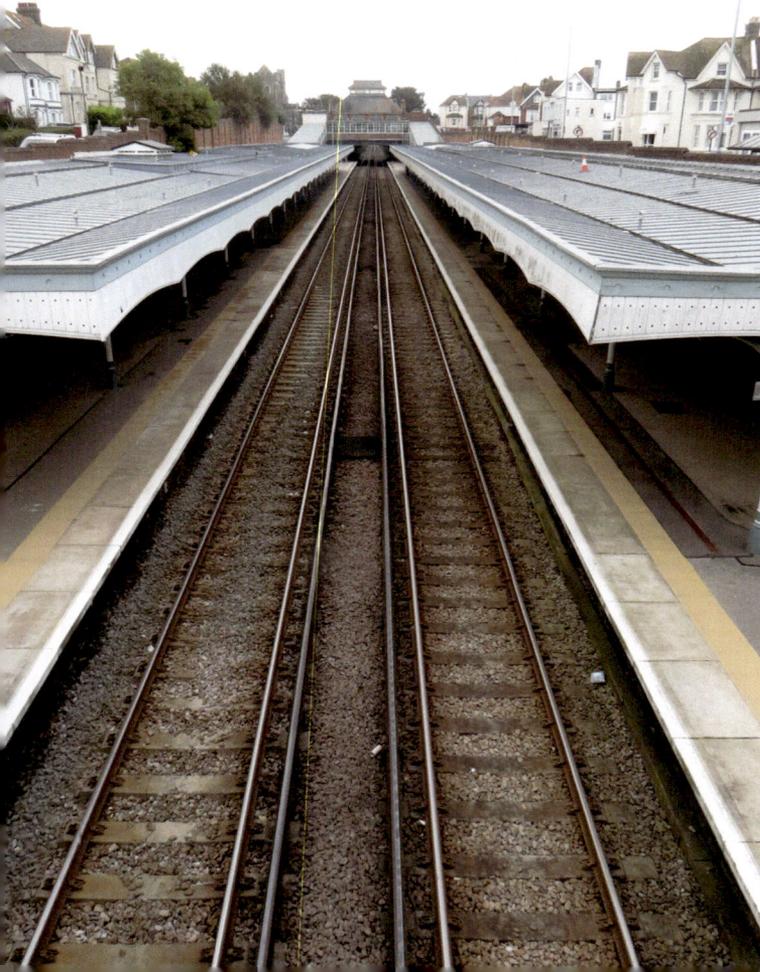

Above and left: Bexhill station.

opened at the station and the stationmaster acted as postmaster. This was subject to a daring safe robbery in 1896, when £113 was stolen.

The station was developed into its third (and present) guise in 1902 with the building of the station fronting Sea Road. Its platforms were connected to the existing platforms and platform access was still available from Devonshire Square. The contractors were Parnell and Sons of Rugby, whose design was greatly admired. Access to the platforms was via wide ramps, and the platforms were 30 feet wide. This was a great improvement on the old station, which was often overcrowded in the summer months.

The station has had its share of memorable arrivals and departures. Most famously is the funeral train which took the Maharajah back to London in 1911. The station came to national attention, in a regrettable way, in 1920 when Florence Nightingale Shore – named after her godmother – was attacked on the train from London. She was discovered at Bexhill, and moved to Hastings hospital, where she died. The murderer was not discovered.

The station was Grade II listed in 1999 and a restoration project to the platform canopies and ticket office area was completed in the summer of 2008. Refurbishing work to the roof took place in 2023.

24. Bexhill Museum

In 1910, Revd John Thompson, newly arrived in Bexhill, decided that the town would benefit from a natural history museum. Walking on the beach, he fell into conversation with the explorer Miss Kate Marsden. Together they planned a museum, directing their attention to the Shelter Hall and tearooms in Egerton Park. They made a successful approach to the owners, Bexhill Corporation, for use of the park building. Kate Marsden became the main motivator for the project.

The museum opened its doors in May 1914. Attendances were good despite the war, but in March 1917, with minimum notice the premises were requisitioned by the military. The Canadian Training School used the building as a mess hall. Exhibits were hurriedly packed away – many were stored in the women's toilet. The Canadians departed by February 1919 and the museum reopened in the May with its exhibits depleted.

A significant waypoint in the museum story was the appointment of Henry Sargent as assistant curator in April 1920, who swiftly became curator. Henry worked for the museum until his death in 1983. A busy man, he was also the Borough Meteorologist. He restarted the walks and lectures which are still part of the museum's activities.

With the coming of the Second World War, Bexhill was designated a Safe Area and child evacuees arrived from London. The museum was busy in providing educational support for the new arrivals. It closed in August 1940, not to reopen until April 1950. During the war it was used for the storage of furniture from

bomb-damaged homes and received some indirect bomb damage. Mr Sargent was busy as a fire watcher.

After the death of Henry Sargent, a band of volunteers kept the museum open. In 2003 it took over the Old Town Museum of Costume and Social History. Space was now a serious matter, and a major extension was funded by Rother District Council in partnership with the Society of Bexhill Museums. This was officially opened in December 2009 by Eddie Izzard.

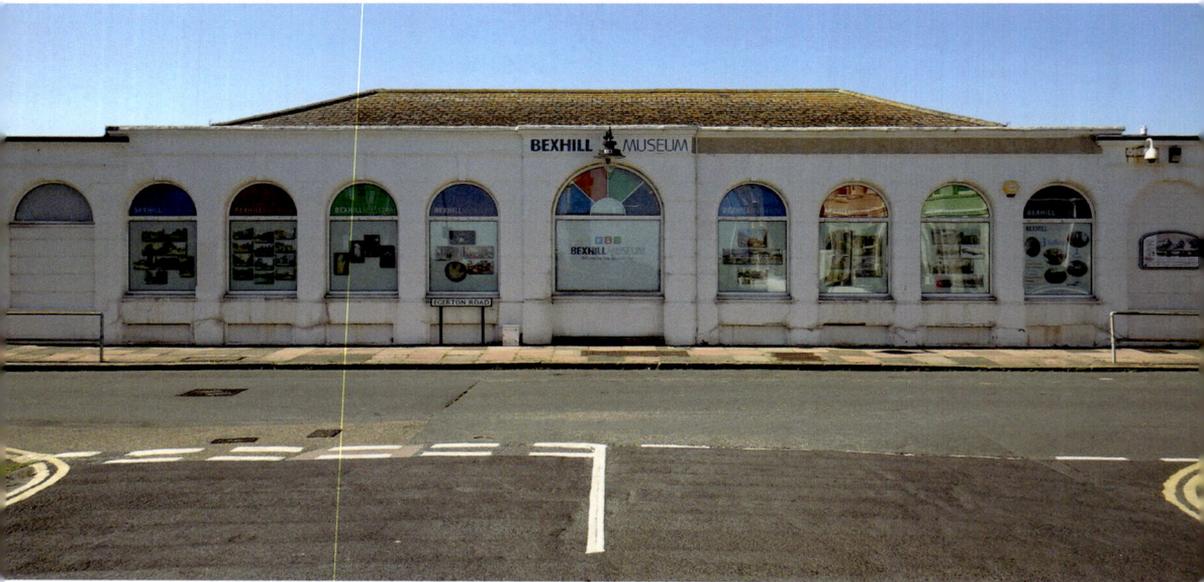

Above: Bexhill Museum.

Below: Bexhill Museum. (Courtesy of Bexhill Museum)

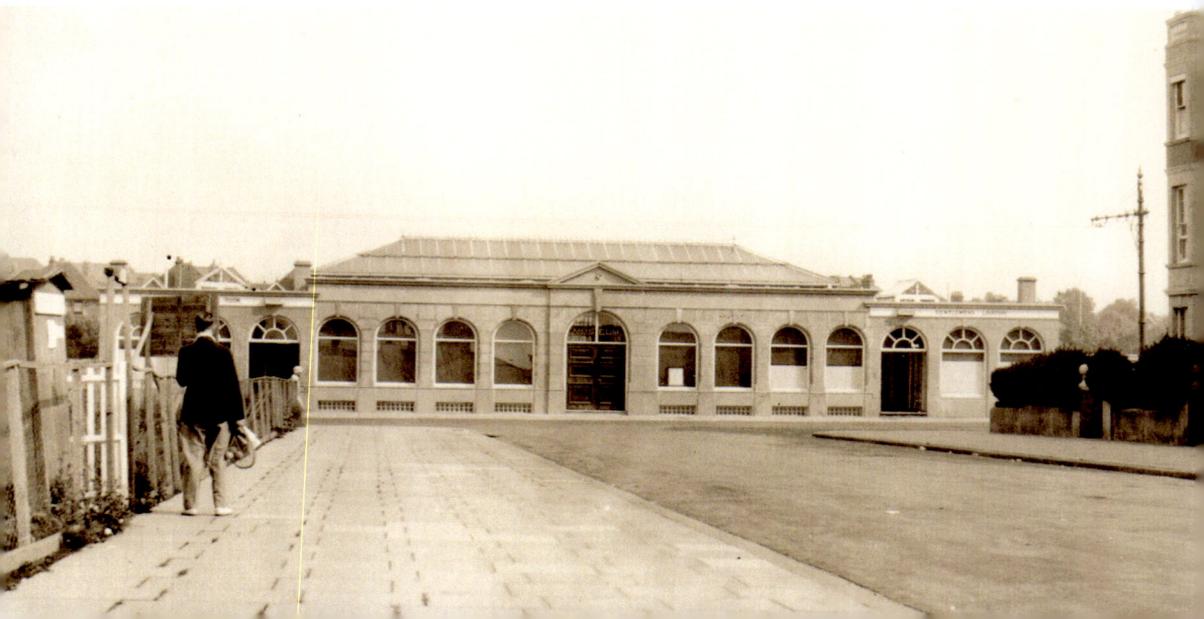

The premises now comprises four galleries, a community room, offices and storage areas. The museum is very active with school visits, children's activities and community projects.

25. Oceania

Dating from 1903, this distinctive house was designed by Arnold Mitchell for William Abraham McCormick, a master builder from London who had been involved in developing the West Parade. The house was not complete when the great storm of September 1903 very nearly wrecked it. By 1907 it had been rebuilt and was for sale. With nine bedrooms, it was considered suitable for a private hotel.

William's daughter Janet McCormick married Arthur Herne Plummer in 1913. Their son, Desmond Plummer, was leader of the Greater London Council from 1967 to 1973. Desmond and his wife Pat and their daughter had many happy

Below left and below right: Oceania.

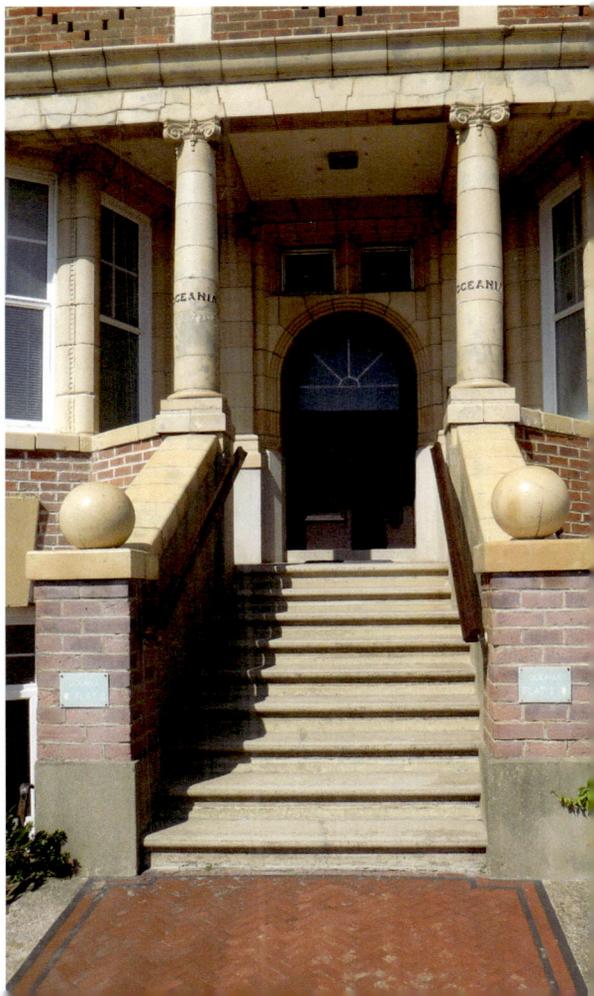

holidays in Bexhill. By 1922 Oceania was owned by the Plummer family, who applied to the local authority to convert the premises into flats. The building has been divided into flats since.

It has had a quiet existence, briefly interrupted in 1928 when one resident, Edwin Paxton, found himself looking at the wrong end of a loaded revolver. Mr Paxton had been meeting Marie Louise Jaquin on the seafront and she soon became his housekeeper. Later, he dismissed her, offering her £1,000 to go away. She felt this was not enough and visited his Oceania apartment with the revolver. She was sentenced to a year's imprisonment with hard labour.

26. Clock Tower

The Clock Tower was first placed in isolation, perhaps in the hope that a busy thoroughfare would soon grow around it. It is still in an awkward spot. Designed to commemorate the coronation of King Edward VII in 1902, the tower was not actually finished until 1904 to the embarrassment of all concerned. It remained without a plaque for 100 years. It was agreed in April 1902 that the Coronation would be marked by public events, and that a memorial would be built. The developer John Webb offered a suitable piece of land. One problem was money: the initial budget of £80 was not adequate, even in 1902.

At the beginning of 1903 a design was put forward by J. B. Wall: a tower in Bath stone with red Mansfield bands and a copper dome. It would have four copper dials. It would be similar in size to the clock tower at Hastings. There was also to be a plaque on one face of the tower stating the purpose of the memorial; other faces would hold meteorological instruments. In August the council formally requested designs for the tower. The selected design was by the architect Robert Hembrow of No. 174 Queen's Road, Hastings, and looked uncannily like the original Hastings design by Mr Ward. The builders were Benjamin Gaston and Frederick Ransome.

Mr Wright, a Bexhill watch and clockmaker, who had made the clock, started it for the first time on 19 July 1904. Upon completion there was no commemorative plaque and the present stone one on the south side, which reads 'Edward VII Coronation Memorial', was only added as part of the Clock Tower's centenary celebrations, when the Town Mayor Councillor Stuart Earl unveiled the plaque on 18 July 2004. The present colours were chosen by the council in 1990 and specialist clockmaker Thwaits and Reed restored the clock in April 2007.

In the summer of 2015, the Clock Tower was refurbished and repainted, including repair of the weathervane and new lights to illuminate the tower at night.

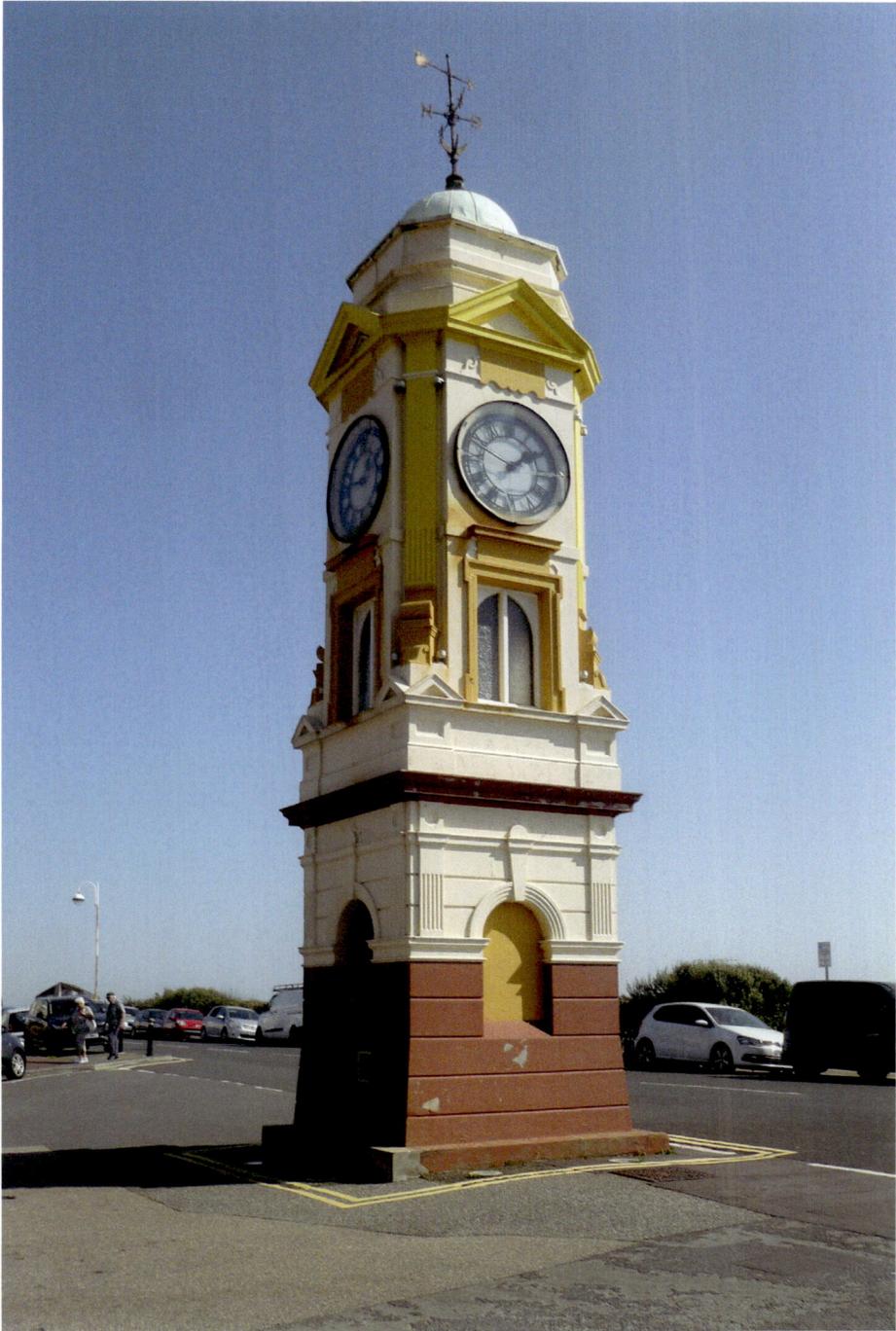

Clock Tower.

27. The Lodge, St Francis Chase

The crenelated lodge building on St Francis Chase is all that remains of the St Francis School for Girls. In 1807 this area was the site of the Gun Tavern and Gun Cottage. A spacious home called Whindown was to be found nearby in the 1890s owned by Dr W. H. Corfield, Professor of Public Health at University College, London. Dr Corfield was an expert in sanitation and took a keen interest in his own health, hence his decision to have a holiday home in Bexhill, having purchased and renamed Down Villa. After his death, the lodge was constructed for a Miss Campbell of Kensington in 1905, providing stables and coachman's living rooms. It was built in 1905 with Luck Brothers as the architects.

In 1909 Whindown became a German school, the Deutsches Pedagogium, under the patronage of Mrs Du Mont of the Manor House. The head was Dr Matthias Frans Blassneck and the pupils included a nephew of the Kaiser. The school was closed at the start of the First World War: Dr Blassneck was interned and most of the German staff employed in the school departed.

After the war Whindown became Garth Place School until the outbreak of the Second World War. Bomb damage at the Town Hall led to council staff being relocated to Garth Place School (only to be bombed again).

Schooling was resumed in 1946 when St Francis School for Girls was opened under the Headmistress Miss Hilda Fulford. The 1905 building, then known as Garth Lodge or the Gate House, became a junior school annexe of St Francis School in 1948. It would have been familiar to the actress Julie Christie when she was a pupil there.

The school was closed in 1972 and the large hall-cum-gymnasium, a fine cedarwood building installed in 1960, was donated to St Michael's Church. After

The Lodge, St Francis Chase.

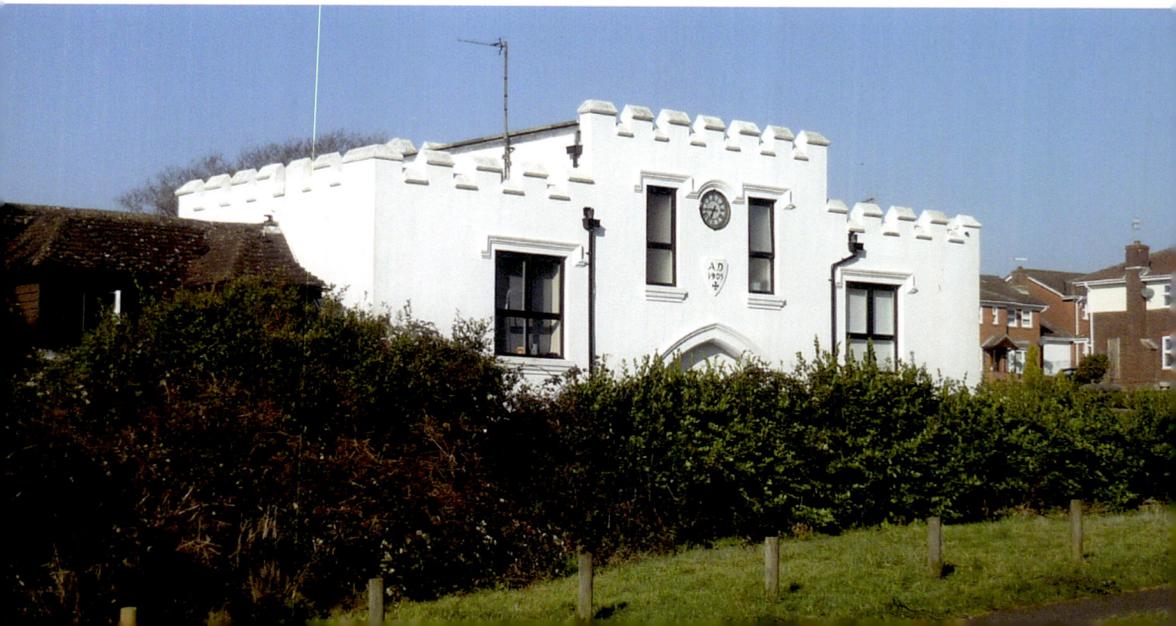

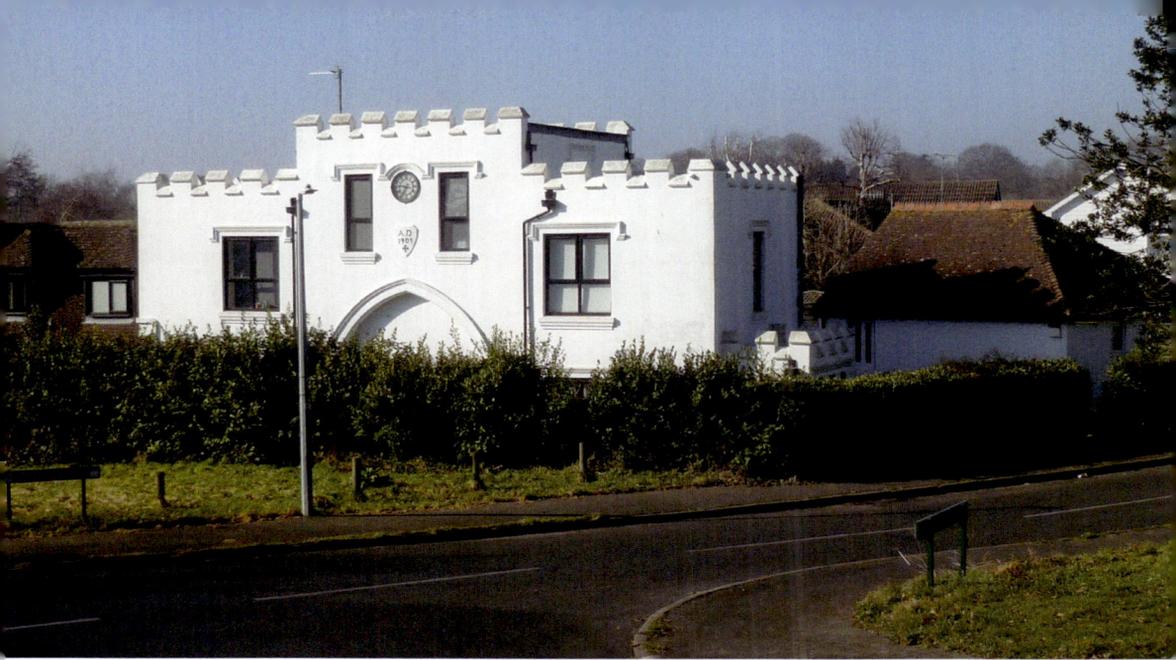

The Lodge, St Francis Chase.

1974 Garth Lodge was refurbished and extended to become The Lodge, St Francis Chase; it is an assisted living residence facility for people of working age with autism and other learning difficulties.

28. King Offa Primary Academy

As Bexhill grew, so did the number of children. In 1901 there were approximately 300 local children, a figure which grew to 900 in 1911. The council had become responsible for elementary education in the town, ending the Church's control. Down School was opened in March 1907, built on the field where the parish workhouse had stood. The local newspaper described an 'almost palatial building', worth more than any other council property apart from the Town Hall. On the first morning there were seven classrooms for 124 pupils, and the school was extended in 1912.

In October 1914 the council handed the property over to Colonel Claude Lowther, who was busily recruiting all over Sussex, adding new battalions to the Royal Sussex Regiment. There was a camp near the golf course at Cooden, but this was overflowing. Soldiers were billeted in private homes, and the Down School was taken over to house the new 12th Battalion. From November, men slept on the floors and trained on the playground. The children transferred to Whindown on the Down in December 1914, which had become vacant following the internment of Dr Blassneck, who ran his Deutsches Pedagogium there. In 1915, 'Lowther's Lambs' departed for France and school resumed its usual function.

When war came again, Bexhill was optimistically designated a Safe Zone. In September 1939 the school received pupils from Creek Road School for Girls and Boys, an LCC school in Deptford. They were catered for with morning classes: the local children were dispersed to a hotch-potch of sites in the town for the morning, returning for afternoon classes. The Londoners staged an exhibition of

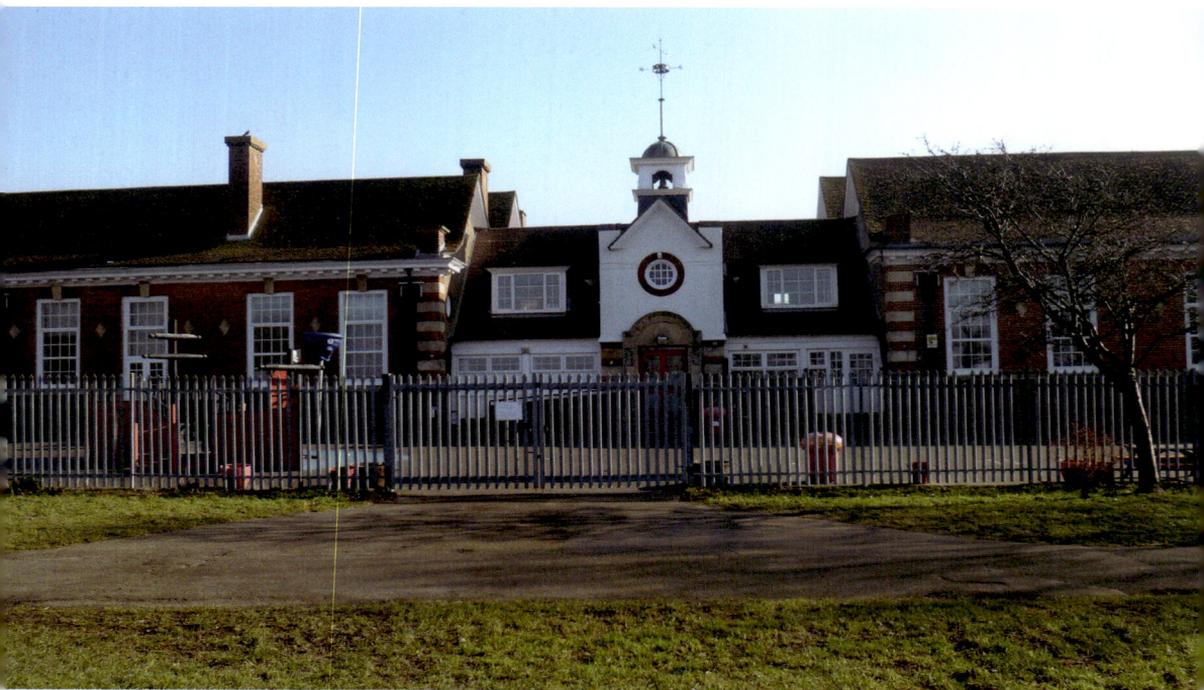

Above and below: King Offa Primary Academy.

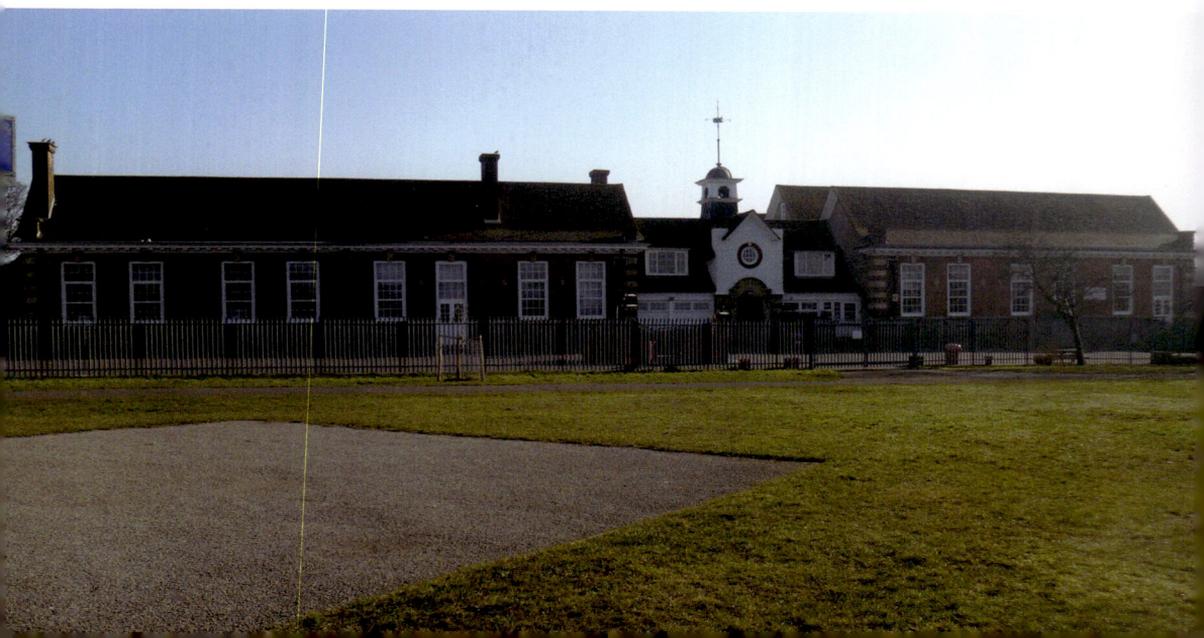

arts and crafts in early 1940, with needlework and bookbinding at the Malet Hall. Following the events of summer 1940, there was a major revision of policy. The London children were evacuated elsewhere and the school itself was evacuated to Letchworth with 304 pupils.

Now known as King Offa Primary Academy formed in 2012, when the former King Offa Primary School became an academy. There are fourteen classrooms and two halls and approximately 440 children in fifteen classes.

29. Marina Court Avenue

Bexhill's links with India are evident in the houses of Marina Court Avenue. They were built in the Mughal style, using red stone and including northern Indian and Central Asian architectural motifs. The Avenue was built between 1903 and 1907 and was Grade II listed in 1997. There were several architects. The main section is the creation of Durward Brown, with Nos 6 and 8 attributed to William Tillott Barlow. No. 22 was designed by Arthur Blackford and is known as the final home of Nripendra Narayan, the Maharajah of Cooch Behar in 1911.

The Maharajah was in some ways a traditional ruler – he shot 500 tigers, for example. But his small state was close to Calcutta, where the British influence was strong. He had been, like Sir Henry Lane, an officer in the Bengal Cavalry. His children attended English public schools, he was an Honorary ADC to Edward VII and a very senior Freemason. He was also seen as enlightened and associated with the Brahmo Samaj group of progressive Hindus.

Marina Court Avenue.

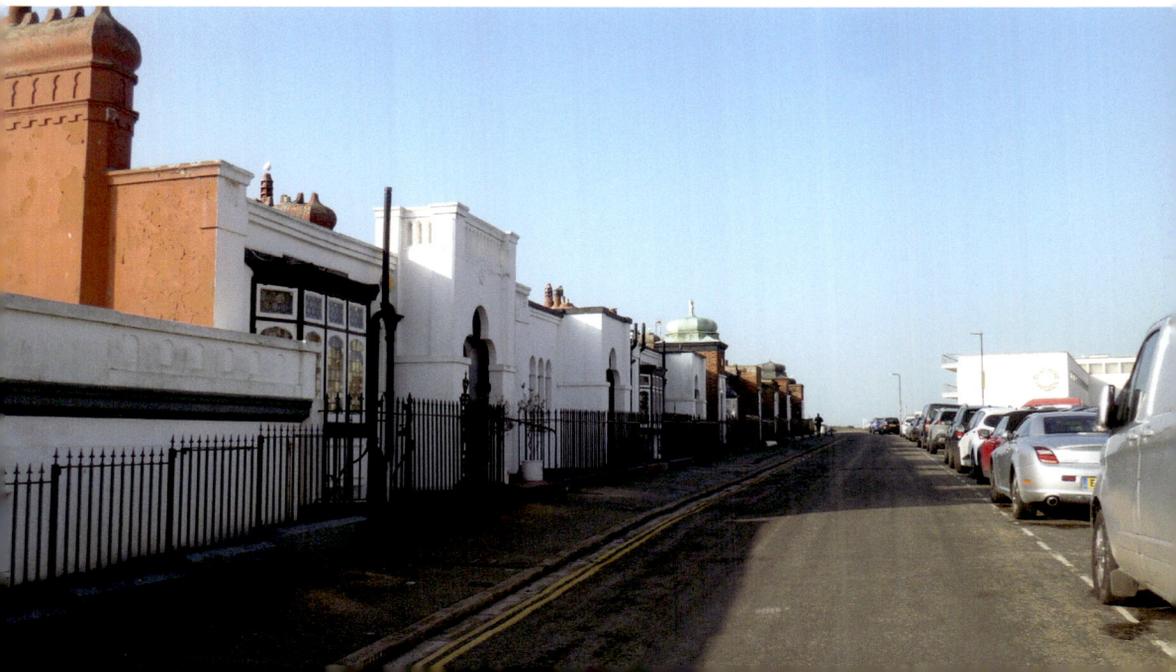

Above: The Maharajah's residence at Marina Court Avenue.

Left: Marina Court Avenue.

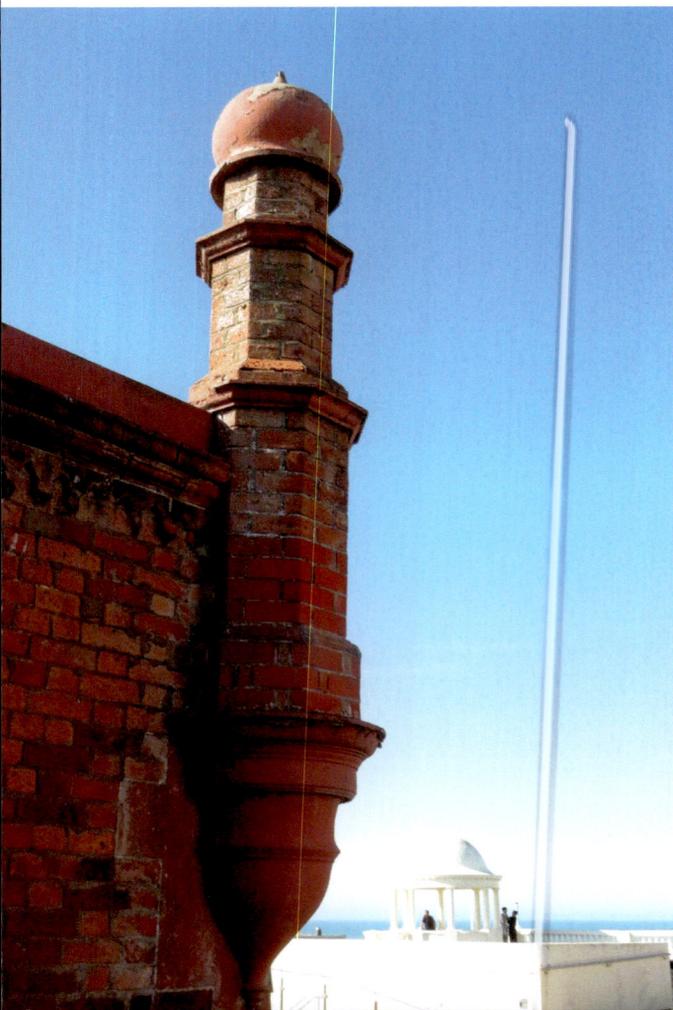

In 1911, aged only forty-eight, he fell ill after attending the Coronation. He moved into No. 22 Marina Court Avenue, perhaps seeking the health-giving benefit of Bexhill's sea air. He had his own Indian doctor and a retinue of attendants who stayed in neighbouring properties. There is, sadly, no truth in the popular idea that he installed his harem along the Avenue. His health was of concern to people in high circles: Queen Alexandra inquired after his progress shortly before he died on 18 September.

The procession of his body to Bexhill station was the town's largest and most important ceremonial occasion. The Maharajah was not personally known to the residents of Bexhill, as he had been confined to his room ever since he arrived here in the middle of July. His family, however, ensured that he was well regarded locally. They contributed to local charities, and even gave the town a monumental water fountain in memory of the deceased. This fountain should be one of Bexhill's famous structures. It was removed for restoration in 1963, however, and was somehow lost.

30. The Colonnade

This majestic white structure, Grade II listed, was built on the site of a demolished Martello Tower. It was commissioned to celebrate the Coronation of King George V. The local architect, Councillor Joseph Wall, was praised for his novel and 'non-fanciful' approach to the task. The style is classical, although the hemispherical domes echo the Mughal influence of the nearby Marine Parade. It was opened by Earl Brassey in July 1911 on a breezy day during the great heatwave of that year. The band of the 4th Dragoon Guards played 'God Save the King' before the guests enjoyed stylish sandwiches, ices and champagne.

The Colonnade had been built very quickly, perhaps because so much of it was concrete, and was soon busy, with regimental bands booked throughout the 1911 season. Unfortunately, bad weather impacted revenues, and the council lost money every year. In October 1922 the council entered a controversial agreement with General Woollcombe, a local worthy, allowing him to provide music through the winter. In the 1930s, the new De La Warr Pavilion was positioned just behind the Colonnade, provoking new questions about the Colonnade. By this time the seaward promenade deck had been destroyed by a storm and the bandstand had been demolished.

When the Second World War came, the Colonnade frontage was covered with sandbags, securing an interior air-raid shelter with room for 150 people. This would protect the seafront throng in case of a sudden attack. But a month after the outbreak of war such a surprise attack had not taken place. Many of the sandbags were taken away for use at other sites, and a brick wall was put in place. After the evacuation of Dunkirk and with the enemy just over the Channel, the seafront was sealed off to the public.

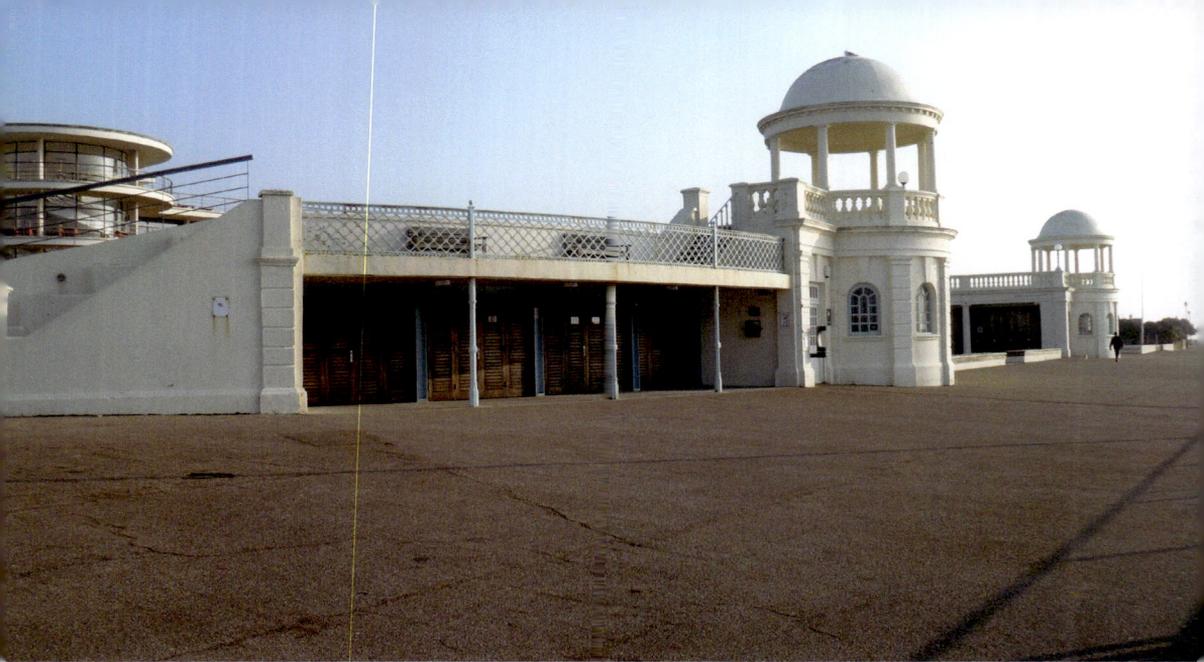

Above and left:
The Colonnade.

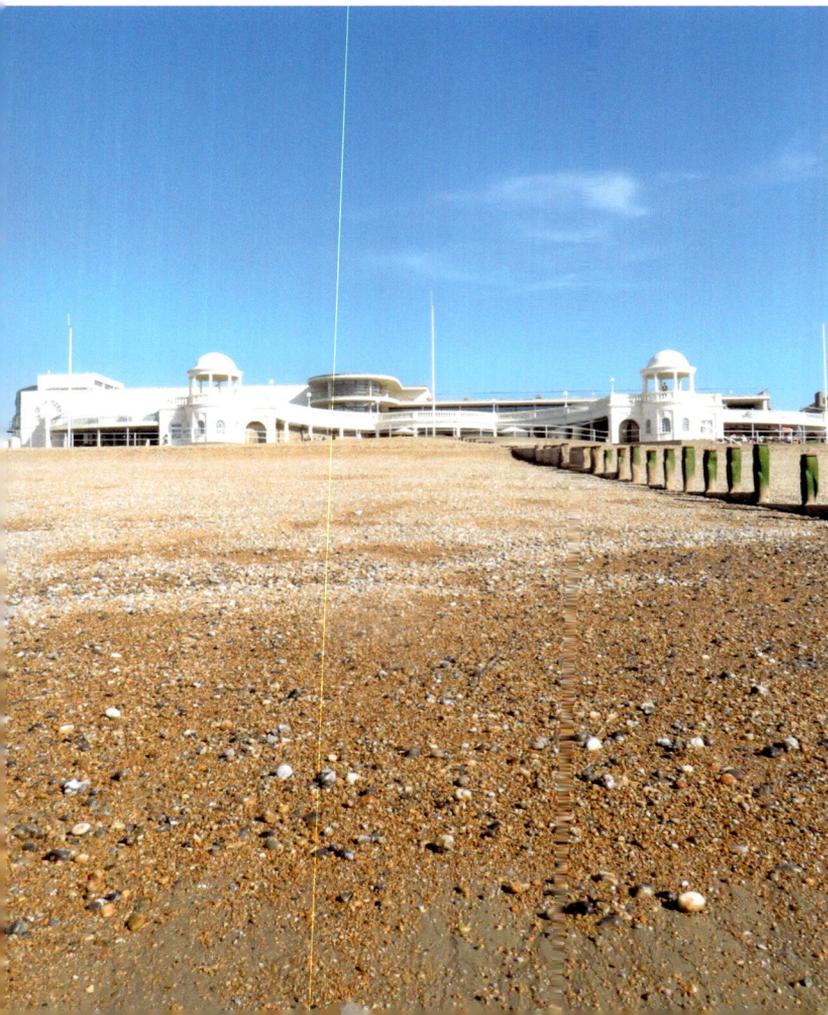

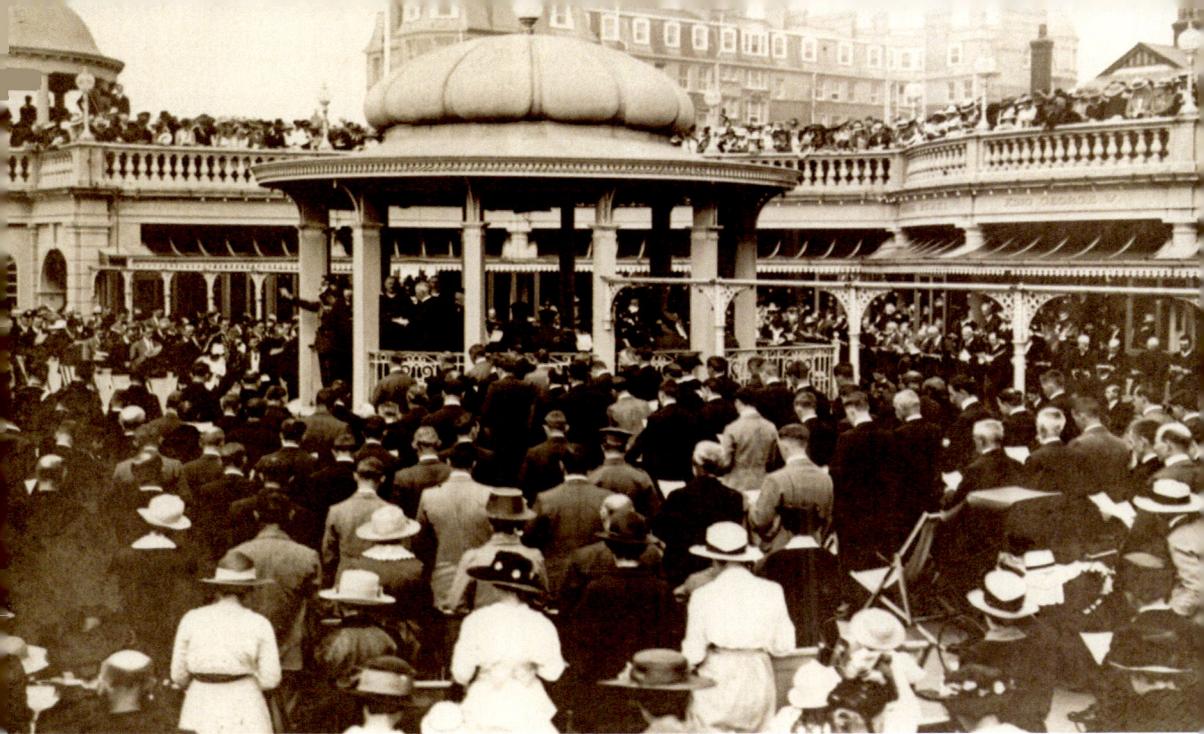

The Colonnade. (Courtesy of Bexhill Museum)

By 1946 the Colonnade was regarded as an eyesore. The next year the council was told that the interior was very damp through water seepage and that remedial works estimated at £100 were necessary. History repeated itself in 2010–11 when major structural work behind the rear wall was carried out. The Colonnade is now a seafront destination known as the Colonnade Quarter with cafés and independent shops.

31. Cooden Beach Golf Club House

The 8th Earl became keen to develop the western end of Bexhill, and plans for the clubhouse were passed by the Bexhill Corporation in November 1911. Tubbs and Messer were the architects of the building. The architect of the golf course was Herbert Fowler, who famously avoided earth-moving, preferring to 'drape' courses over existing landscapes. A new access road was built to encourage motorists, and there was an archetypal modern moment in October 1912: two flyers from Eastbourne landed their Bristol biplane by the first tee and played a round.

Viewed from the west, the clubhouse remains remarkably as it did in 1912. By 1913 interior work was completed and the adjacent Dormy House was completed, which consisted of fourteen bedrooms and six bathrooms.

This was all in time for the outbreak of the First World War, when Dormy House was occupied by officers of Colonel Lowther's Southdown Battalions. While

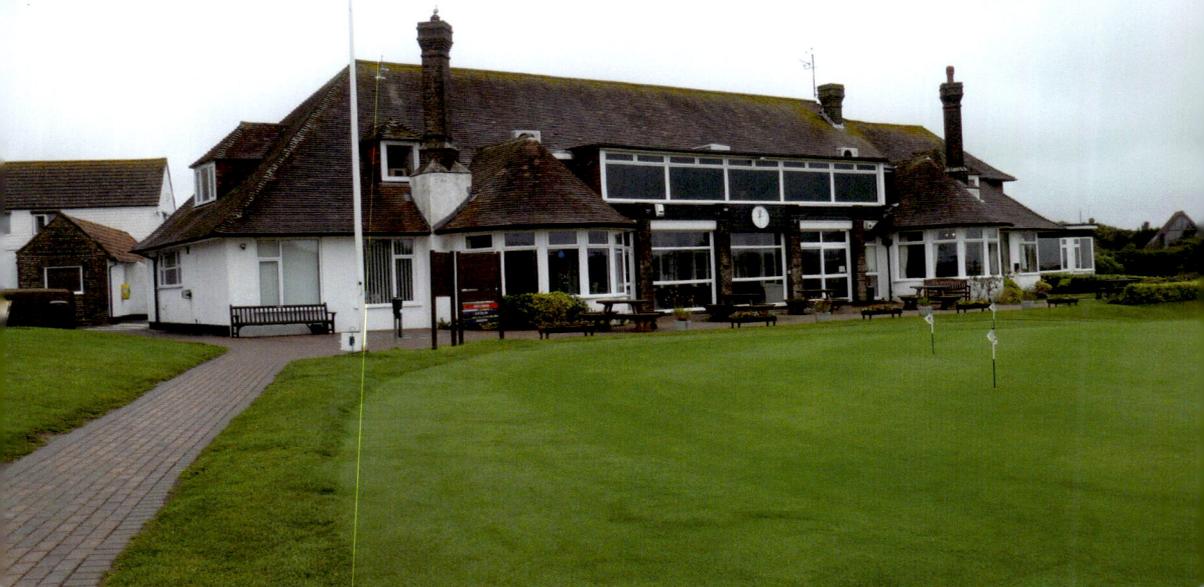

Above and below: Cooden Beach Golf Club house.

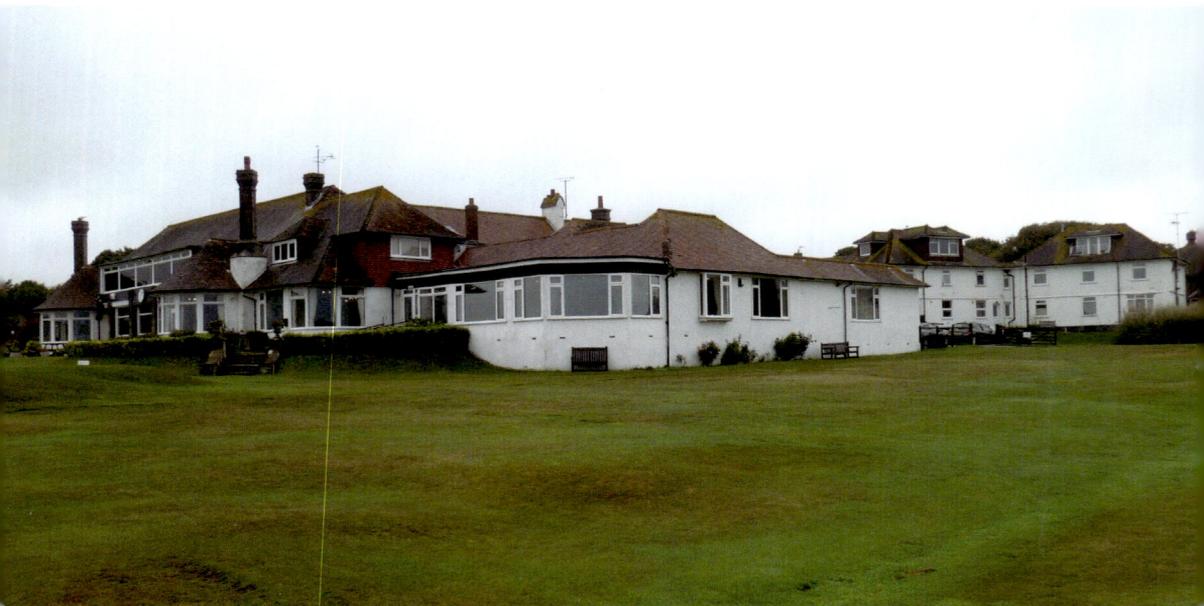

the clubhouse continued to be used by the members it also became an officers' mess. The arrangements went smoothly, perhaps because Clement Peache, who had succeeded Major Wright Warren as golf club secretary, was also a captain in 'Lowther's Lambs'. There was some crowding of bedrooms in the Dormy House, with up to the five officers occupying one room.

In the interwar years, the golf club, like the neighbouring Cooden Beach Hotel, had some well-known visitors, including the Prime Minister, Ramsey MacDonald.

During the Second World War the course was reduced to six holes and anti-tank traps were constructed and mines laid. One of these killed a member, George Gatey, in 1940, a retired solicitor who had entered the course from a footpath.

When the club's lease from Earl De La Warr was due to expire in 1959, a special meeting of members in June 1957 decided to purchase the site. The property included the golf course, the clubhouse and other buildings inside the courtyard, plus the Dormy House. To achieve this, a new club with a brand-new set of rules and a new company were required. The new company called C.B.G.C. Limited was to hold the freehold.

32. Malet Memorial Hall

At the end of the nineteenth century, Bexhill-on-Sea was a fashionable aristocratic watering place. It became the third home of Lady Ermyntrude Malet, who also had residences in Eaton Square and the Chateau Malet in Monaco. In 1897 she and her husband employed a local architect, George Herbert Gray, to design a house for them, to be called Wrest Wood in what is now Wrestwood Road. Her husband, Sir Edward Malet, was said to be the first man in Bexhill to own a car.

Sir Edward, a senior diplomat who had served in Paris and Berlin, died in 1908. His widow decided to build a memorial to him in the town, in the form of a public hall. This was not surprising; although she did not take an active part in local affairs, she donated to local charities and allowed groups such as the Girl Guides

Malet Memorial Hall.

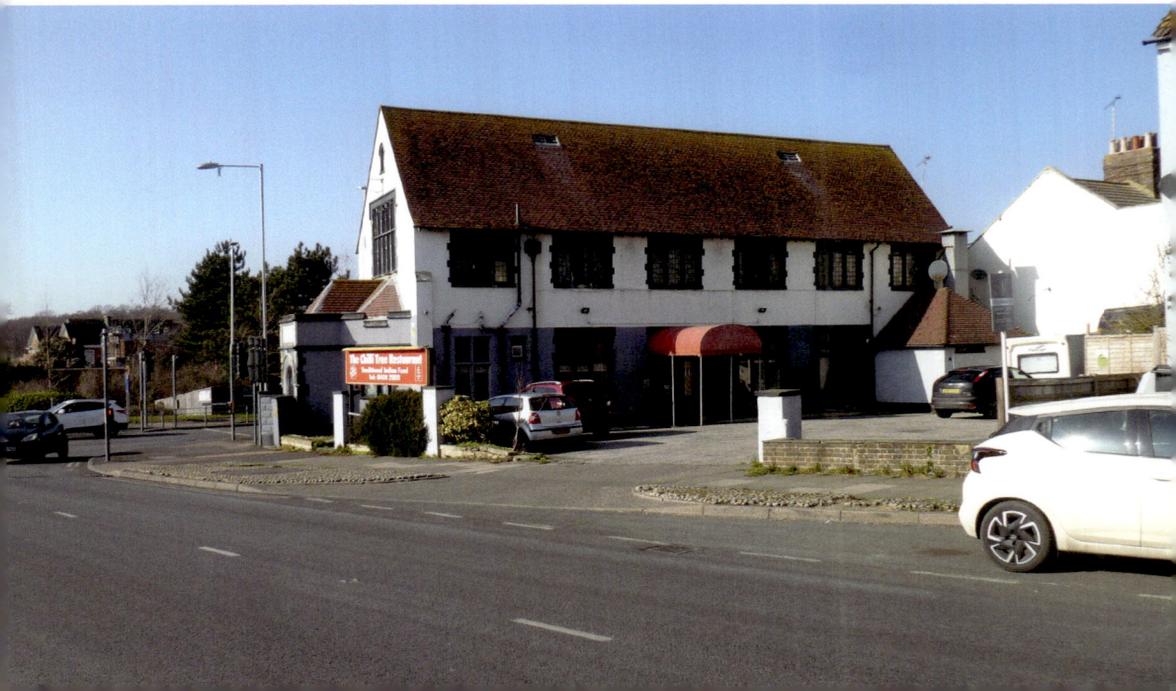

to hold fetes in her garden. Lady Ermyntrude once more employed George Gray as her architect, and he provided a useful hall with a Tudor-themed exterior in Bath stone and red brick.

At first the hall was called the Malet Memorial Church Institute. It was situated in a working-class part of town and housed a mission church. The Bishop of Chichester dedicated the institute in October 1913. There was seating for 200 in the upstairs chapel, with meeting rooms (one for men and one for women), a tearoom and a soup kitchen. There would be lectures and social gatherings, all under the auspices of the Church. The upstairs chapel was titled the Church of the Good Shepherd, taking the name of an older iron church on the Down which had been dismantled.

The Church of the Good Shepherd closed with a farewell service held on 14 January 1995. In recent years the ground floor has been a restaurant: first it was The Double Dragon Chinese restaurant and now The Chilli Tree Indian restaurant, which retains the Chinese interior decor. A few pillars of the original boundary wall remain, one bearing a dedication to Margaret Ann Scrivens in respect of her social work.

33. War Memorial

The town War Memorial, located on the seafront at the end of Sea Road, was unveiled on 12 December 1920. The unveiling was carried out by Brigadier General Henry O'Donnell, a Bexhill resident who went on to be a lynchpin of the local British Legion. The procession was led by the town band and then as now the procession included representatives of many armed forces and civilian bodies. The memorial's sculptor Louis Roslyn was present. There was a nineteen-gun salute and a two-minute silence.

In March 1919, a war memorial committee had been formed. The committee was chaired by the Mayor and included local councillors and clergy, retired military men and a very small number of the bereaved families. The committee received eight designs in total, all following a similar format. Other forms of memorial – such as a new wing for the local hospital in Hastings – had also been considered. The committee decided on the design by sculptor Louis Frederick Roslyn RBS, a prolific designer of war memorials. The cost was £1,400 and efforts were being made to gather in funding to meet the target.

The memorial they chose is a 28-feet-high Portland stone obelisk with a bronze statue of Victory facing the Western Front and grasping the sword of sacrifice. On either side of Victory there are bronze tablets engraved with the names of the Bexhillians who had died during the two world wars.

In November 1947 work began on a temporary reconditioning of the First World War plaques. In June 1948, the Mayor appealed to be told the names of the Second World War dead – there was no official list. In August a general memorial

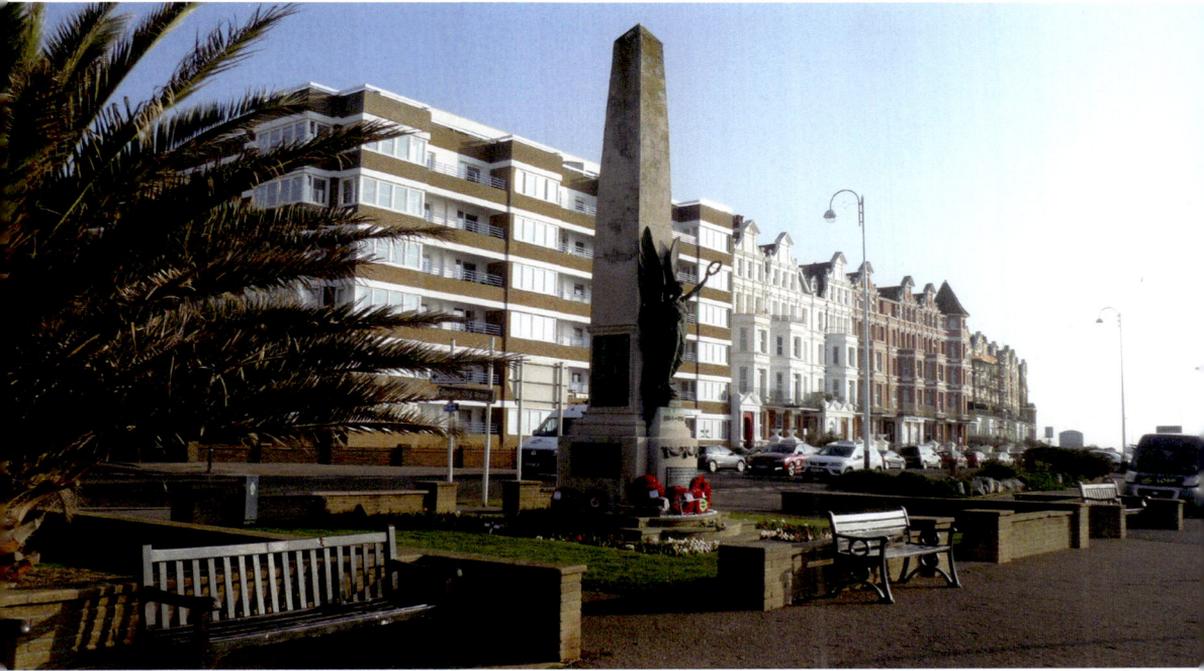

Above and right: War Memorial.

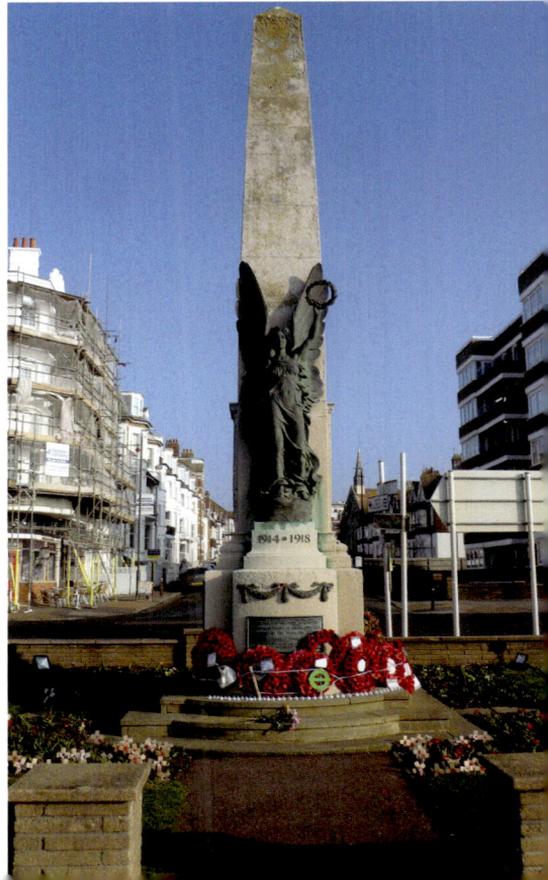

plaque was installed on the south wall. Assuming that space was available for 300 names – at a cost of £2 each – he appealed for donations to fund the necessary £600. The result was the May 1949 unveiling of the Second World War plaques with due ceremony. There were 111 names (including a duplication). One year later, fourteen additional names were added in plaques on the eastern and northern walls.

34. The Picture Playhouse

Bexhill, being a modern town, came early to the cinema. In 1898, the Kursaal – the seaside entertainments pavilion – was showing a Velograph of Gladstone's funeral, and in 1912 the town had its own production company, filming Sherlock Holmes stories, with location shots in Sidley and Little Common.

There were business opportunities here, and during the First World War there were excellent profits from the purpose-built Cinema De Luxe in Western Road. In 1919 its owners launched a new company called Playhouses (Bexhill) to build a bigger, better and hopefully even more profitable cinema, right next to the original one.

It was inaugurated at 3 p.m. on 8 July 1921 by the Duchess of Norfolk, who was not especially interested in film. She was there to promote the British Red Cross. The cinema was officially opened when she cut a rope to reveal the cinema screen. An image of King George V was projected, and the audience sang the national anthem.

The architect was the Eastbourne-based Peter Dulvey Stoneham, who had designed the old De Luxe cinema. Several of his other cinemas are still standing along the south coast. The 800-seat cinema was ornate outside and inside. The interior walls were decorated with 'art-paper'. The lighting was especially artistic in using a novel switch called the 'dimmer'. Another innovation was air-conditioning, very welcome in the hot summer of 1921.

A refit in 1930, costing £3,000, provided the Playhouse with a Western Electric sound system. The cinema could now show talkies, starting off with *High Treason* – an 'All-talking spectacle of the future'. The thirties were the great period of the movies. At that time, Bexhill had four cinemas and three of them changed their names.

After the Second World War, the cinema went into a decline, and the Picture Playhouse followed. It became the Classic and then the Curzon. It hosted a bingo hall, then a shop. It closed in 1991, reopened for a few years, then closed again in 2004. After a brief spell as the Redstack Theatre, it closed again, in 2008.

Currently it is a lively and popular venue, owned by Wetherspoons. It has regained its name of The Picture Playhouse.

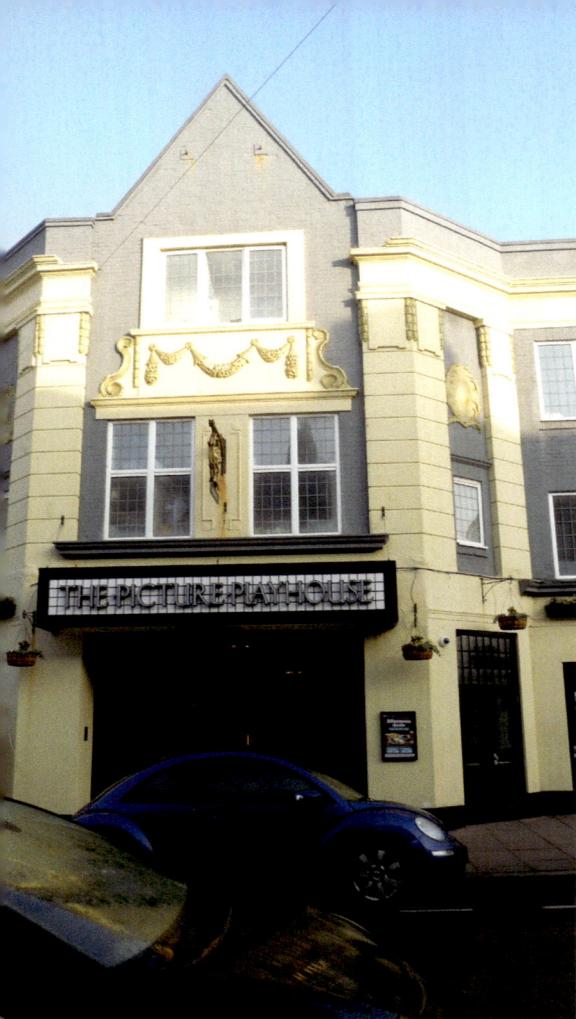

Above left and above right: The Picture Playhouse.

Right: The Picture Playhouse. (Courtesy of Bexhill Museum)

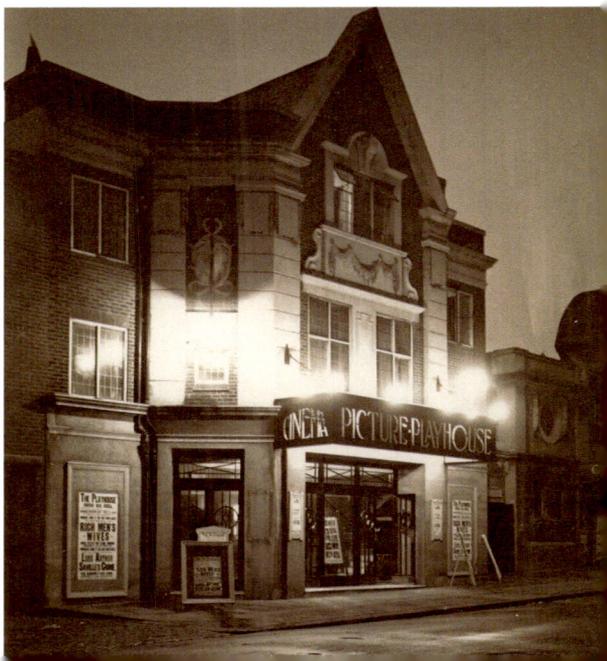

35. Cooden Beach Hotel

Cooden Beach had once been a piece of open land, notable for holding the largest barn in the district. Then the golf course was constructed in 1912 and there were hopes for a hotel on the site. These were delayed, but the Cooden Beach Hotel finally opened in 1931, three shops being converted for the purpose.

Ownership was in the hands of the De La Warr family. The hotel was run by Helena, the Countess De La Warr, assisted by the redoubtable Blanche Ireland MBE. Miss Ireland had risen to a high rank in the Women's Army Auxiliary Corps and worked as private secretary to the countess. Together they created a country-club type of hotel, which attracted a very stylish clientele in the 1930s. On a weekend stay you might encounter bright young things playing backgammon or catch sight of actresses like Gladys Cooper and Gertrude Lawrence. The MP and diarist 'Chips' Channon stayed there in 1937 and listened to the guests discuss Edward and Mrs Simpson. He remarked that the hotel was run by the De La Warrs on tearoom lines, with a touch of Indian Colonel – a comment which might also have been applied to other parts of Bexhill. Famous visitors to the Cooden Beach Hotel included Montagu Norman (the Governor of the Bank of England), King George V and Queen Mary and the Duke and Duchess of York (afterwards King George VI and Queen Elizabeth, later the Queen Mother). Prime Minister Ramsay MacDonald stayed there quietly for a week in November 1933. In June 1939, the German ambassador stayed there, who had come to visit his daughter at the Augusta-Victoria College.

As with many commercial enterprises the hotel has had name changes, being known as the Jarvis Cooden Beach in the late 1990s. James and Lesley

Cooden Beach Hotel.

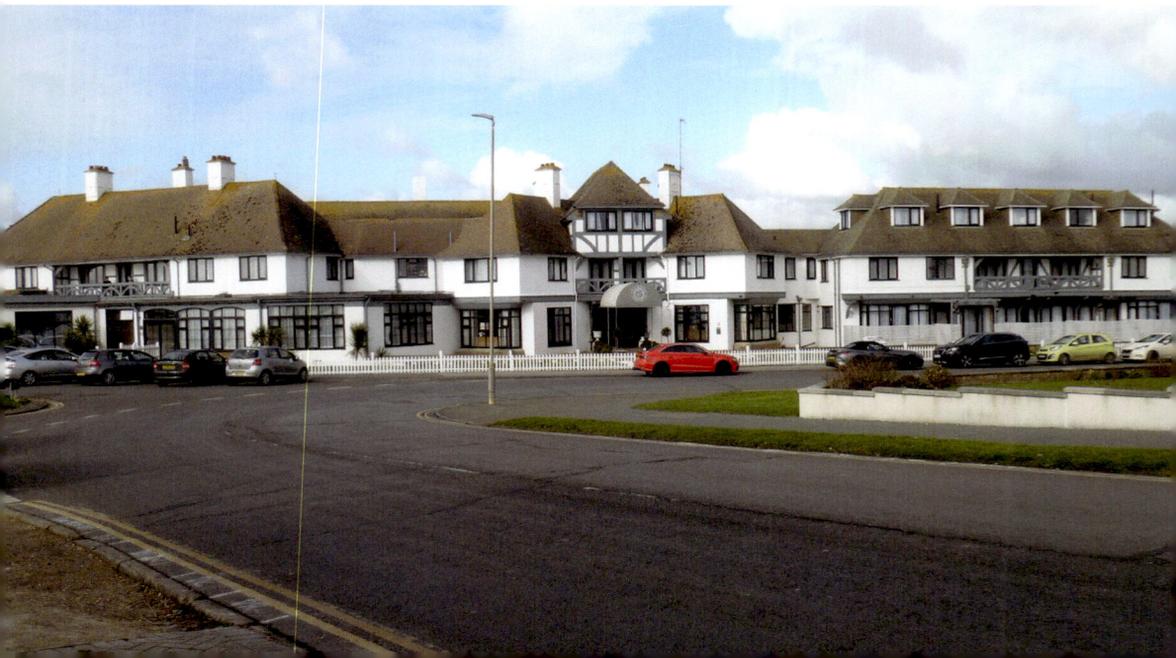

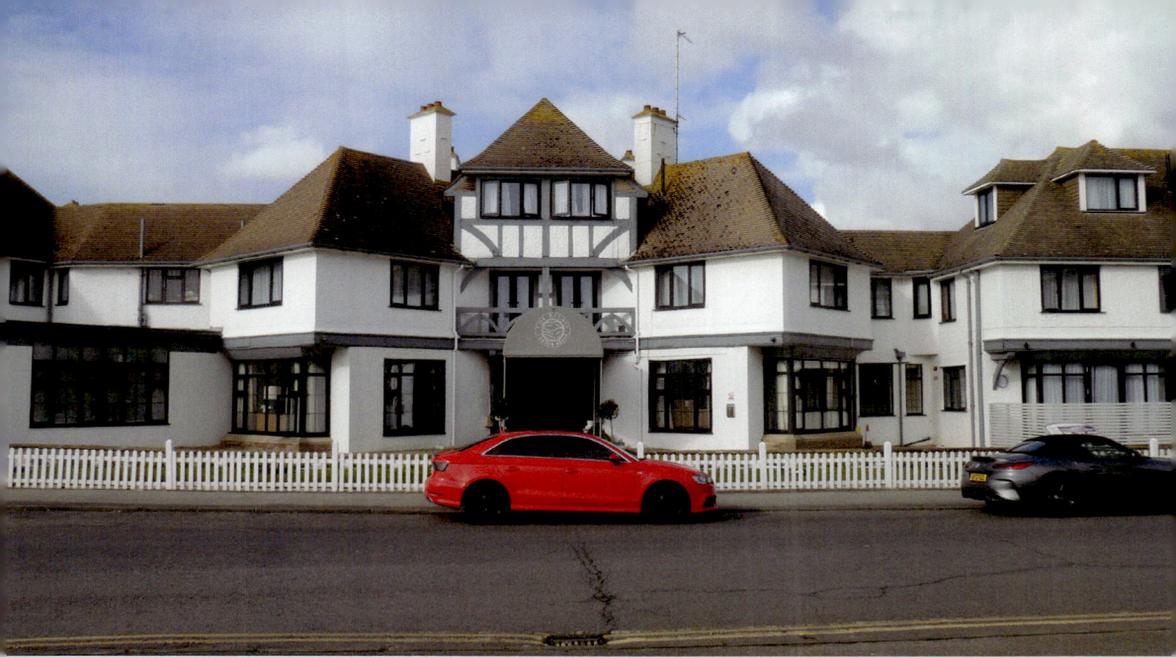

Cooden Beach Hotel.

Kimber owned the hotel in recent years and in 2021 sold to Grace Leo and Tim Hartnoll, who have refurbished the property and renamed it as The Relais Cooden Beach.

36. Boots Store

The modern age was confirmed in Bexhill when the De La Warr Pavilion opened in 1935. The pavilion was not, however, the first modernist building in the town: that honour belongs to the 1930 Boots store in Devonshire Road.

No. 16, on the corner of Parkhurst Road, was originally the location for F. Wimhurst, chemist. Next door at No. 14 was John Hicks the photographer, whose shop was turned into Branch 983 of Boots Cash Chemists in 1913. When Frederick Wimhurst merged his business with Collis's in St Leonard's Road in 1929, Boots saw an opportunity to build a large new store. The result was an undeniably modernist affair, with no superficial ornament, white walls, plenty of glass and a flat roof – substantially the store which we still see today.

The company was not averse to modern construction: their D10 building in Beeston, under construction at this time, became famous as the 'Factory of Utopia'. Even so, the decision to build the Bexhill store in an overtly modern style is odd. The architect was Percy J. Bartlett, responsible for most of the stores in the country. He designed each store to match its location, and he produced some timber-framed façades in the 1930s. Why he thought modernism was appropriate for Bexhill, we do not know. Certainly, the local council was not prepared for

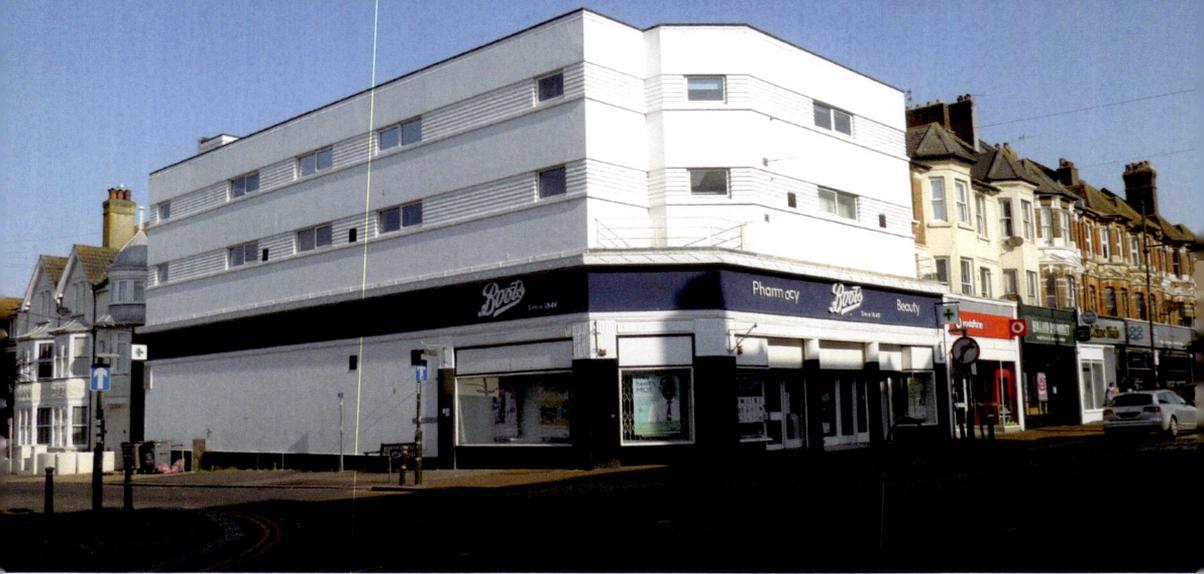

Above: Boots store.

Below: Boots store. (Courtesy of The Boots Archive)

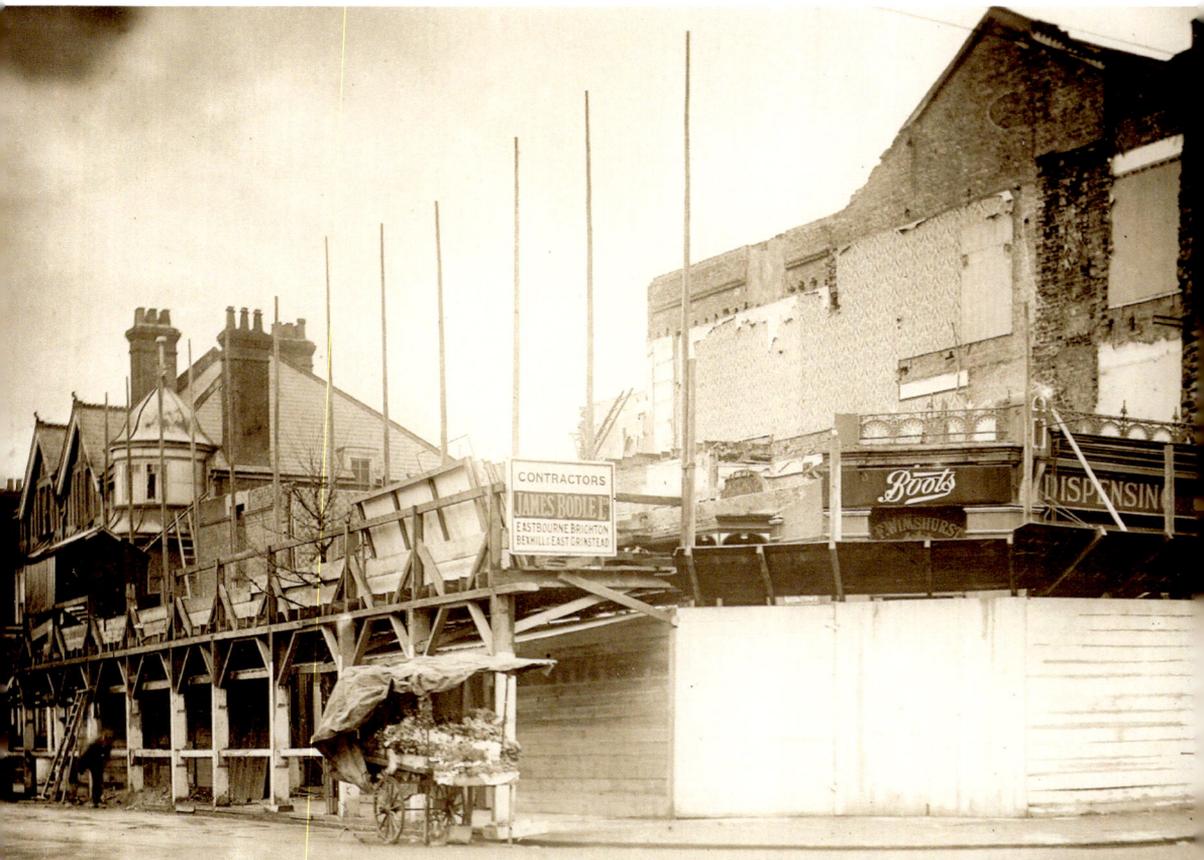

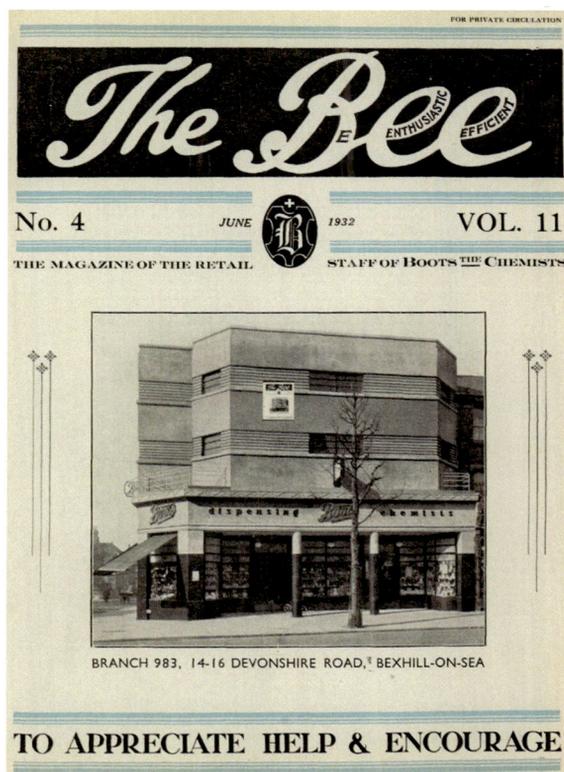

FOR PRIVATE CIRCULATION

The Bee

E ENTHUSIASTIC EFFICIENT

No. 4 JUNE 1932 VOL. 11

THE MAGAZINE OF THE RETAIL STAFF OF BOOTS THE CHEMISTS

BRANCH 983, 14-16 DEVONSHIRE ROAD, BEXHILL-ON-SEA

TO APPRECIATE HELP & ENCOURAGE

Boots store. (Courtesy of The Boots Archive)

this. There was a minor constitutional crisis between the council and its Rating Committee as they tried to find an appropriate rateable value for the 'modern and novel type of building'.

The new Boots was not simply a pharmacist's outlet. There was an extensive lending library on the first floor, along with Fancy, Silver, Arts and Stationery. Downstairs there was Drug, Dispensing, Toilet and Photography. Added to which, one of the staff, Barry Lucas, was an eminent local archaeologist.

During the Second World War, the premises were used as an exhibition hall, showing serious military hardware, during the various War Weeks which encouraged the purchase of War Bonds: 1941 War Weapons Week; 1942 Warship Week; 1943 Wings for Victory; 1944 Salute the Soldier Week.

37. Augusta-Victoria College

The building currently numbered 128 Dorset Road – it has been numbered 58 and 88 – has had a long history of education. St Etheldreda's was founded here in 1912 by Mrs May Jacoby, who left Bexhill in 1922 for Battle Abbey School. From 1923 St Andrew's Preparatory School occupied the site.

The Augusta-Victoria College was a finishing school, established in Bexhill about 1932 by Frau Rocholl, with Baroness von Korff as her chief assistant. It had both German and English girl students, and among the former were several Lutherans, who worshipped at St George's Presbyterian Church in Cantelupe Road.

In 1937 the German, English and Finnish students went to the German Embassy in London to welcome Field Marshall von Blomberg, the German War Minister, who was the principal representative of the Reich at the Coronation. The youngest student presented a bouquet of carnations, while the others greeted him with the Nazi salute. The students wore pretty, light blue blazers with a badge bearing the Union Jack in one corner and the swastika in the other.

The school received financial privileges from the German government, and the school welcomed the daughters of some high-ranking Germans. Joachim von Ribbentrop, the Foreign Minister, sent his daughter Bettina here. Another student was Reinhild von Hardenberg. She was arrested in Germany in 1944 when her fiancé and her father were implicated in the Stauffenberg attempt on Hitler's life.

In 1938 with the Munich Crisis, the principal, vice-principal and twenty-four German students returned to Germany. This was a temporary expedient as the school returned to Bexhill and finally left in August 1939 on the eve of war.

Augusta-Victoria College. (Courtesy of Alex Markwick)

During the war the building was taken over by the Women's Voluntary Service (WVS) as a hospital facility. Post-war, under the ownership of Mrs Sutherland, the premises became the Lindsay Hall Nursing Home – later the Lindsay Hall Dementia Care Centre. Lindsay Hall was the name of the house before it became a school. It has now been refurbished and is divided into apartments.

38. Leasingham Gardens

A large part of Bexhill was designed and built by a single company, R. A. Larkin and Brothers Ltd. This was largely controlled by a single individual: Reginald Arthur Larkin (1898–1985).

He began as a plumber and trained to be a draughtsman. After war service and employment in Lancashire and Wales he moved to Bexhill in 1924 and was joined in partnership by his brother John (known as Jack); they worked together as building sub-contractors. A third brother, Geoffrey joined the company later. They built whole houses, but work was sporadic. To ensure a smoother flow of work, Larkin decided to build speculatively, a practice he maintained through most of his peacetime career. Many of his earlier houses were designed by Tubbs and Messer of Bexhill, although other architects were used, including J. E. Maynard, the architect of 'Saxons', who designed the Whitehouse Farm estate.

Leasingham Gardens was Larkin's first estate development. It was begun in 1932 and initially comprised a mix of fourteen detached and semi-detached houses. The gardens were described as 'a quiet and picturesque close, tastefully planned'. With families settled, the first birth occurred in 1933 and the first death

Leasingham Gardens.

Leasingham Gardens.

in 1934. The name of the close appears to link to Leasingham, a village 3 miles to the east of RAF Cranwell where Reginald Larkin had served. In fact, he named his early home in Gunters Lane as Cranwell.

In all, Larkin claimed to have built 2,000 homes in the town. These developments did not only change the material fabric of the town; he brought in a new type of person. One early inhabitant of Mr Larkin's houses was the eminent playwright David Hare, who grew up in Newlands Avenue and hated the boredom – perhaps the estate was not designed for teenagers. As many as 95 per cent of Larkin's customers were incomers, usually from London, and most of these were retirees, enjoying the respectable safety and quiet of Mr Larkin's 'nice little bungalows'. Some were attracted by the slick advertising, but many were following friends and relatives who had already moved. Over the decades, Larkin's speculative estates changed Bexhill society.

39. Bexhill Hospital

In the 1920s, the need for a local hospital had become pressing. Bexhill's population of 23,000 depended on the services of the East Sussex Hospital at Hastings (today the site of the White Rock Theatre). A 10-mile return journey was involved.

The Bexhill Hospital trustees purchased land in Bexhill for the erection of a hospital out of public subscriptions. The hospital building was completed in 1931 at a cost of £34,000 and officially opened in 1933, free of debt. The scheme was entirely dependent on active fundraising, which commenced in 1926. A 'brick for

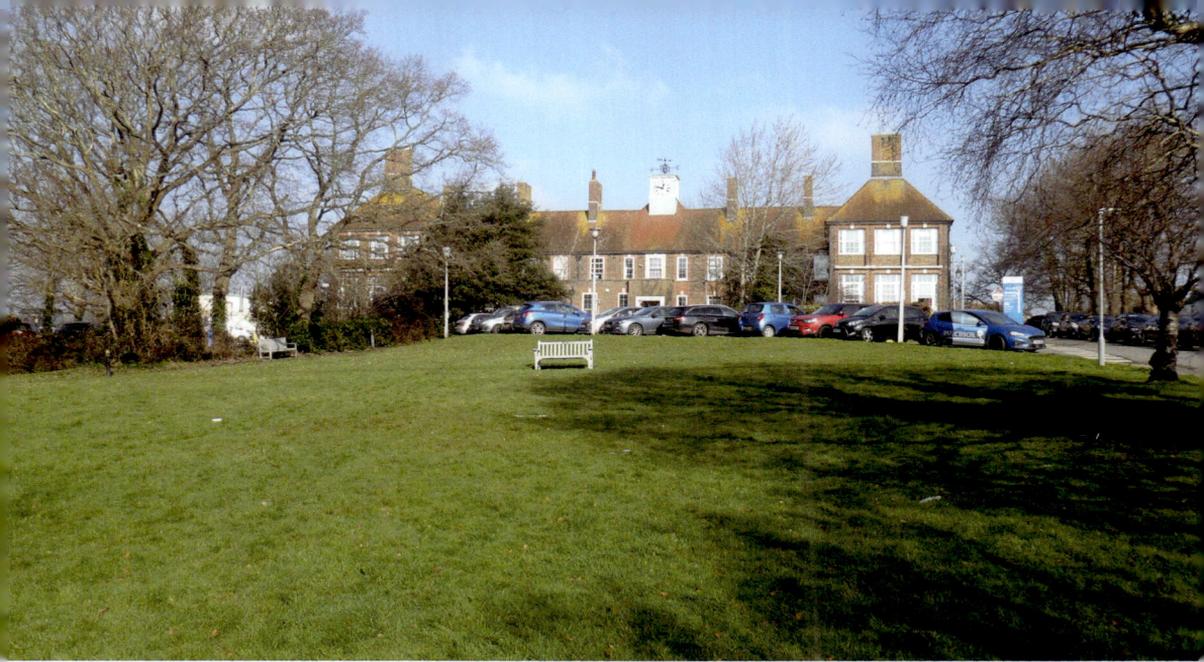

Above and right: Bexhill Hospital.

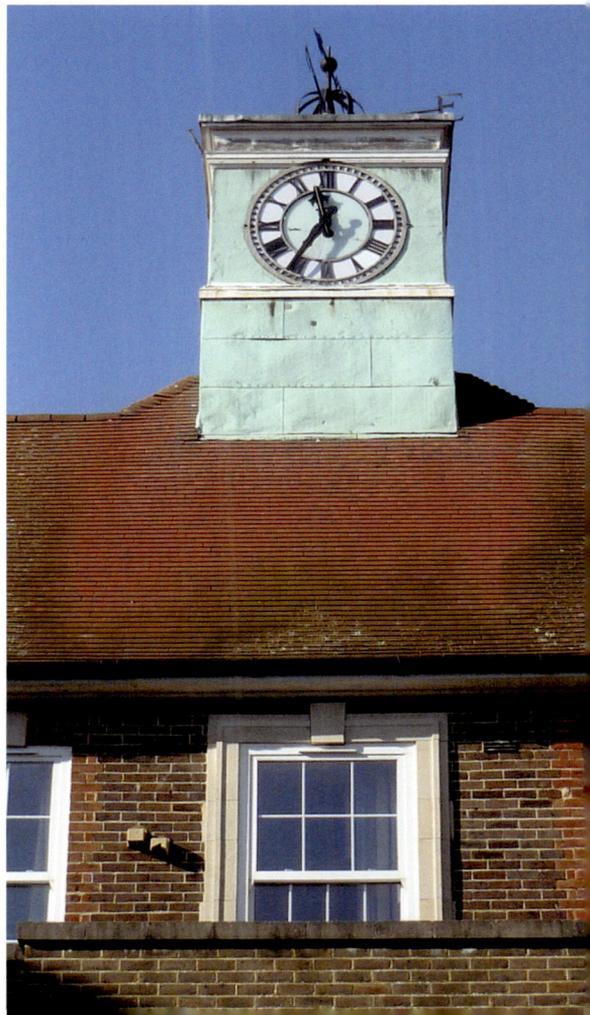

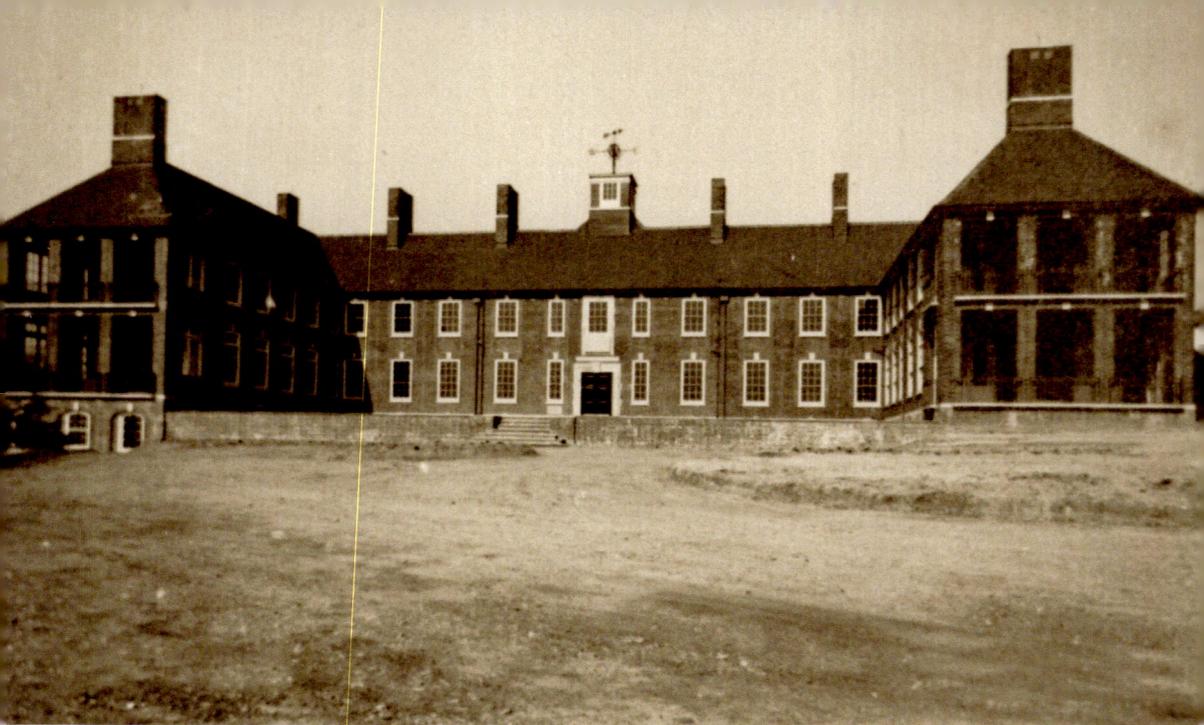

Bexhill Hospital. (Courtesy of Bexhill Museum)

sixpence' was a popular activity. The hospital was built to provide accommodation for forty-five patients in four wards, a children's ward, seven private wards and an operating theatre.

For the admirers of modern architecture, Bexhill Hospital might have been a disappointment when it opened. The architects were Adams, Holden and Pearson of Knightsbridge, who had designed scores of hospitals, but were also known for modern design: for London Underground stations and the University of London in Malet Street. The hospital in Bexhill is perhaps staid, especially in the light of contemporaneous developments in the town.

The approach to healthcare, however, was enlightened, fully in accord with the Bexhill motto of 'Sol et Salubritas'. It was to be a modern, hygienic environment, and the windows would be made of Vita glass to allow ultra-violet rays to enter. Each ward would have an open veranda, looking out to the sea and Beachy Head.

The facility developed. A nurse's home with thirty-one beds was built by public subscription in 1934. A further £17,000 enabled an outpatients department to be built, which was opened in 1938 and modernised in 1966. A chapel was built in 1954. A geriatric unit was added in 1973. Now the hospital has a rehabilitation centre The Irvine Unit with fifty-four beds, The hospital also now provides an Ophthalmic Day Surgery Unit and the Dowling Unit dealing with age-related macular degeneration.

The voluntary fundraising ethos continues with The League of Friends of Bexhill Hospital, who, since 1952, continue to raise large sums of money to assist with capital schemes and equipment.

40. De La Warr Pavilion

Bexhill's iconic building, the Grade I listed Pavilion was arguably the first major work of the modern movement in Britain. Completed in 1935, it was especially remarkable because it was funded by local ratepayers.

It was the achievement of Herbrand Sackville, the 9th Earl De La Warr, and it is appropriately named after him. His family had already left its mark on Bexhill: on the town's seafront from Herbrand Walk in the west to the Sackville Hotel on the De La Warr Parade in the east. Herbrand had friends in very high places but was also a progressive and a socialist. He was the first Labour member of the House of Lords and was a government minister; he was also the Mayor of Bexhill and dedicated his remarkable political skills to this municipal project.

In 1933 Herbrand proposed a new entertainments centre 'according to the traditions of the town'. There was to be an open competition, but the wording of the brief gave a strong hint of what was required: heavy stonework was ruled out and steel frames were ruled in – the building had to be light and attractive. RIBA held an independent competition, with a modernist architect appointed as the judge, and the winning design was the strikingly modern proposal from Mendelsohn and Chermayeff.

Their design was swiftly modified to use a welded steel frame – another first in Britain – and construction was completed in less than twelve months. There was an entertainments centre, with a large hall and restaurant, but also a reference library. It was a Scandinavian dream of sunlight and social progress but was blessed by the royal presence. King George V informally visited the building site in

De La Warr Pavilion.

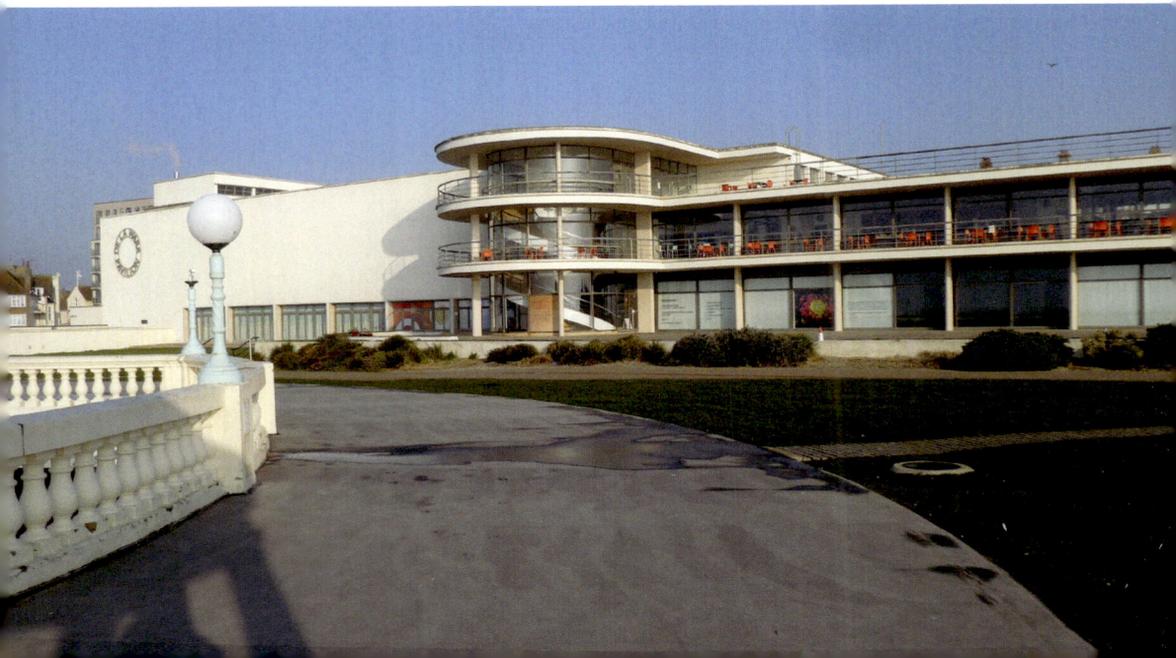

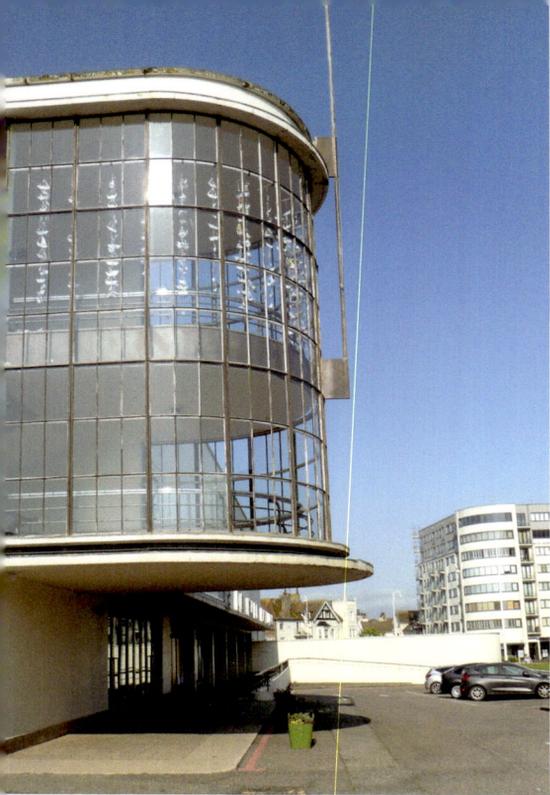

Left: De La Warr Pavilion.

Below: De La Warr Pavilion construction.
(Courtesy of Bexhill Museum)

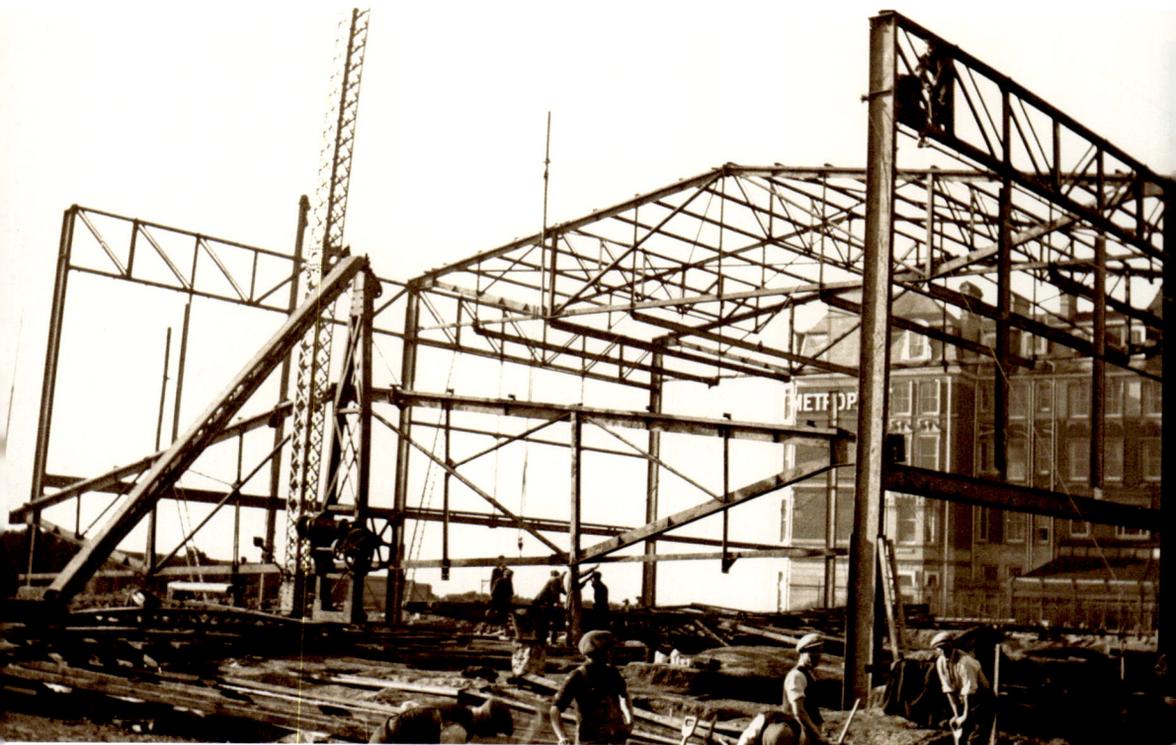

March 1935 – he cannily noticed some steel bolts being used – before the building was opened by the Duke and Duchess of York in December 1935.

The full plan, with a giant statue of Persephone and a swimming pool, was never realised, and over the years the building suffered from neglect. In 2005, after a comprehensive restoration project, it reopened as a contemporary arts centre.

41. Bowls Pavilion, Egerton Park

The Pavilion in Egerton Park is an interwar gem. It looks just as a municipal pavilion should. The walls are rendered and painted in brilliant white; the woodwork, at the front at least, is glossed in British racing green. At the time of writing, the windows are draped with long net curtains in a very muted shade of white.

This bowls and tennis pavilion was built by Godwin and Sons in 1935, replacing an earlier hut which had fallen into disrepair. The architect was William Pearce, the Borough Surveyor. The game of bowls is suitable for all ages and has long been played in Bexhill. To begin with, the local council resisted calls for greens and private gardens were used. The Bexhill Bowling Club was formed at the Devonshire Hotel in August 1907. Their first green was originally unfenced, with the result that woods sometimes ended up in the pond. A new green measuring 42 by 35 feet was opened in 1908, but there were complaints about the green for many decades after.

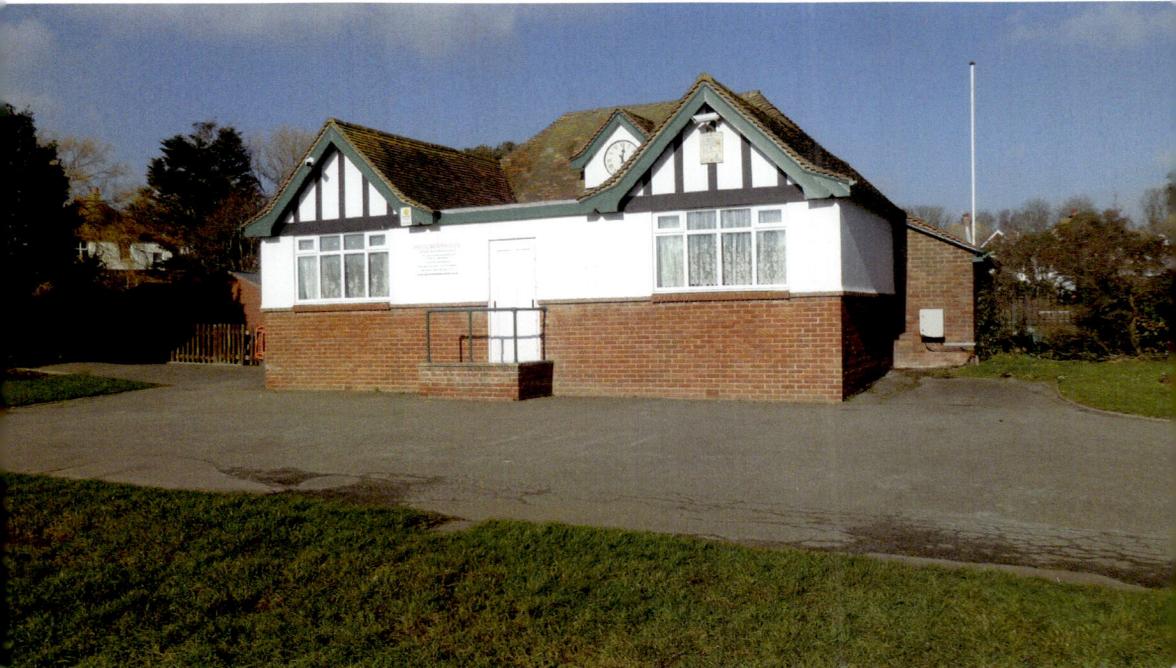

Bowls Pavilion, Egerton Park.

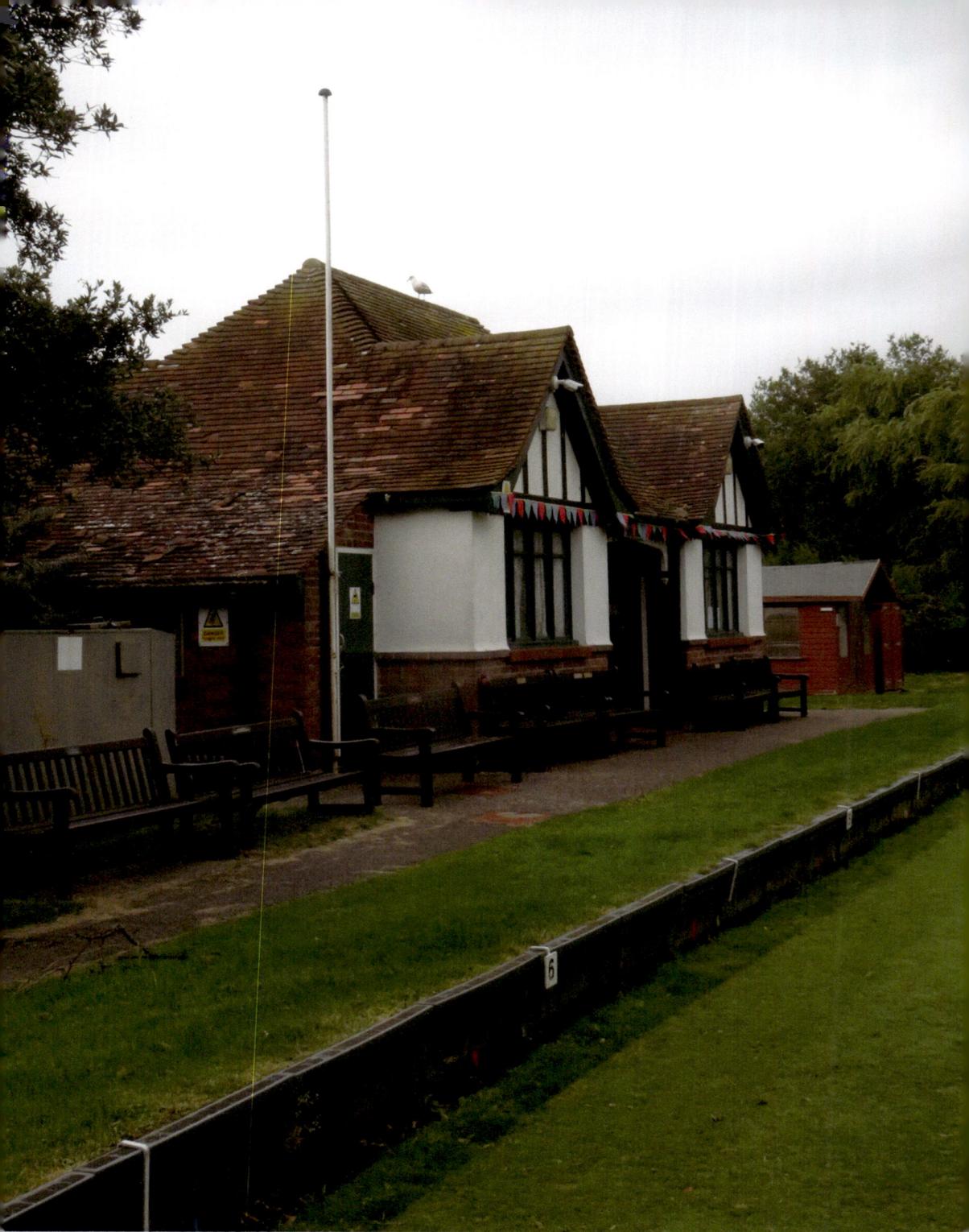

Bowls Pavilion, Egerton Park.

The Spartan Bowling Club was formed in the summer of 1920. There had been an argument within the Bexhill Bowling Club over the selection of teams. Matters became heated and several members of the existing club split off to form a rival club. It was decided, however, that both clubs would share the Egerton Park greens. When the Polegrove rinks were opened in 1924 the Spartans played there, as well as at Egerton Park. For many years players were unhappy with the accommodation offered. It was little more than a hut and became dilapidated. Finally, in 1934, the council agreed to prepare for a new building.

Coming up to date there have been two bowls clubs using the Egerton Park outdoor rink, the Spartan Bowling Club and the Lakeside Ladies Bowling Club. In 2016 the Spartan Bowling Club amalgamated with the Lakeside Ladies Bowling Club. But in 2024 the club played its last season.

42. Saxons

The development of West Bexhill in the 1920s was intended to create a residential estate of high-class properties. The West Cliff estate was 30 acres in all and offered 4,000 feet of sea frontage. No shops were planned, and each house had to cost at least £1,500. The project was in the hands of G. E. Maynard, the estate agent based in Collington Avenue.

The most celebrated dwelling in West Bexhill is Saxons on South Cliff, dating from 1934. It was designed by J. E. Maynard, the architect son of the estate agent. Maynard had designed many of the houses on his father's estate, but this one was constructed by R. A. Larkin. It was designed in the international style, with

Saxons.

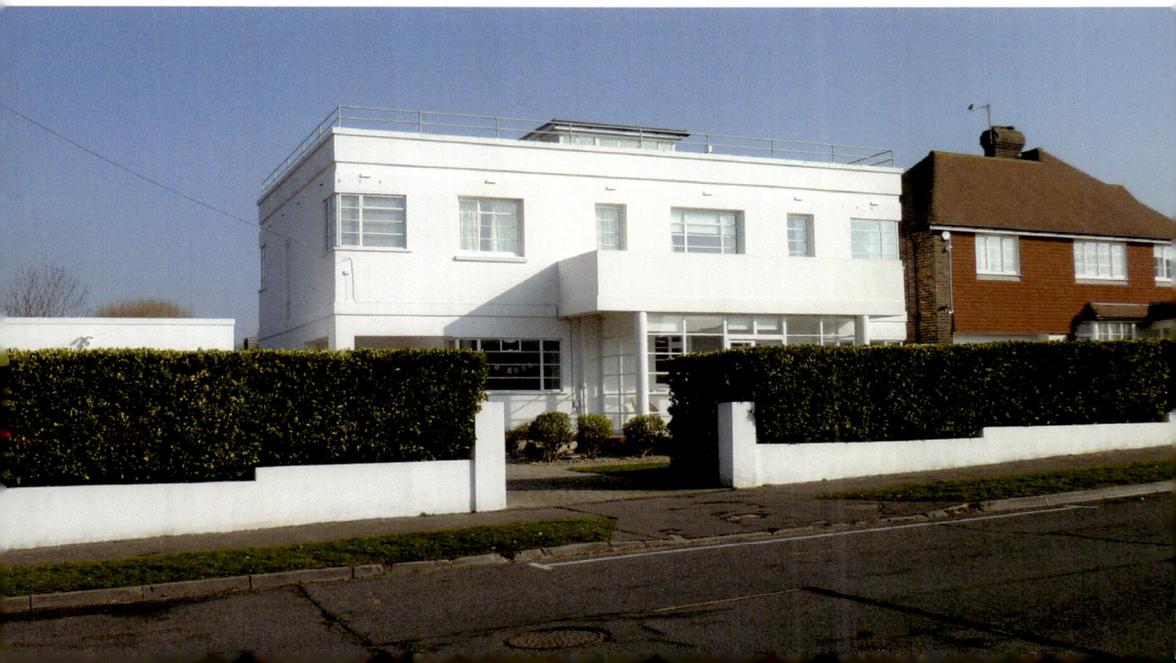

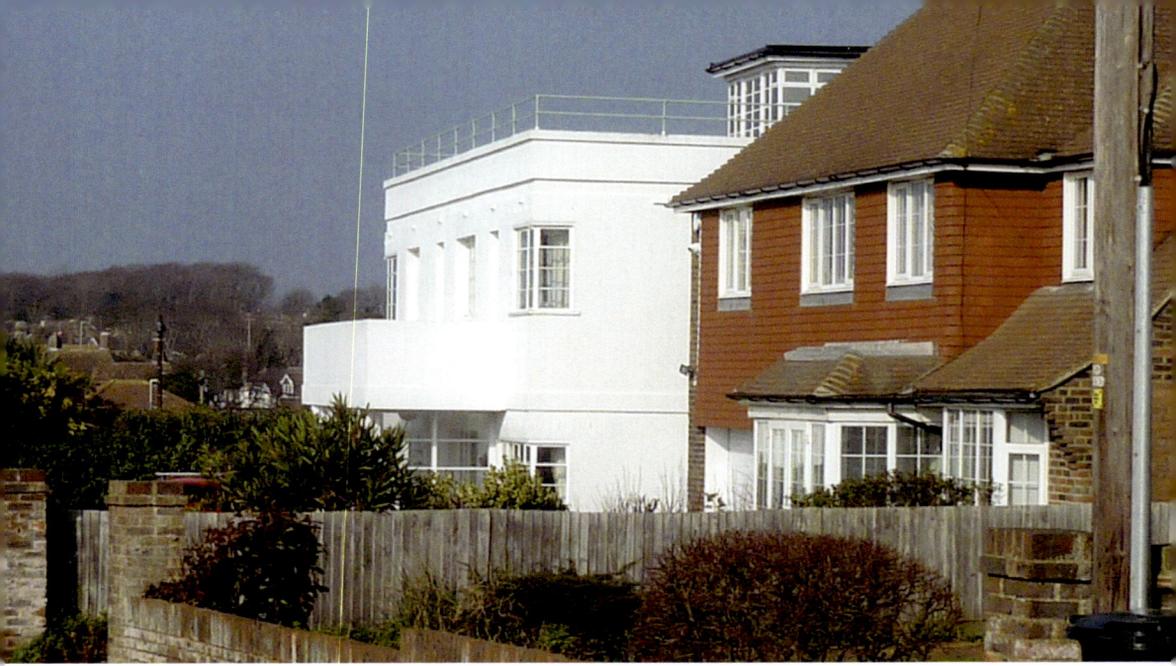

Above: Saxons.

Below: Saxons. (Courtesy of Bexhill Museum)

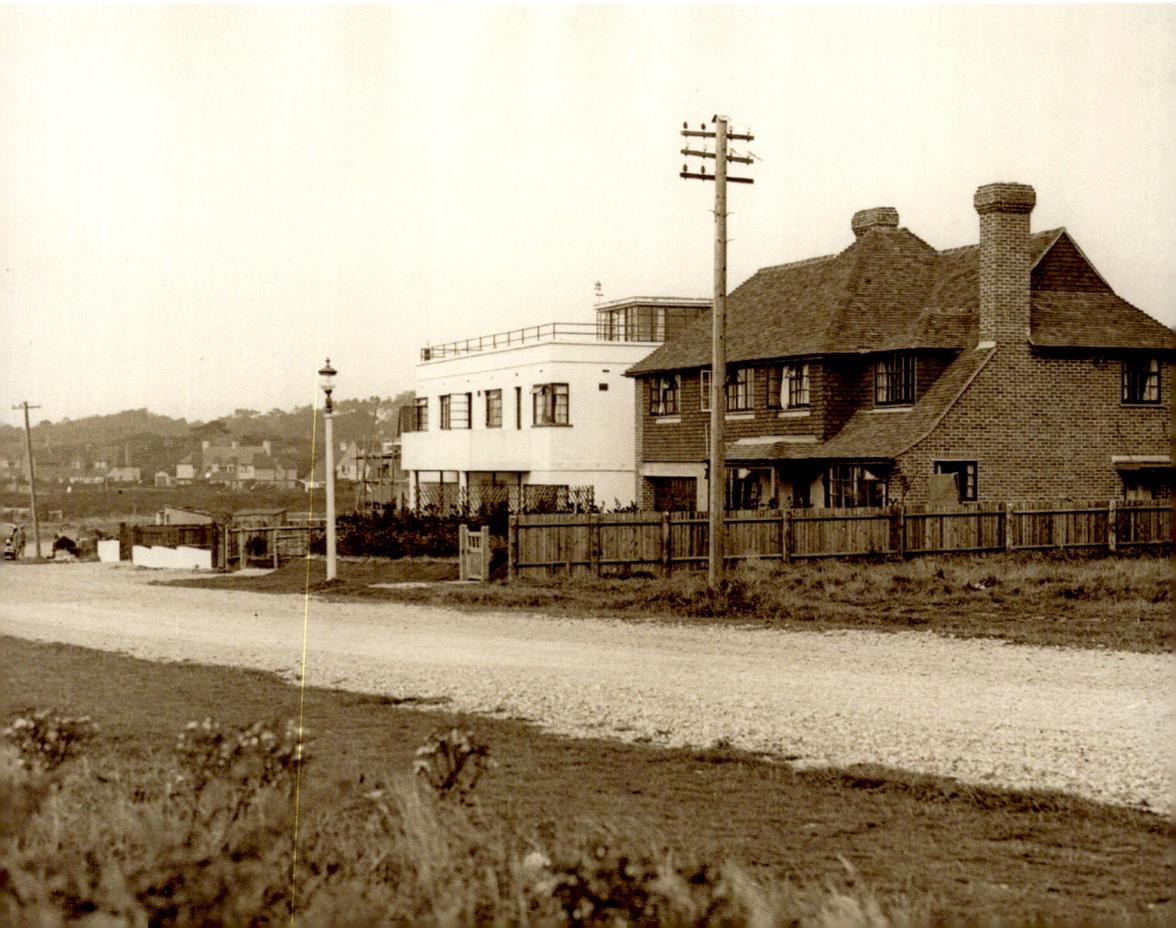

a white front and a flat roof topped by a sunroom. This was by the Channel, not the Mediterranean, and the flat roof was to be covered in Lavacrete from Messrs Briggs.

The first occupant was Edwin Charles Baker, a motor engineer, and his wife Lilian. He had been based in Tonbridge but moved to Bexhill on his partial retirement in 1935. Following his death in 1942 he left Saxons to his daughter. This distinctive modern house is Grade II listed.

43. Motcombe Court

Motcombe Court was built in 1938, designed by Henry Tanner, architect of the Park Lane Hotel and the Strand Palace Hotel. The builders were Walter Lawrence & Son, whose projects included the Royal London Mutual Insurance building in Finsbury Square, at one time London's tallest building. The show flat was furnished by a local company, Miller & Franklin. It was consciously modern. The marketing prospectus listed kitchen with refrigerator, electric lifts, constant hot water, and central heating.

The glory days were short-lived. Fortunately, the block was unoccupied except for the caretaker when, in January 1943, it was hit in a tip-and-run Luftwaffe raid. The east wing collapsed, losing four floors and destroying seven flats. The incident caught the attention of the Ministry of Home Security's Research and Experiments Department, who carried out a detailed examination of the building. Little was done to clear up the debris. Eventually, in September, local builders were contracted to clean up the site as its wrecked state was bad for wartime

Motcombe Court.

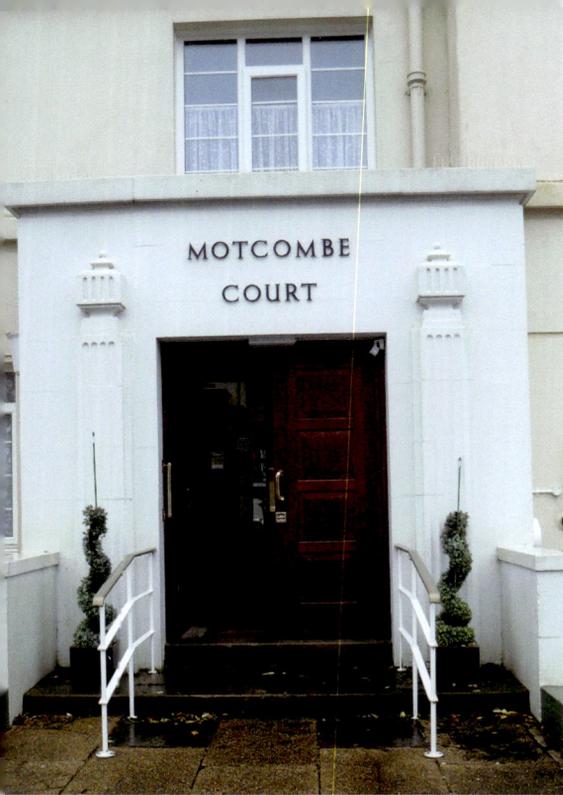

Left: Motcombe Court.

Below: Motcombe Court 1943 bombing. (Courtesy of the National Archives HO 192/1016 Crown copyright reserved)

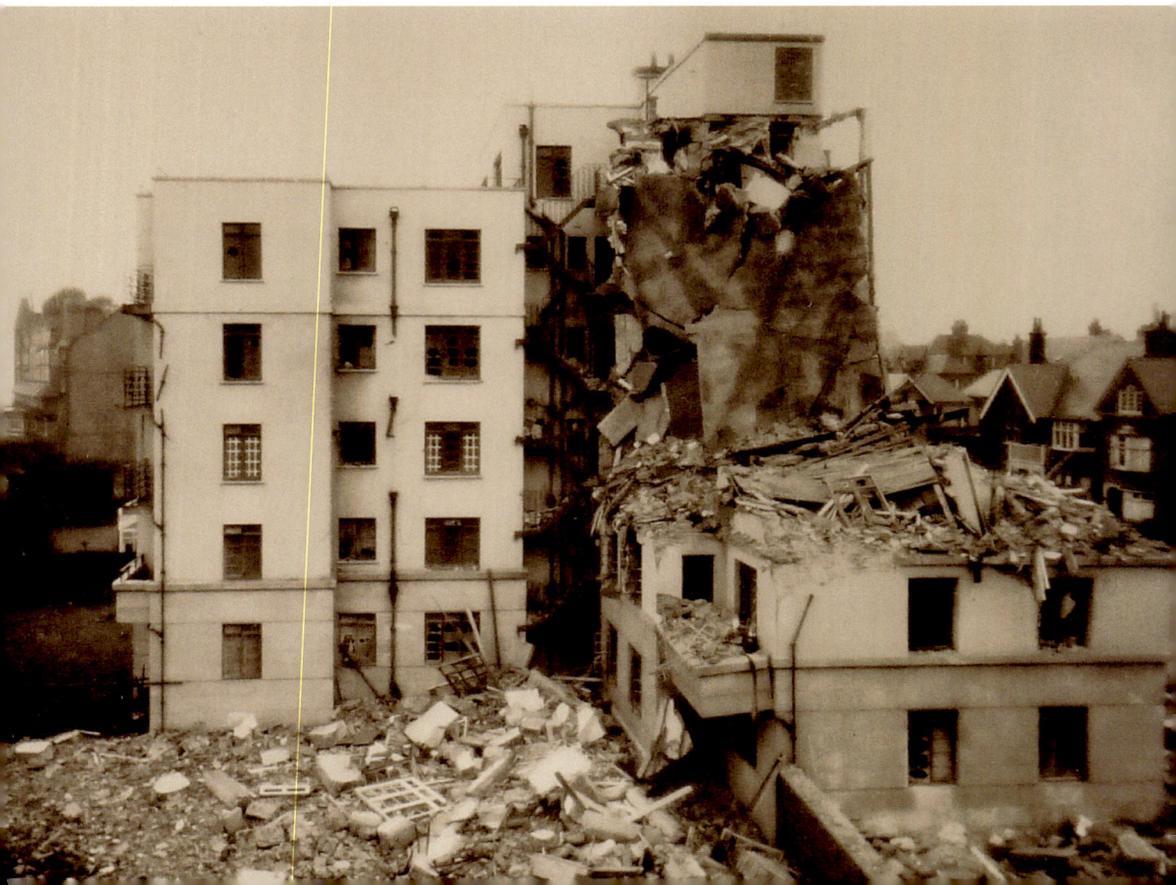

morale. After the war, one of its residents was Sir Atul Chatterjee, the Indian High Commissioner in London.

In 2016 extensive external repairs and redecoration was carried out. Motcombe Court comprises twenty-four apartments.

44. Upper Sea Road Air-raid Shelter

The Home Office Air Raid Precautions organisation (ARP) exercised strict control in the early months of the Second World War but needed to adapt quickly to unpleasant surprises. Bexhill Council complained at one point that the instructions from above were contradictory.

ARP authorised Bexhill Corporation to provide shelters for that 5 per cent of the population who could not reach their homes within five minutes. By October 1939 fifteen shelters had been built. The one in Upper Sea Road had room for forty-two people and had twelve bunks. It would have been a tight fit, but there were sturdy blast walls, an air vent and a chemical toilet. A newspaper survey in 1940 revealed that many of Bexhill's shelters were letting in water.

Upper Sea Road air-raid shelter.

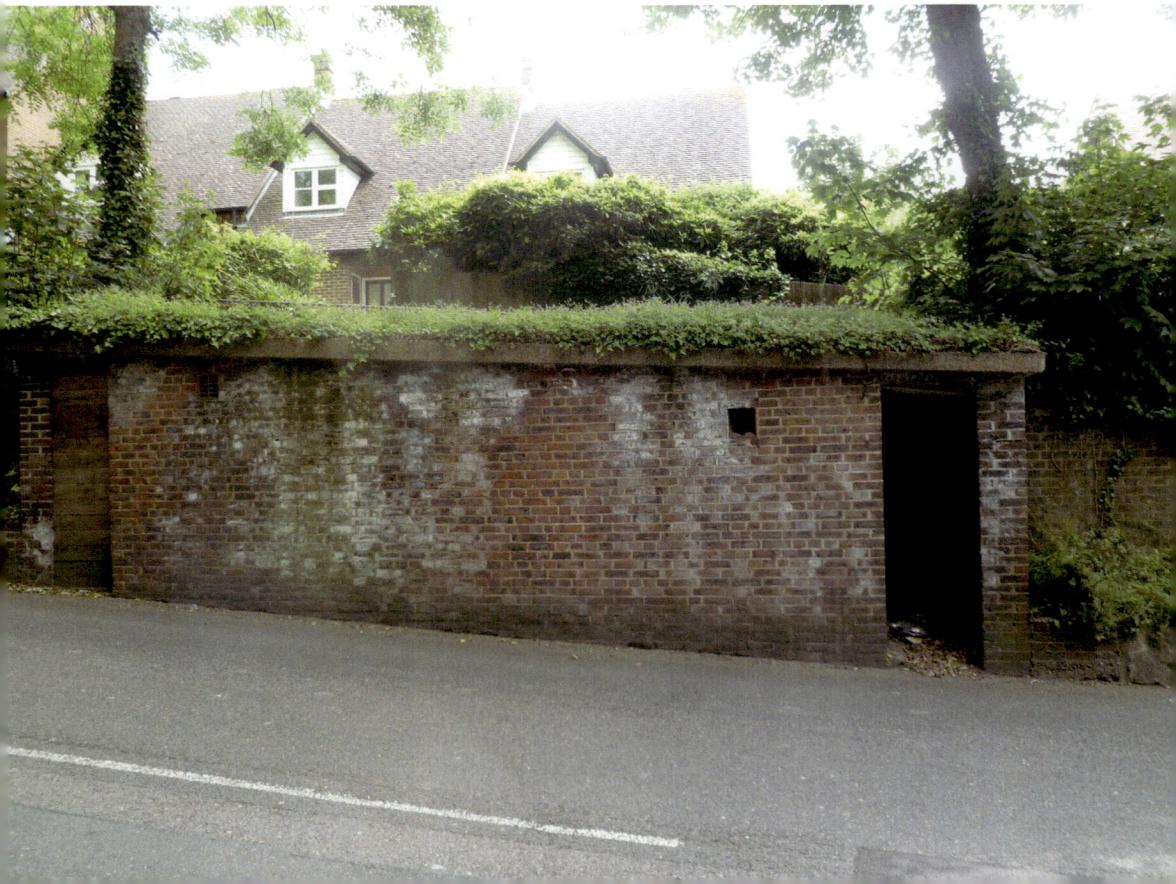

At the start of the war, the town was regarded as a safe zone, receiving evacuees from London. In other parts of the country, councils were distributing Anderson shelters in kit form – homeowners were badgered into assembling the sheets of corrugated iron. There was no expectation of Bexhill becoming a target, and people were more concerned by the problems of assimilating evacuee children. By August 1940, when the whole of southern England was open to aerial bombardment, Andersons were no longer being made as the material was needed for other purposes. So, Bexhill went without.

The Upper Sea Road shelter had a near miss on 19 September 1940 when three bombs came down on the opposite side of the road. One demolished a new house, Twinehams. Three tradesmen were present, including a plumber called Jack Croft, who was killed. A second bomb brought down trees on an embankment, narrowly missing a passer-by. The third did not explode but was discovered during building works and defused in 2009.

In July 1941 an equipment inventory showed that light bulbs and biscuits (Crawford chocolate wholemeal) were targets of theft. Some wardens left one bulb in the shelter and kept the rest at home. During a single week, seven incidents were recorded, mainly involving lightbulbs. In theory every shelter should have been checked twice daily, but no one was ever caught.

45. West Indies Apartments

R. A. Larkin is associated in Bexhill with the mid-century spread of traditionally built, quiet suburban estates, beginning with Leasingham Gardens in 1932. In the 1970s, however, he modernised the seafront in a dramatic way. The West Indies apartments are a series of monumental square blocks dominating the Western Parade from Brockley Road to Richmond Road.

They were built on a rectangle of land at Polegrove which had never been developed. For several decades there had been discussion on what to do with the patch of land, sometimes known as the sunken land. There was a 1960s application to build a mini marina and hotel at the plot, with access via a bridge and lock on West Parade.

In the period 1969–82 Larkins built six large apartment blocks at a rate of one every two years. The names reflect the holiday destinations of the Larkin family and they are, in order of build: St Lucia, Montserrat, St Kitts, Grenada, St Thomas, Tobago. Each block was designed by the practice of Messrs Lionel Heather and Evenden. There was a lucky escape in 1987 when Captain Mark Smith was persuaded to evacuate his penthouse flat before the great storm – the remains of his penthouse demolished garages when they were blown down.

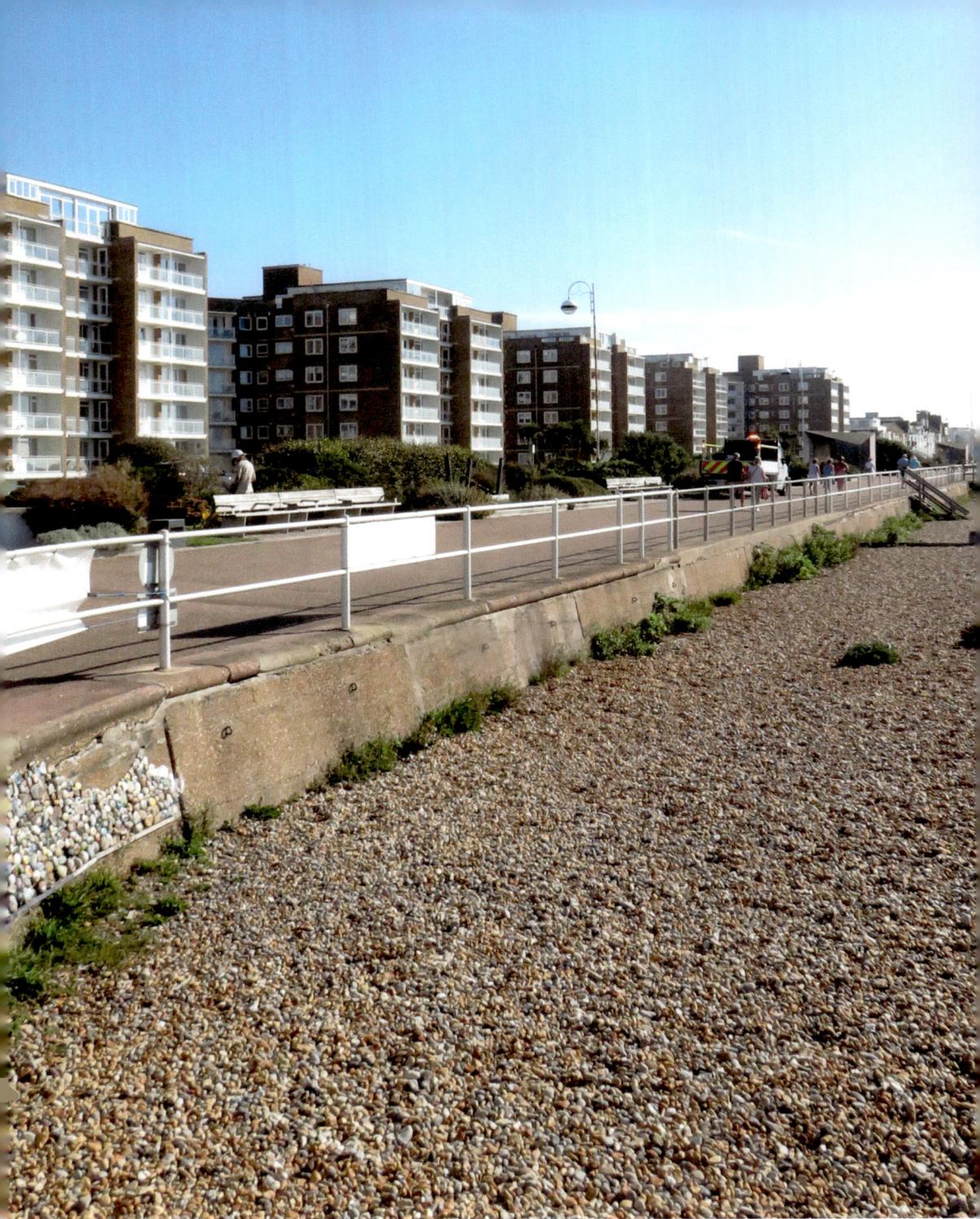

West Indies apartments.

West Indies apartments.

46. Conquest House

This site has moved in step with the local economy, beginning as a private school, being taken over by the military, then finally becoming an administrative centre.

St John's School for girls was opened in 1910 complete with twenty tennis courts. In June 1940 the school evacuated to Horsham, never to return. As with so many buildings in Bexhill the Army took over and in 1946 the school became the Royal Merchant Navy School, a junior school for fatherless children of the Merchant Navy officers and men.

In 1959 the Hastings and Thanet Building Society bought the site. It renamed the building Thrift House – thrift was in those far-off days regarded as a virtue – and established a state-of-the-art administration centre. The school building was demolished in 1972 and rebuilt; during the work, the local removal company Mepham's moved the contents of the building into eighty-five temporary locations. The building society was planning to move out by 1983 and consideration was given to relocate the Town Hall there. By the mid-1980s the occupiers were the South East Thames Regional Health Authority. The Hastings Direct insurance company moved in during 1997 and is now a major local employer.

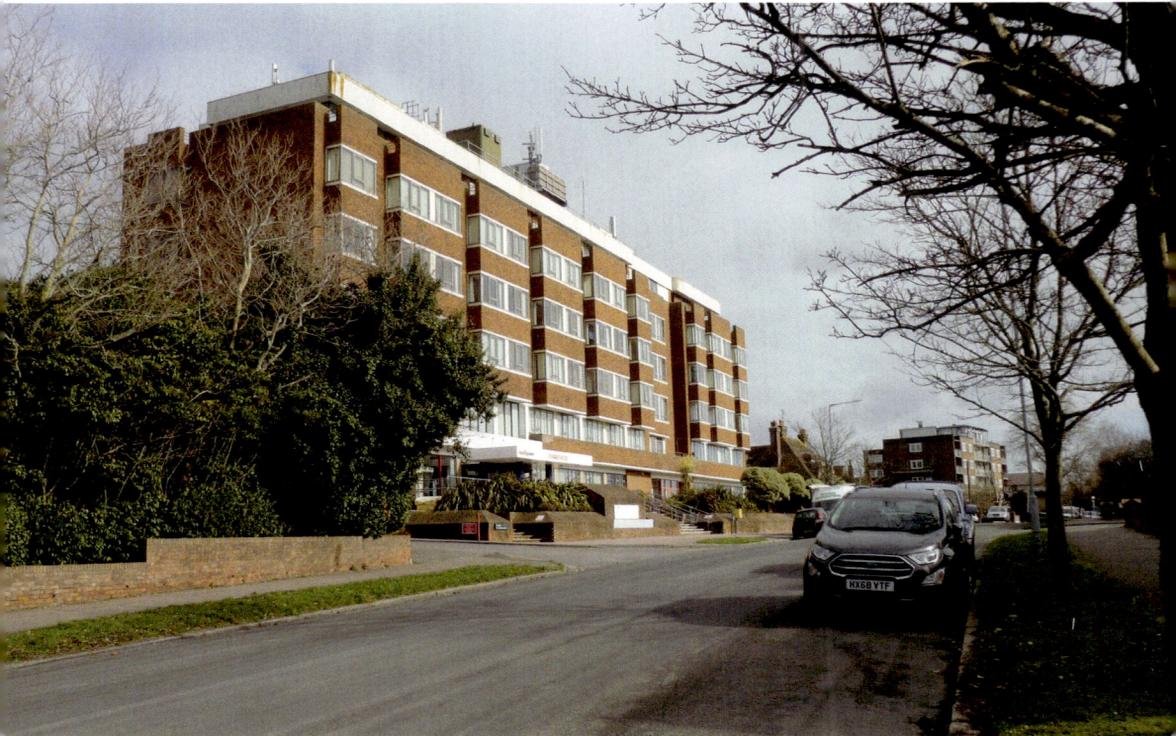

Conquest House.

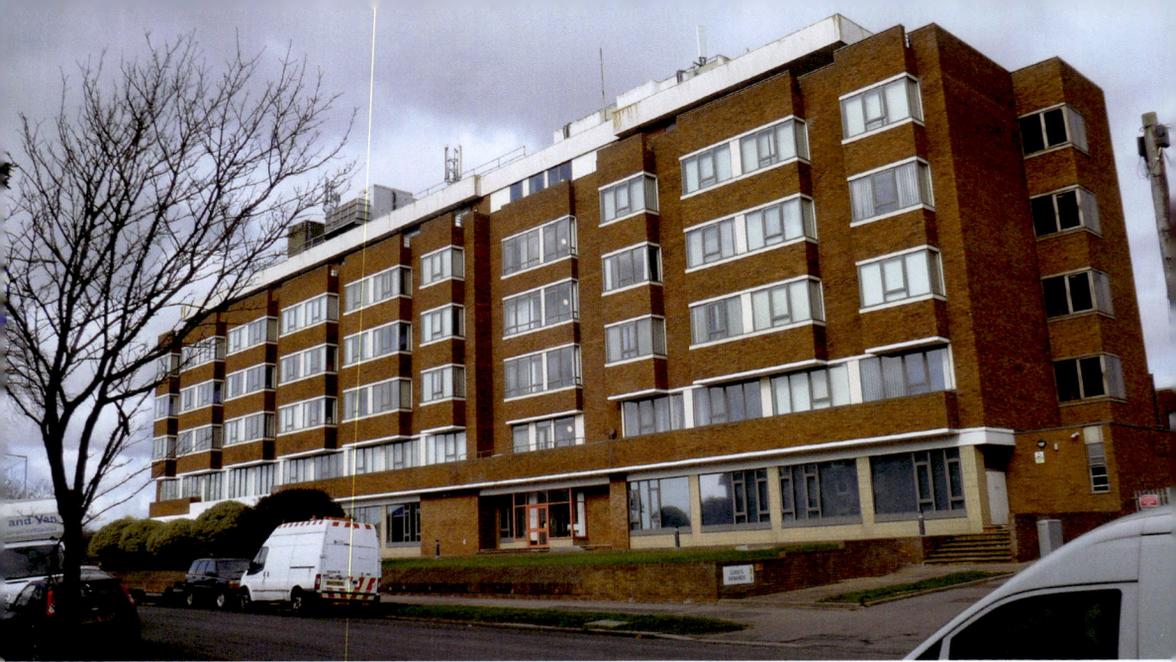

Conquest House.

47. Ravenside Retail Park

In 1989 Bexhill followed the national trend and built a new shopping centre, slightly out-of-town. The retail park at Glyne Gap, on the east of Bexhill, is mainly an outlet for national chains. It is one of many such parks in the country called Ravenside. It does, however, have an interesting local history.

It was the site of the Glyne Gap Gasworks established by Hastings & St Leonards Gas Company in 1900. This came about partly because the local gasworks were inadequate. The location also allowed the company to avoid paying coal taxes to the Hastings Corporation. Manufacture of gas commenced in 1904. The noise and odours from Glyne Gap put paid to Earl De La Warr's efforts to develop east Bexhill. Henceforth the higher quality residential developments would be in the west.

The gasworks were attacked by tip-and-run aircraft in 1943. Three bombs landed here, causing considerable damage and setting the retort house on fire. A reference to the poor weather conditions comes from the Luftwaffe debrief, in which the pilots reported dropping bombs on 'houses between Bexhill and Hastings'. There were twelve casualties, eight serious and four slight. Two of the seriously injured died later. The plant was out of action for several hours.

The gasworks eventually closed in 1969 and some twenty years later Land Securities in conjunction with Wimpey Construction embarked on the £20 million development of a retail and leisure park using the Norman Hitchcox Partnership as architects. At the same time East Sussex County Council were endeavouring to complete the adjacent roundabout.

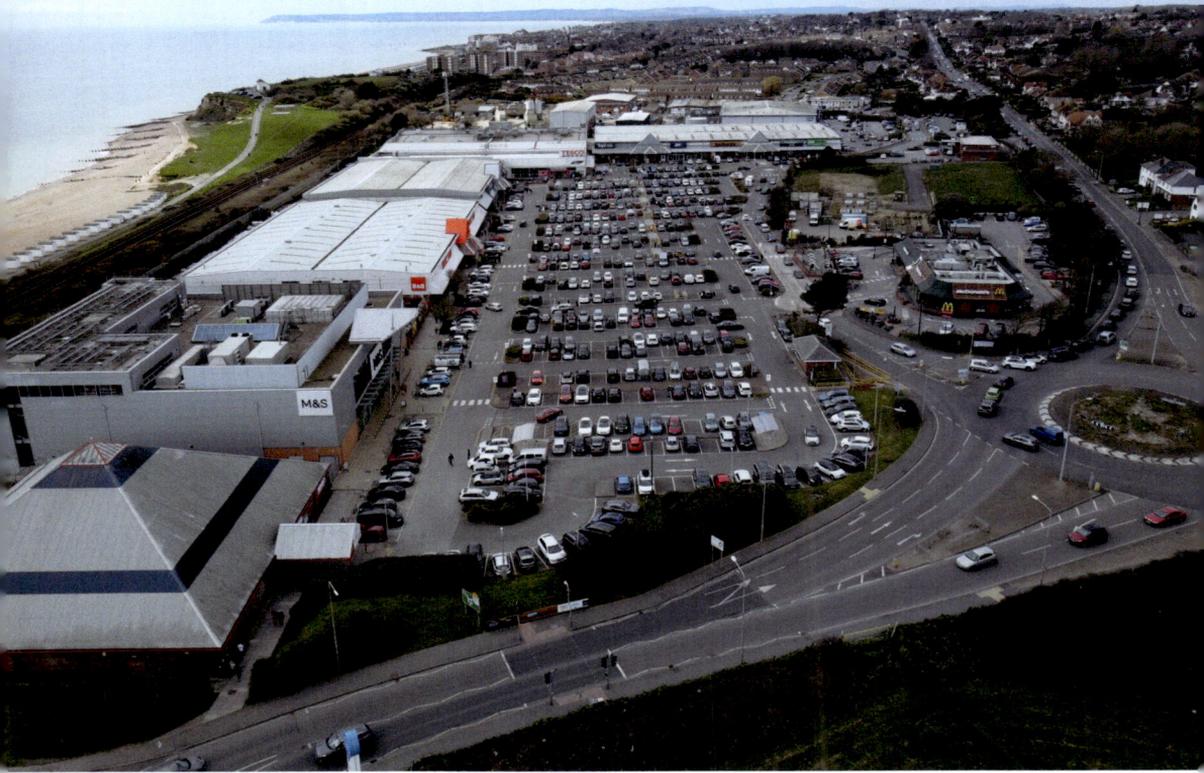

Above: Ravenside Retail Park. (Courtesy of Alex Markwick)

Below: Hastings Gas Works. (Courtesy of Bexhill Museum)

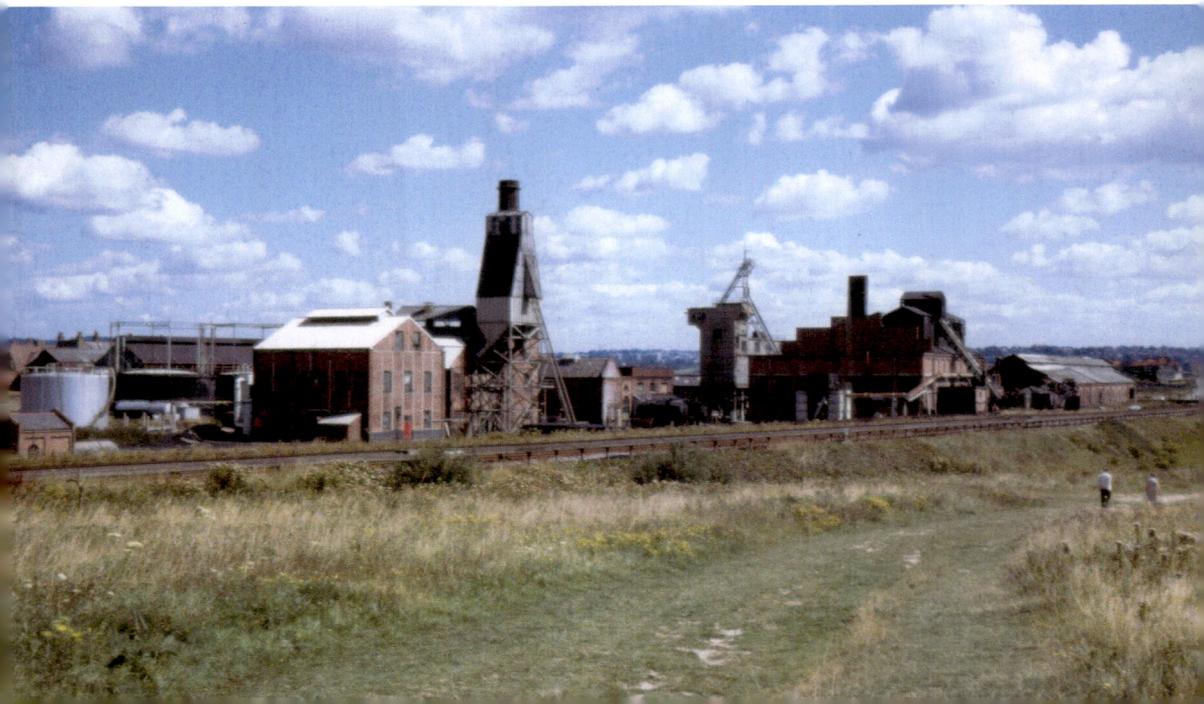

Several stores were at the starting gate, opening for the August bank holiday 1989. The actual official opening was in November, with Coronation Street actor William Roache doing the honours. He was supported by Garfield the Cat and a big balloon launch.

The leisure aspect has diminished somewhat with the closing of the bowling alley, although the swimming pool remains. With 255,000 square feet there are fourteen retail units and 881 car parking spaces.

48. Coastguard Station

As part of the Maritime and Coastguard Agency, this is the home of the Bexhill Coastguard Rescue Team. It was built in 1996 by C. J. Gray Builders based in Deal at a cost of £60,000. Bexhill resident and actor Desmond Llewelyn ('Q' in the James Bond films) did the opening honours. The facility replaced a brick and timber structure erected in the late 1970s. For the Coastguards it was a welcome improvement as it comprised a galley, flushing toilet, office, observation area, storage and garage.

Galley Hill is the highest point along the coast between Eastbourne and Hastings and has a background of government service: it was an army training ground during the Second World War where troops were introduced to one of 'Hobart's funnies' – a flamethrower tank.

In the Cold War years, a Royal Observer Corps reporting post was installed. This was a claustrophobic concrete bunker from which its occupants could monitor nuclear blast, flash and fall-out. This was operational from 1963 to 1968 and was finally dug out in 1971.

Coastguard Station.

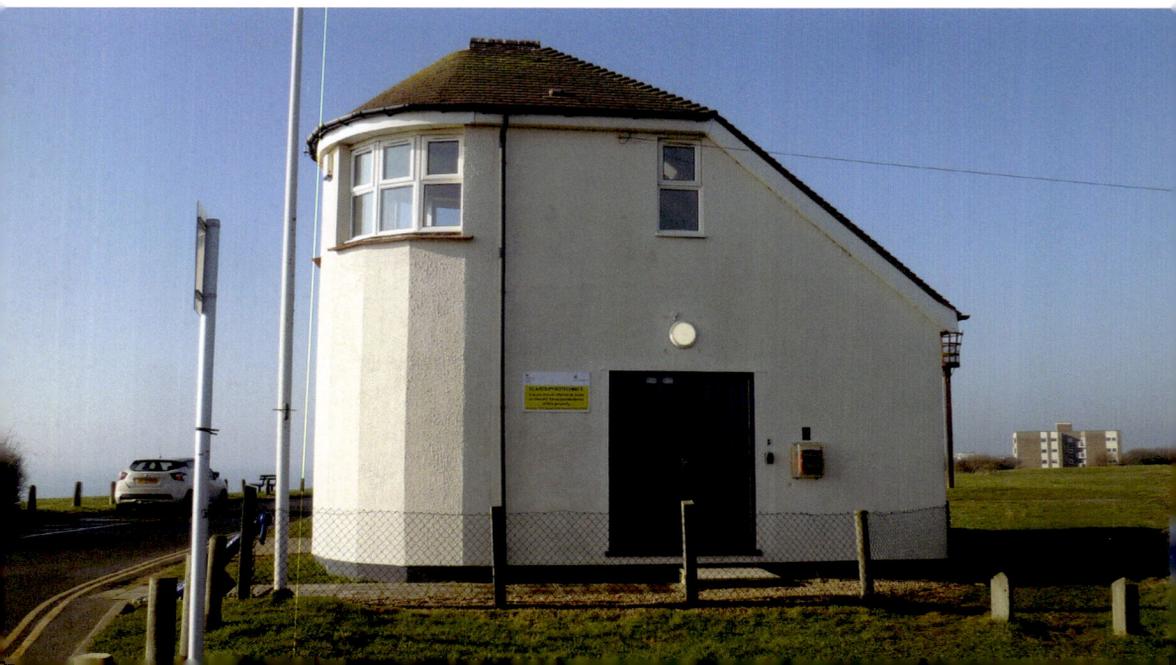

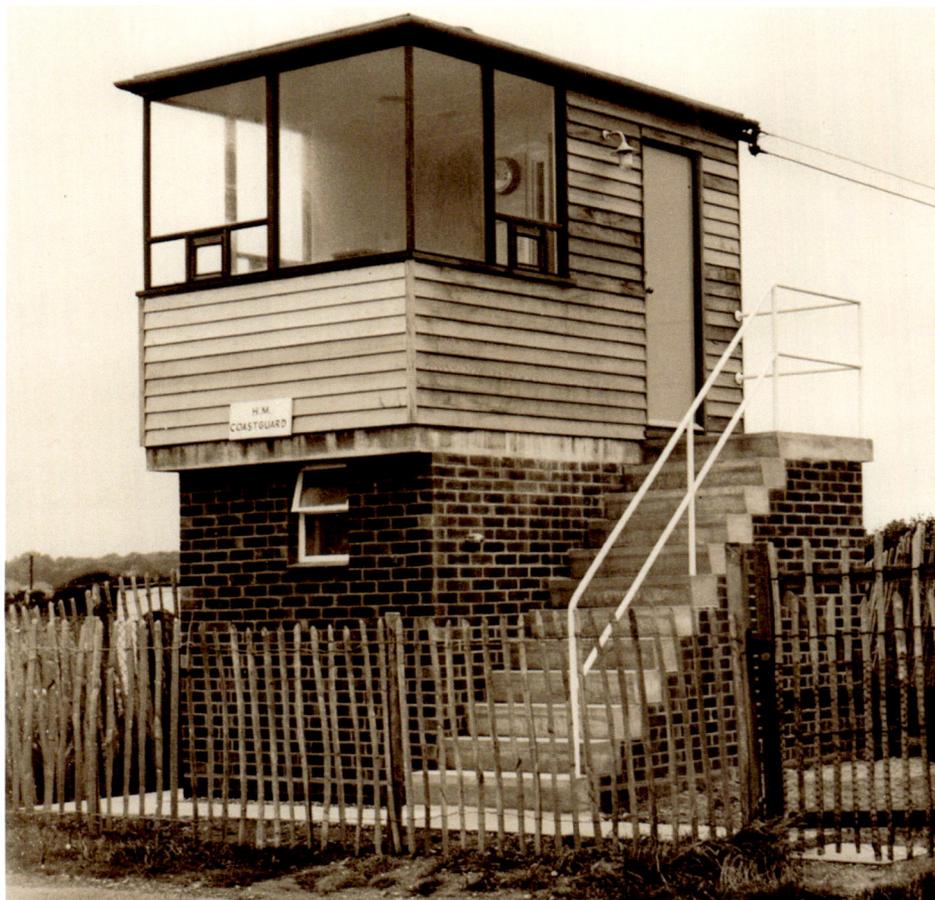

Coastguard Station. (Courtesy of Bexhill Museum)

49. Bexhill College

There has been a school on this site since 1898, when Revd Francis Robert Burrows moved his boys' preparatory school from St Leonards. Prior to that, the field had been best known as a location for a huge jubilee bonfire. The school was called Ancaster House School. Due to Burrows's ill health, his wife Theodosia continued the enterprise as a girls' school. Following her death in 1933 her daughter, Miss Frances Henrietta Burrows, took over, retiring in 1953. Frances was also a Girl Guide District Commissioner.

Ancaster House School was a huge enterprise, with over 150 girls, mostly full-time boarders. In 1986 the school merged with another girls' school, Charters Towers School, in nearby Hastings Road. The new identity was Charters Ancaster School and teaching continued at Ancaster House until Charters Ancaster closed

in 1995. Following closure, the buildings became derelict and burnt down in 2001. Fire crews from Battle and Hastings assisted crews from Bexhill and Hailsham. Ninety per cent of three three-storey blocks where the fire began had been gutted.

A short distance away, in Turkey Road, a grammar school had been established in 1926 known as the County Schools for Boys and Girls. The boys' and girls' schools amalgamated in 1970 to form Bexhill College. When Ancaster House burned down, Bexhill College applied to build a new campus on the Ancaster site, funded by the sale of the Turkey Road.

Bexhill College is a dedicated sixth form college encompassing over fifty subjects with all its facilities on the 5.6-hectare site. The Izzard Theatre was opened in December 2013 by Eddie Izzard. It is a 200-seater space, complemented by a drama studio, music rooms, recording studio, hair salon, catering kitchen, conference facilities and IT rooms. The theatre is used for multiple events such as shows performed by students to assemblies and political hustings. Sports facilities consist of a 3G all-weather pitch, two dance studios, an indoor multisport hall, a climbing wall, three tennis courts, a large grass training area and a modern gym. Other facilities Include six science laboratories, the library and student study centre, a creative media department, a swimming pool and professional catering training facilities.

Bexhill College. (Courtesy of Alex Markwick)

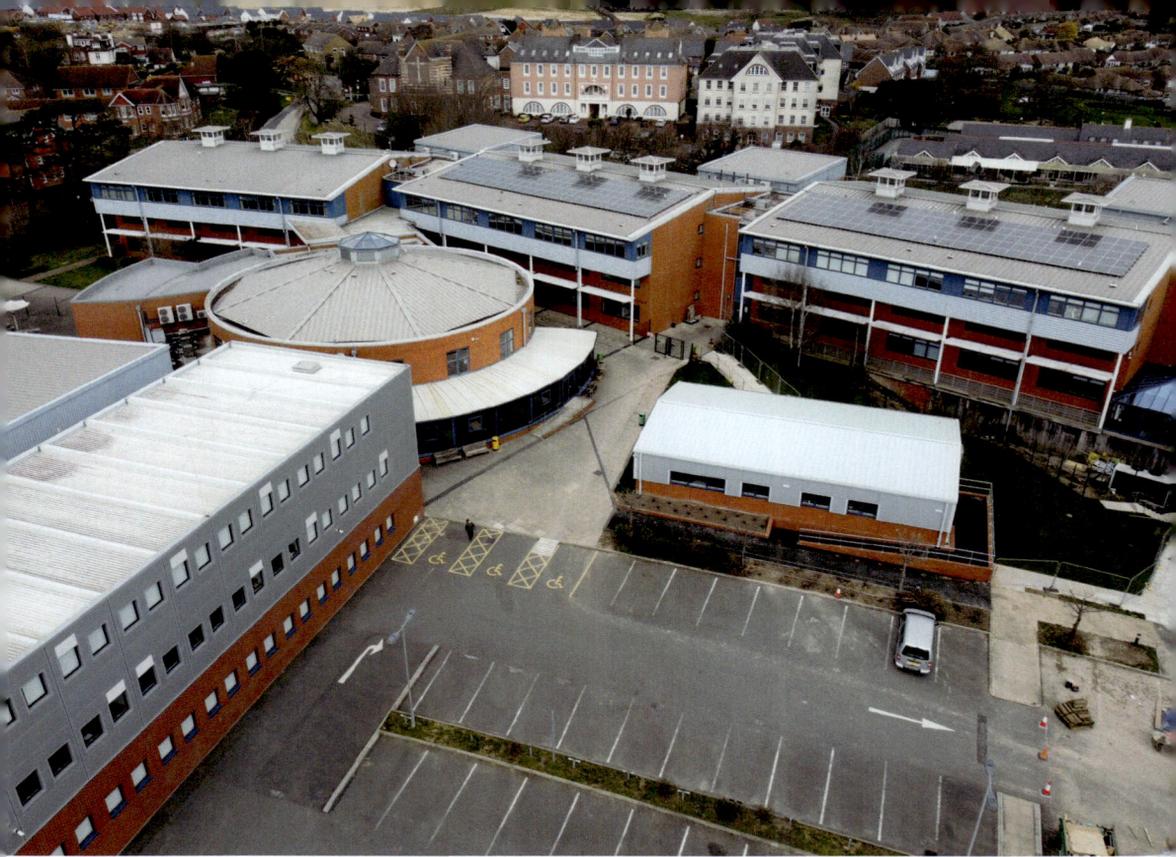

Bexhill College. (Courtesy of Alex Markwick)

5C. West Parade Shelters

The East Parade has always retained a period charm, recalling the 8th Earl's original vision. The West Parade, by contrast, has been a patchwork affair.

There was an attempt to give the seafront a more modernised look in 2010. This was the purpose of the £5 million Next Wave project, funded by Rother District Council and the Commission for Architecture and the Built Environment (CABE), who provided a £1 million grant. Included was a refurbishment of the Colonnade, new premises for the Bexhill Rowing Club and the installation of new seafront shelters and a kiosk. The promenade itself was to be redesigned and feature replanted gardens, landscaping and new seating, the new shelters and resurfacing, plus new signage.

There was local opposition, especially to the shelters. The kiosk would, no doubt, have attracted further opposition but this was dropped from the plan on the grounds of cost. There was a competition, which attracted an interesting range of entries. Perhaps it is fair to say that the old shelters on the seafront had been designed with shelter in mind, and then artistic touches were added to the exterior. Some entries for the modern shelter took a different, and perhaps opposite, approach.

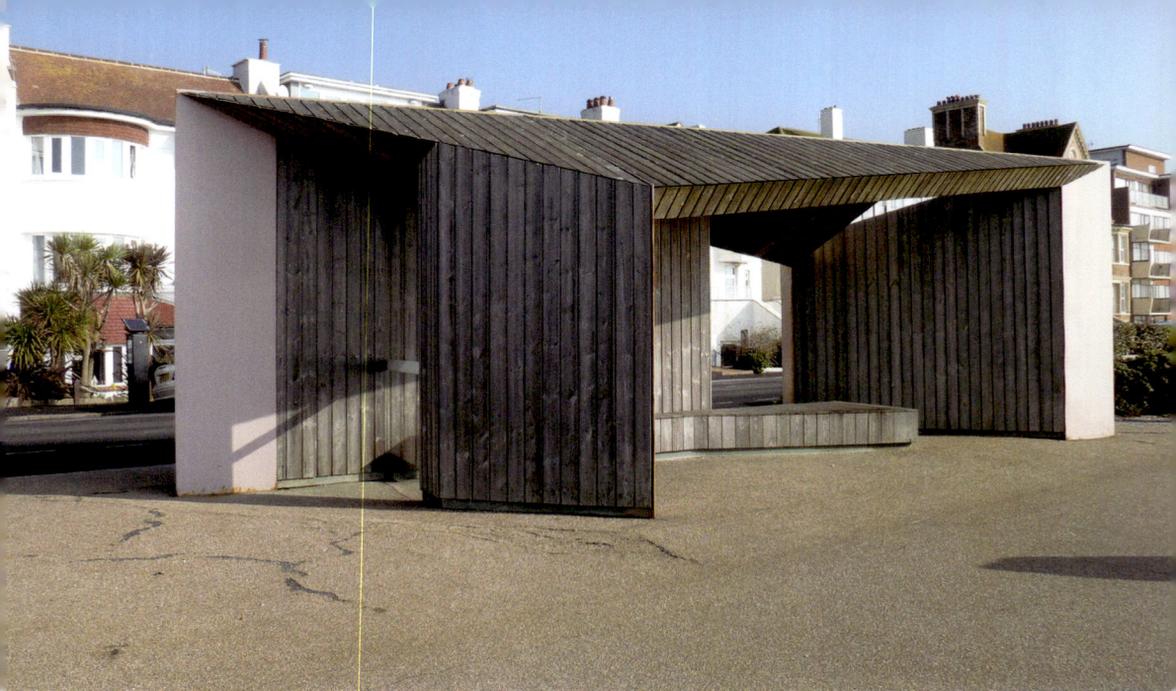

Above: West Parade shelter.

Below: The meeting of the promenades. (Courtesy of Alex Markwick)

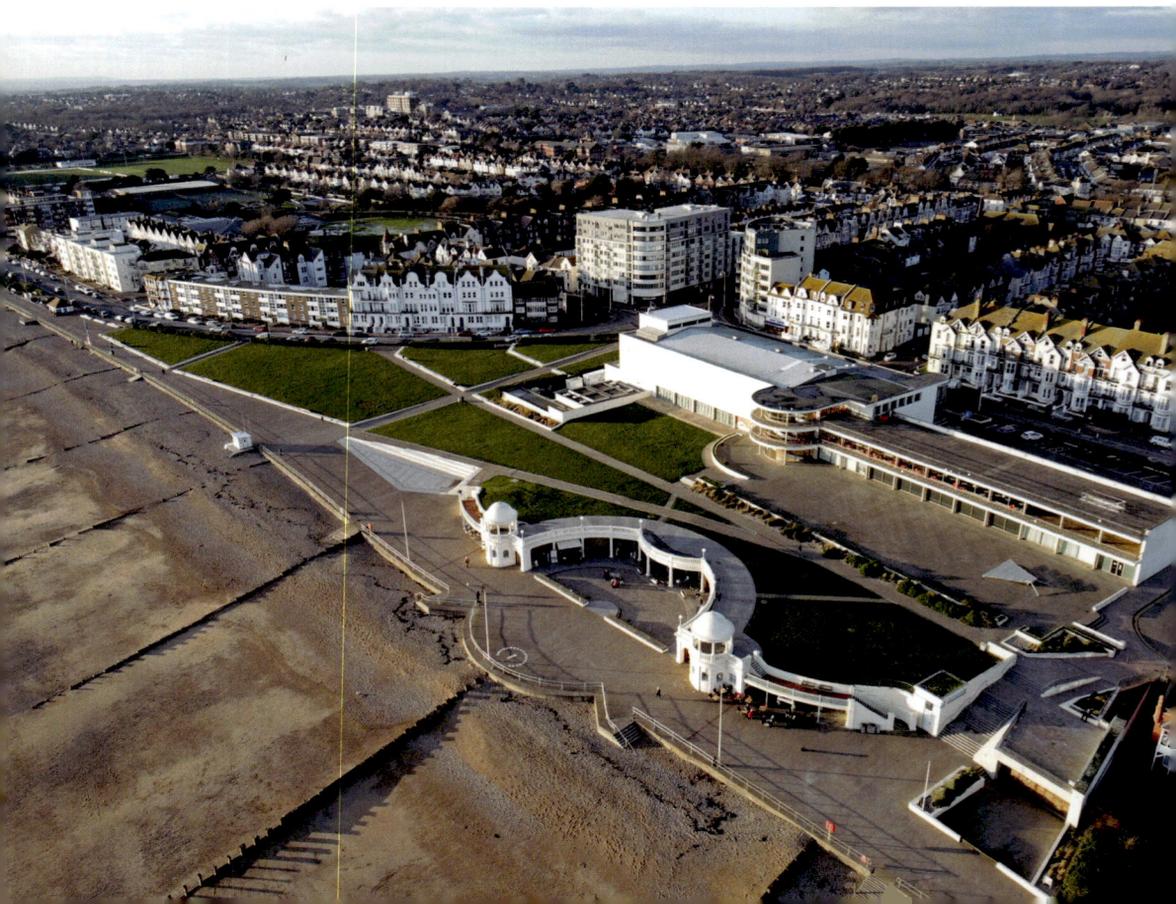

After a competition, the council selected the second-placed entry, describing it as 'an enduring and creative addition' to the town. A spokesperson from CABE Space said that the shelters continued Bexhill's tradition of hosting innovative and contemporary architecture. A pressure group 'Save Our Seafront' sprang up. An opposition councillor described the design as a 'tin shed surrounded by puzzle pieces', and a lasting complaint is that the expensive shelters do not provide shelter. They were installed in April 2011, but after only two years, the shelters were fenced off for repairs. At one point twenty councillors assembled inside one to demonstrate their ergonomics.

Defenders of the shelters have looked back to the controversial Pavilion. In fairness, the shelters have had an impact. In September 2014 the Royal Mail issued a series of stamps on the theme of seaside architecture. A West Parade shelter was on the £1.28 stamp.

Acknowledgements

All photographs are by the authors unless otherwise indicated. Our thanks are due to Chris Baldry, John Dowling (sub-editor), Philip Elms, Will Hatherell, Alex Markwick (drone photographer), Julian Porter, Tony Tolputt and John and Sue Tyson. We have been greatly helped by the Bexhill Museum, the Boots Archive and Cooden Beach Golf Club, and special thanks are due to Sue and Jennie.

About the Authors

David Hatherell is a local historian with a special interest in the armed forces. He is a volunteer with Bexhill Museum, lecturing and organising local walks and is involved in oral history in the Bexhill area. He volunteers for the Commonwealth War Graves Commission, leading tours and giving lectures, as well as tending graves at Bexhill Cemetery and St Mark's churchyard in Little Common. He also volunteers with the local Talking Newspaper.

Alan Starr worked in IT in the City and since retirement has been researching local history. He has produced three books for Amberley and has also published works on Pevensey and on garden history. He lectures on local history and is the history advisor on Pevensey's Mint House project, restoring a Tudor building. He has a D.Phil from the University of Sussex and one of his books is on Sussex literary figures.